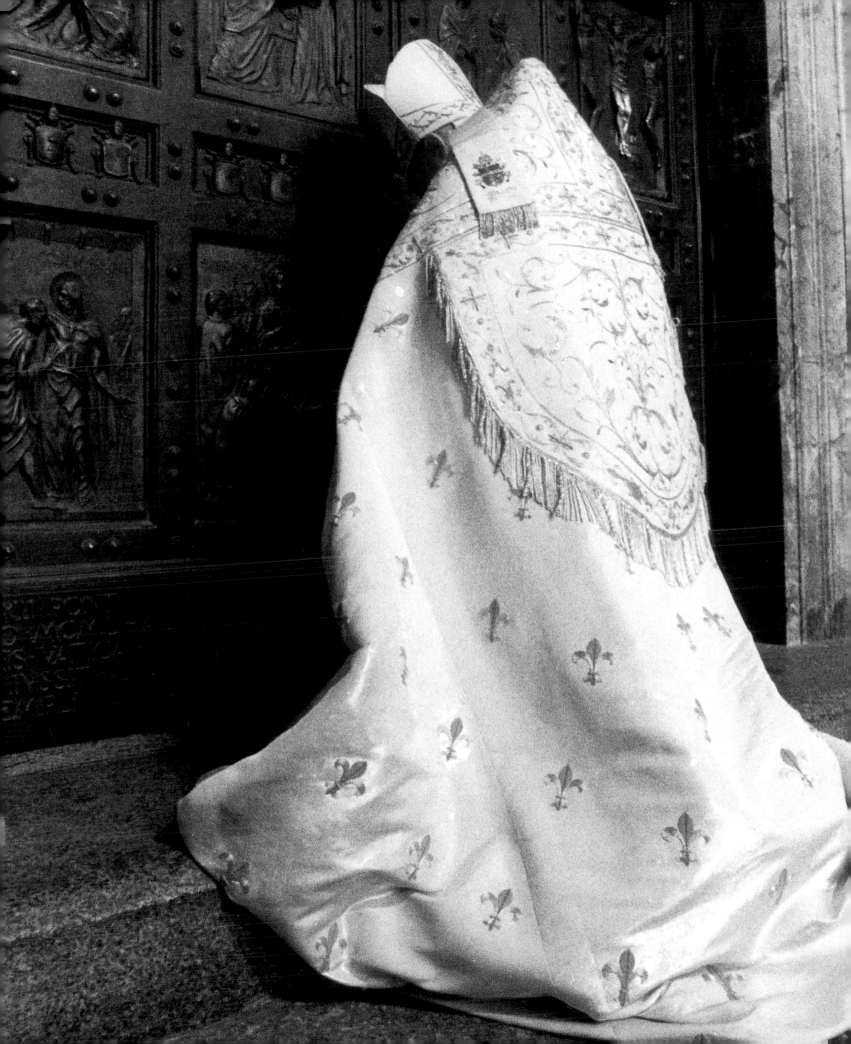

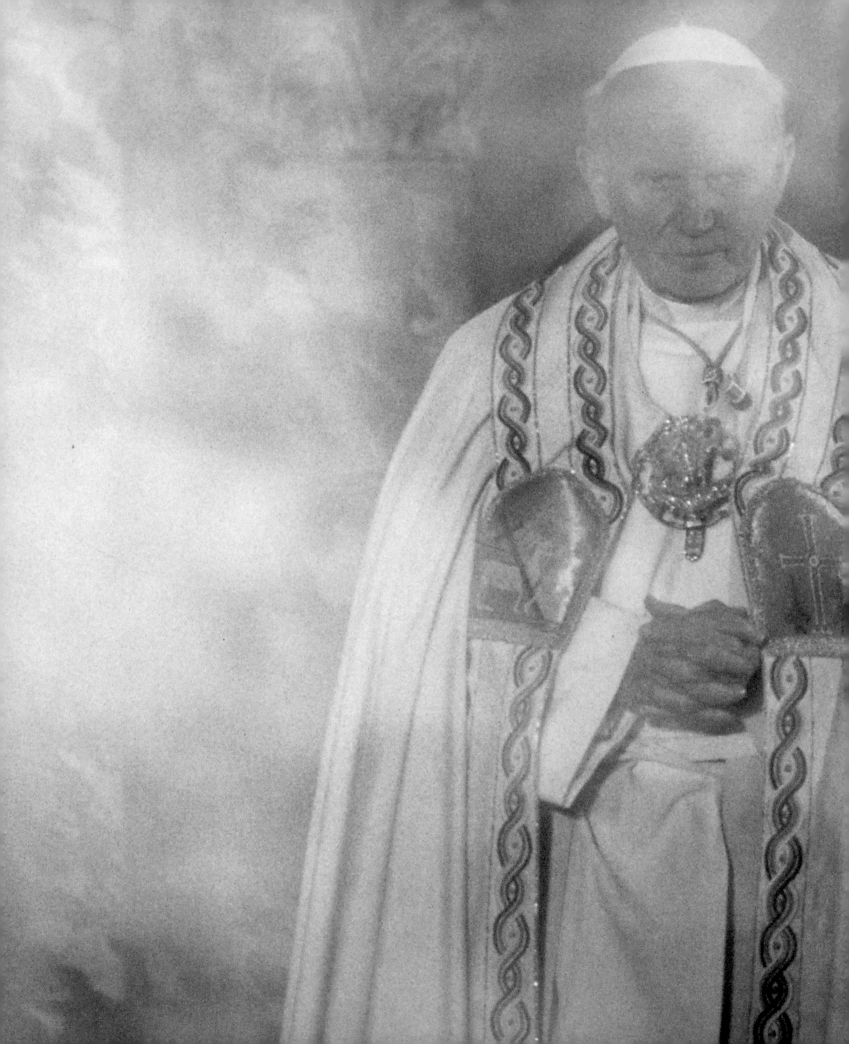

LIFE

POPE JOHN PAUL II

Toward Sainthood

BY ROBERT SULLIVAN
AND THE
EDITORS OF **LIFE**

With a Foreword
by the Reverend
Billy Graham

LIFE Books

Managing Editor
Robert Sullivan

President
John Q. Griffin

Business Manager
Roger Adler

STAFF FOR
THIS EDITION

Editor
Robert Andreas

Picture Editor
Barbara Baker Burrows

Design Directors
Neal Boulton
Anke Stohlmann
 (2011 edition)

Deputy Picture Editor
Christina Lieberman

Writers
Robert Sullivan
Ben Harte
 ("The Papacy
 Through the Years")

**Associate Picture
Editor**
Dot McMahon

Associate Designer
Matthew Bates

Picture Research
Alice Albert
Kierstin Meyer

Reporters
Hildegard Anderson
Daren Fonda
Marilyn Fu
Mimi Murphy (Rome)
Eleanor N. Schwartz
Elizabeth E. White

Copy Chief
Kathleen Berger

Copy Desk
Madeleine Edmondson
Joel Griffiths
Christine McNulty
Larry Nesbitt
Jerome Rufino
Pam Warren

TIME HOME ENTERTAINMENT

Publisher
Richard Fraiman

General Manager
Steven Sandonato

**Executive Director,
Marketing Services**
Carol Pittard

**Executive Director,
Retail & Special Sales**
Tom Mifsud

**Executive Director, New
Product Development**
Peter Harper

**Director, Bookazine
Development &
Marketing**
Laura Adam

Publishing Director
Joy Butts

**Assistant General
Counsel**
Helen Wan

**Book Production
Manager**
Suzanne Janso

**Design & Prepress
Manager**
Anne-Michelle Gallero

Brand Manager
Roshni Patel

SPECIAL THANKS:
Christine Austin
Jeremy Biloon
Glenn Buonocore
Jim Childs
Susan Chodakiewicz
Rose Cirrincione
Jacqueline Fitzgerald
Carrie Frazier Hertan
Christine Font
Lauren Hall
Malena Jones
Mona Li
Robert Marasco
Kimberly Marshall
Amy Migliaccio
Nina Mistry
Dave Rozzelle
Ilene Schreider
Adriana Tierno
Alex Voznesenskiy
Jonathan White
Vanessa Wu

ISBN 10: 1-60320-220-X
ISBN 13: 978-1-60320-220-6
Library of Congress Control
Number: 2011926738

"LIFE" is a registered
trademark of Time Inc.

We welcome your
comments and
suggestions about
LIFE Books. Please
write to us at:
LIFE Books
Attention: Book Editors
PO Box 11016
Des Moines, IA 50336-1016

If you would like to order
any of our hardcover
Collector's Edition books,
please call us at
1-800-327-6388.
(Monday through Friday,
7:00 a.m.— 8:00 p.m. or
Saturday, 7:00 a.m.—
6:00 p.m. Central Time).

Permission to quote from
Gift and Mystery and
other writings of Pope
John Paul II: Libraria
Editrice Vaticana

PAGE 1:
Adam Bujak

TITLE PAGE:
Massimo Siragusa/
Contrasto/Redux

CONTENTS PAGE:
Adam Bujak

LIFE

POPE JOHN PAUL II

Toward Sainthood

CONTENTS

Foreword

When future historians look back on the most influential personalities of the 20th century, the name of Pope John Paul II will unquestionably loom large in their accounts. Few individuals have had a greater impact—not just religiously but socially and morally—on the modern world. He will stand as the most influential moral voice of our time.

I first became acquainted with the name of this remarkable man when I visited Poland in 1978. At the time, he was known as Karol Cardinal Wojtyla, and he had invited me to have tea with him and to preach in his home church, St. Anne's in Kraków. As it turned out, however, we did not meet; he had been called away to Rome to participate in the election of a new pope following the unexpected death of John Paul I. To everyone's surprise—including his, I'm sure—Karol Wojtyla was elected pope, taking the name of John Paul II. When my plane from Poland landed in New York, after his election had been announced, I was interviewed by the media. They had scores of questions to ask because they knew I had just finished a

On March 10, 1993, the American evangelist and the Polish pope talked during an audience at the Vatican. Their mutual admiration dated to the 1970s, when Billy Graham was a globe-trotting preacher and Karol Wojtyla—pronounced Voy-*tih*-wuh, as Graham knew—was the Metropolitan Archbishop of Kraków.

preaching series in Poland that included several Catholic cathedrals. I remember one incident on *Good Morning America* when David Hartman asked me how to pronounce his name. When I told him, he slapped his knee and said that he might be the only reporter in New York who knew how to pronounce the name.

After that, John Paul welcomed me several times at the Vatican, and although we came from different backgrounds, we developed a warm friendship with each other. His courageous stands for morality and faith in an age of rampant secularism, as well as his compassion for all who suffer and his strong commitment to social justice, won him the respect not only of his fellow Roman Catholics but of anyone concerned about the moral and spiritual confusion of our time. His call for young people to renounce the false paths that our modern world beckons and to commit their lives to Christ and His will struck a responsive chord in the hearts of millions.

As the world faces the challenges of a new millennium, may Christ's call to repentance and faith be heard with ever greater clarity by each of us.

—*The Reverend Billy Graham*

Lolek

On June 16, 1999, a frail 79-year-old man—the Supreme Pontiff of the Universal Church, Bishop of Rome, heir to Saint Peter, leader of the world's one billion Catholics—visited a yellow stone house at 7 Kościelna Street in the Polish village of Wadowice. On that day did John Paul II become, again, Karol Wojtyla, nicknamed Lolek, the boy he had been when he lived in a small apartment on the second floor. "People say that it's good everywhere, but it's best to be at home," the old man said on Kościelna Street. "This pilgrimage is like a return to the beginning."

The Wojtylas' toddler not only looked like a little angel, he was one. Neighbors in Wadowice remembered him as a sweet, good-humored child, and then an energetic, kind, honest, vastly talented boy—a boy you couldn't help but notice. He was raised with God as an omnipresent being. His family's three-room, second-floor apartment was in the shadow of St. Mary's Church; his mother kept a font filled with fresh holy water in the apartment.

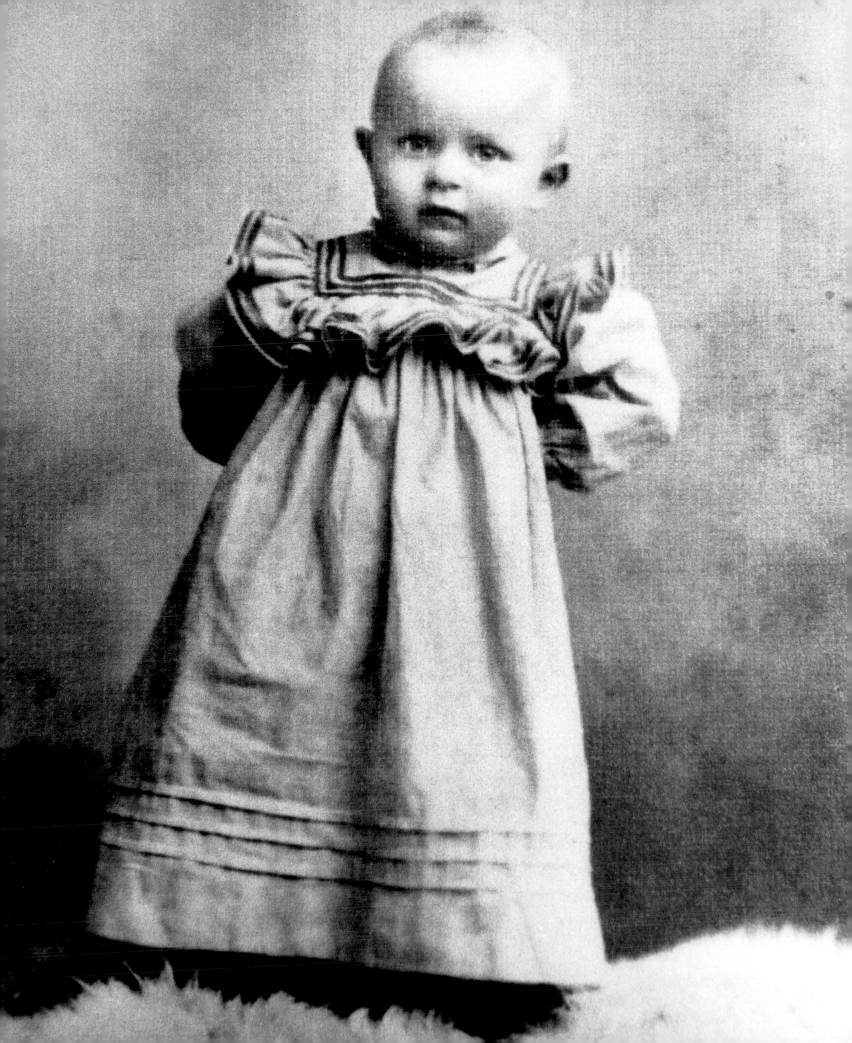

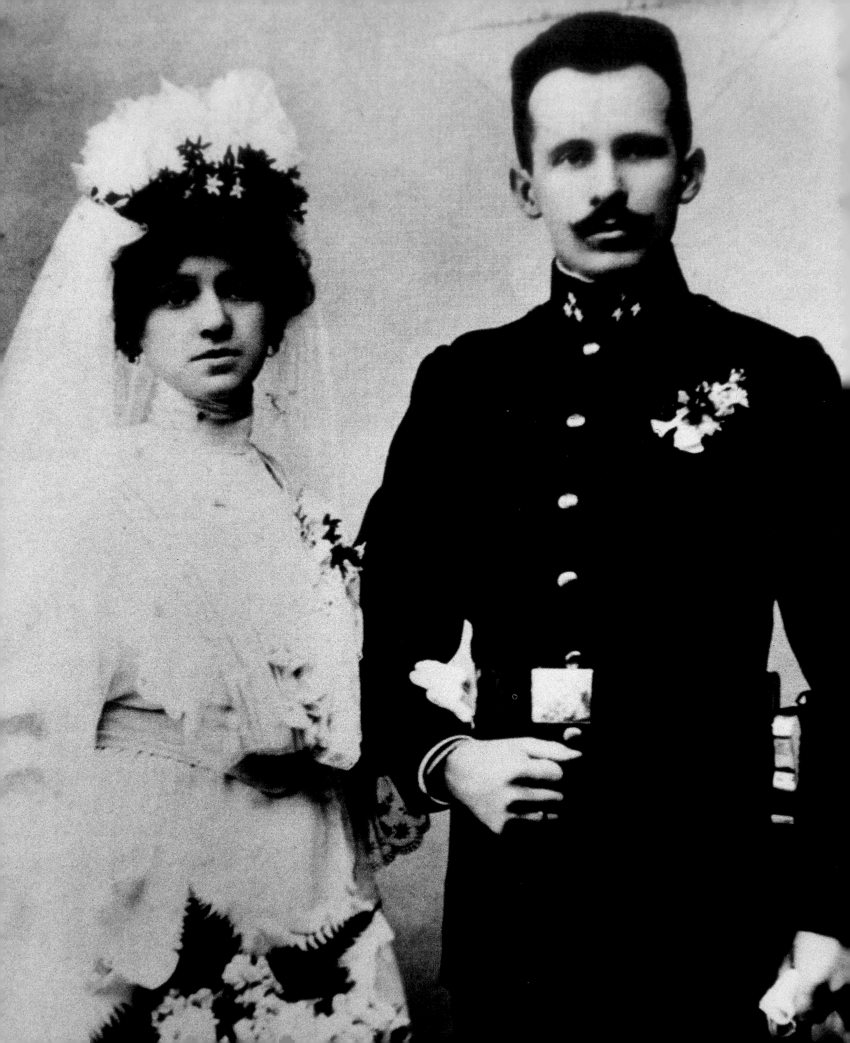

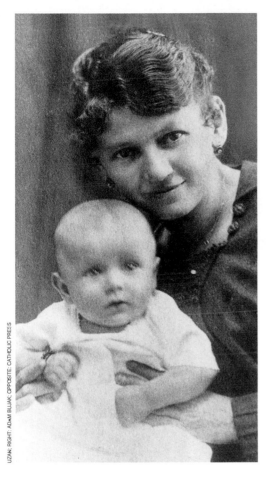

Karol Wojtyla wed Emilia Kaczorowska in Kraków in 1906. He was, at the time, a sergeant and platoon commander in the Austrian Army. But he was Polish in his heart and soul, and with the rebirth of his country he became an officer in the Polish Army and was stationed in Wadowice (top right). Somehow, Emilia always knew her second son, Karol (above), was destined for greatness. Helena Szczepanska, a neighbor who used to baby-sit Lolek, once recalled, "His mother used to yell up to us to say, 'You will see what a great man will grow from this baby.' We all used to laugh at her and say she had a loving heart but could not predict the future. But everyone fussed over him as if he was a prince, so you never can tell."

In Wadowice, seeing the world through Lolek's eyes, the old man revisited the days when he ran races and shared sweets with his young friends, friends like Jerzy Kluger, who—thank God— would survive the Nazis but whose parents and sister and so many other Wadowice Jews, would not. He again went down to the candy store holding the hand of his older brother, Edmund, to buy cream cakes. He kicked a soccer ball made of rags around the flat with his father. He suffered through much-too-short visits with his mother, who, in her last years, was very sick and could rise from her bed only on occasion. He again fell to his knees each morning alongside his father and prayed for his mother.

He again envisioned the view from his boyhood bedroom window. Lolek gazed out the window at the sundial on the store next door and wondered after the motto emblazoned upon it: TIME FLIES—ETERNITY WAITS.

Wadowice in 1920 was a town of 6,000 Catholics and 1,500 Jews, among them burghers, farmers, professionals and merchants. Located in the Carpathian foothills just 30 miles southwest of Kraków, Wadowice derived its character from the mountains and that wondrous medieval and Renaissance town. The much larger city of Warsaw, capital of the modern Poland, was 200 miles away and had little influence in Wadowice.

This modern Poland was brand-new. The nation had been obliterated in the late 18th century, its parts divided among Austria, Prussia and Russia. For more than a hundred years the restoration of sovereignty had been the Polish dream, but it wasn't until 1918, when Woodrow Wilson's postwar Fourteen Points included "independence for Poland," that the dream was realized. It was ratified—if, indeed, a dream can be ratified—by the Versailles peace treaty of 1919.

On Tuesday, May 18, 1920, Karol Józef Wojtyla was born in Wadowice, and all of this—the Polish Catholicism, the Jewish neighbors, the surrounding mountains and rivers, the romance and traditions of Kraków, that city's hallowed places of learning, the remembered pain of a vanished nation, the glory of its resurrection and the sweet taste of freedom—all of this would inform who and what he would become.

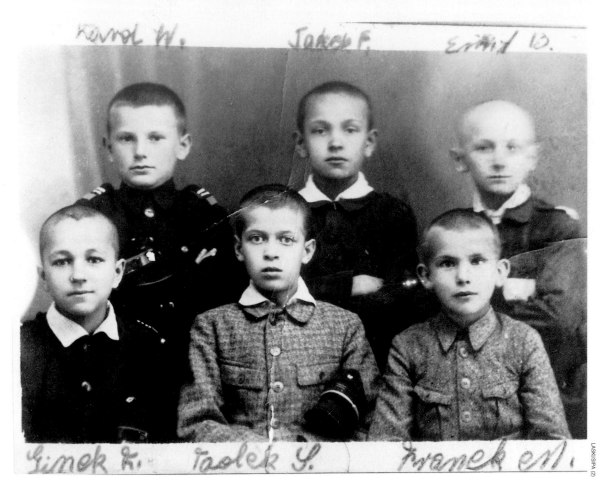

12 As would, of course, his family life, which during his early years was tragic and painful.

His father, also Karol, was a tailor and a military man, his mother, Emilia, an intelligent woman with a convent education. They had been married 14 years by the time the future pope was born. Edmund was already 14 in 1920; a second child, Olga, had died as a baby. Wojtyla *père* was a first lieutenant in the Polish Army posted to the supply command of the 12th Infantry Regiment in Wadowice. His namesake son was christened on June 20 by a military chaplain in the chapel across the street from the Wojtyla apartment. The name "Karol" is the equivalent of Charles in English, and the family took to calling the boy by the diminutive Lolus—equivalent to Charlie. This evolved into Lolek, and followed young Karol out onto the streets of Wadowice and off to school.

Lolek's elementary school occupied the second floor of a municipal building, and there were as many as 60 students in a class. The boy got top grades from Day One and showed early on the inquisitive, contemplative, philosophical bent that would be a hallmark of his adult personality. Which is not to say he was just a bookworm; after school he played soccer (he was a good goalkeeper), swam, hiked in the hills and, in winter, skied. He was a daredevil on the slopes. His love of sport, too, would last a lifetime: As pope, he watched hardly any television, unless there was a crucial soccer match being played.

Indoor activities ranged from listening to his father read history to Ping-Pong games at his friend Boguslaw Banas's house to priest-playing. Polish Catholics are among the world's most devout, and expressions of their faith are ubiquitous and often colorful. The boys of Wadowice would dress as priests and enact rituals of the Mass. His mother made Lolek a white robe to wear while praying and built a small altar for his room. Most of the young "priests," including Lolek, were, in fact, altar boys at the church.

Lolek had many friends and no enemies. Though anti-Semitism was on the rise in the Poland of the 1920s and '30s, Lolek's circle included both Christians and Jews. Lolek even accepted invitations to the town synagogue, where he heard a music very different from that of his hymnal.

Music was central to his life, music and

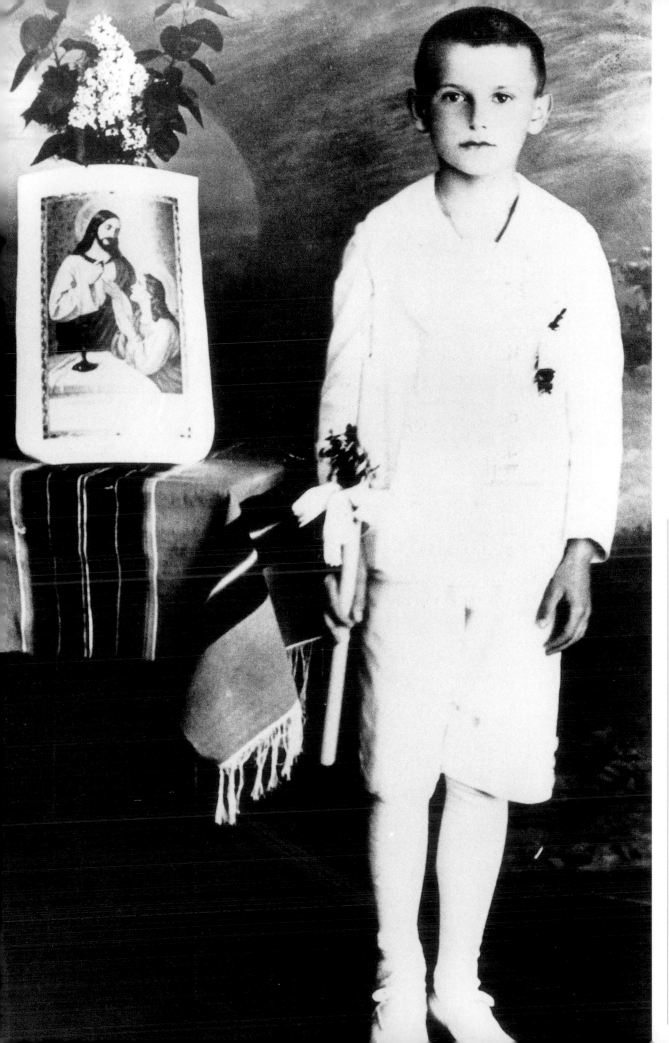

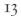

Lolek was nine when these photos were taken. Opposite: He posed, top left, with classmates at the elementary school (the boys later wrote their names on the snapshot). Left: In 1929, on the day of his First Communion. With his older brother's departure for medical school in Kraków, and then his mother's death, life's rhythms changed for Lolek. In the new ritual, father and son would sleep in the same room and, upon waking, pray together. After school and sports, Lolek would meet his father at home, and the two would take walks through the streets of Wadowice. His father's deep spirituality was handed down daily.

WIELICZKA - 26

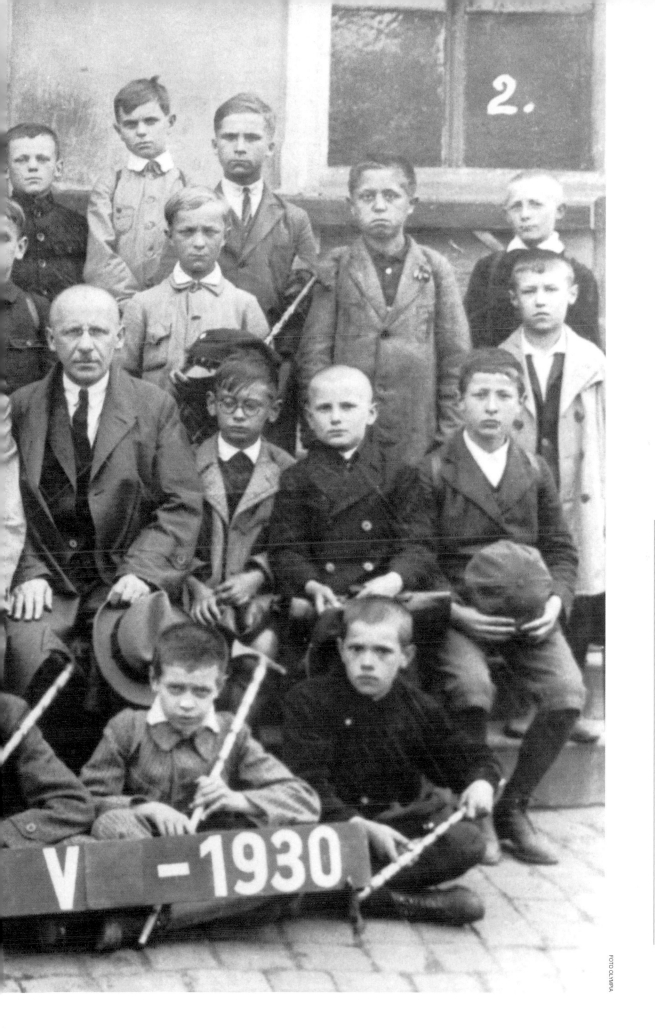

In school, Lolek (second row, second from right) was always at the top of the class. Two days after this picture was taken, on May 28, 1930, Lolek accompanied his father on a trip to Kraków to see his brother, Edmund, graduate from Jagiellonian University's medical school. In 1931, Lolek began studies at the Wadowice boys' high school. While his favorite and best sport throughout his life was skiing, he spent much of his after-school time playing for the soccer team. Most interscholastic games were between Catholic and Jewish teams, but if a Jewish side was shorthanded, Lolek would volunteer to play for the other team.

15

In high school, Lolek began to be influenced by priests. Father Leonard Prochownik taught him that anti-Semitism was "unchristian." Father Kazimierz Figlewicz, here seated next to Lolek, inspired the boy in many ways. "Thanks to him I grew closer to the parish," John Paul II recalled in 1996. When Father Wojtyla said his first Mass as a priest in 1946, "Father Figlewicz stood beside me and acted as my guide."

16 then drama and poetry. He was sometimes more comfortable speaking through art, as in the instance of his mother's death. She died in 1929 at the age of 45, after years of illness, and everyone marveled at Lolek's self-possession. "It was God's will," the eight-year-old said upon being called from class and told the news. It wasn't until a decade later, when Karol began to write poetry at Jagiellonian University in Kraków, that he found a means through which he could properly express his grief and sense of loss:

> Oh, how many years have gone by
> Without you—how many years? . . .
> Over Your white grave
> O Mother, my extinct beloved,
> For a son's full love,
> A prayer:
> Eternal Rest—

Later still, as pope, he confided that her untimely death, coupled with Edmund's death from scarlet fever just three years later, left a hole in his life. He became reliant on his father. "I had not yet received my First Holy Communion when I lost my mother," the pope

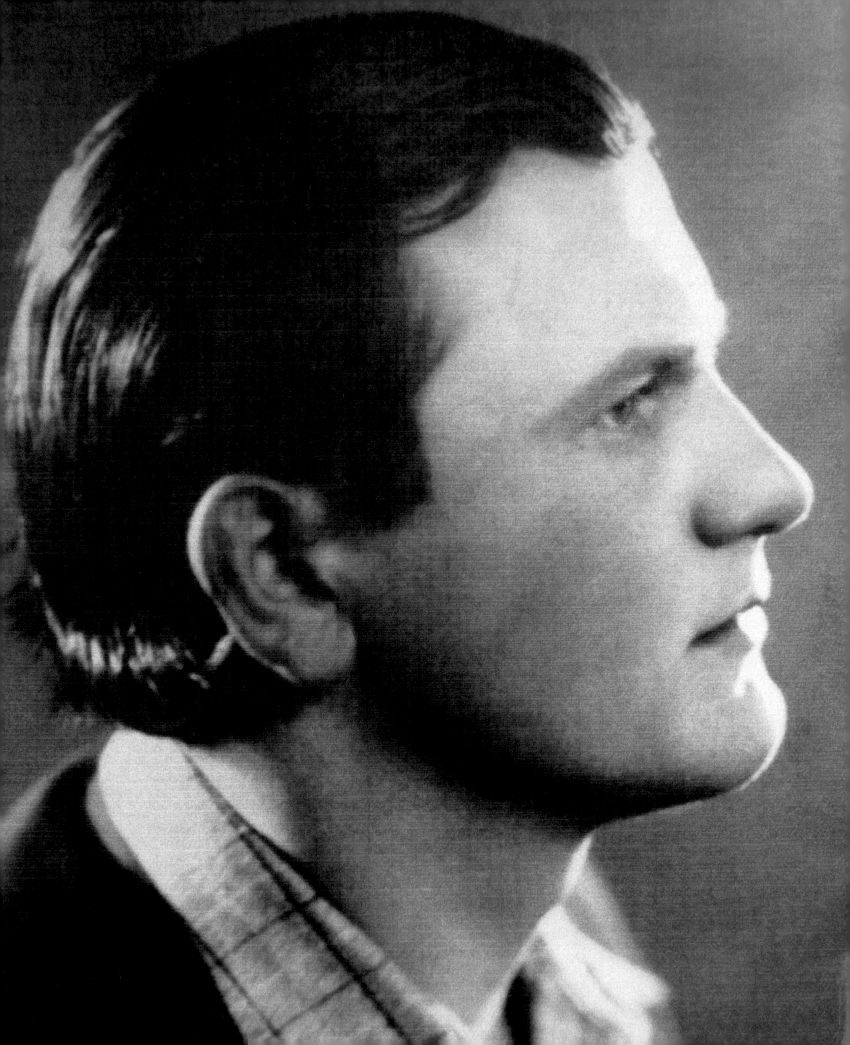

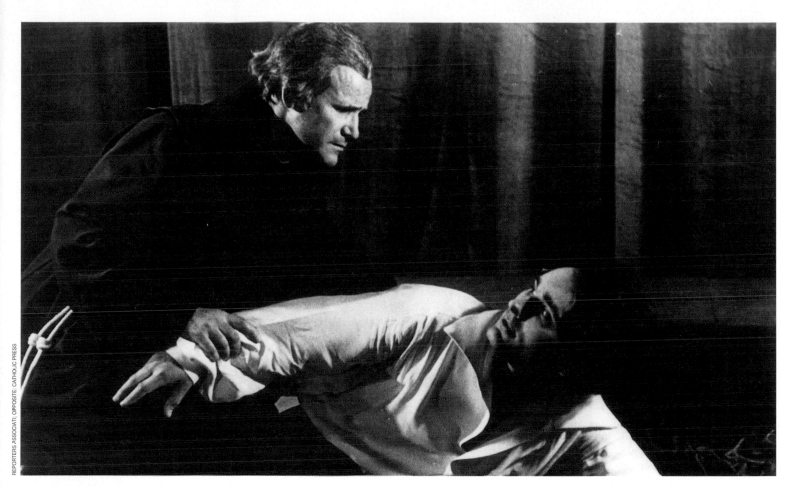

The importance of literature, art and drama in the life of Karol Wojtyla cannot be overstressed. By the time of his graduation from high school (opposite) he had been acting for four years in the joint boys' and girls' high school theater group, the Wadowice Theater Circle. At university in Kraków he joined Studio 39, the drama school of the Kraków Theater Brotherhood, as well as the Lovers of the Polish Language Association. During the Nazi occupation, he was a member of the Theater of the Living Word and the Rhapsodic Theater, which performed patriotic works. He took up playwriting, a pursuit he continued even after taking his vows; he proved to be a lifelong devotee of Dostoyevsky and the poet Rilke. In his career as a thespian, he played everything from romantic leads to roles closer to home. Above: as a monk.

wrote in his 1996 memoir, *Gift and Mystery*. "After her death, and later, the death of my older brother, I was left alone with my father, a deeply religious man. Day after day I was able to observe the austere way in which he lived. By profession he was a soldier and, after my mother's death, his life became one of constant prayer. Sometimes I would wake up during the night and find my father on his knees, just as I would always see him kneeling in the parish church." The pontiff concluded: "His example was in a way my very first seminary, a kind of domestic seminary."

Lolek's father was one of the earliest, but hardly the last, to steer the boy toward the priesthood. John Paul II once recalled his father's telling him, "I know you have a girl and are thinking about civilian life. I will not live long and would like to be certain before I die that you will commit yourself to God's service."

Whether or not Lolek had a girlfriend—the Vatican and all of Karol Wojtyla's friends and confidants always denied persistent rumors of a long-ago engagement—the boy had the inclinations and impulses of a normal teenager. In 1937 he was playing the romantic lead in a high school play in Wadowice, and during a private rehearsal with his leading lady he confided, after reading through a love scene, "I wish it were so in reality." On that occasion he was spurned, but his coterie included girls as well as boys.

As Lolek's graduation from high school neared, it was clear to all that young Wojtyla was something special, a lad headed for bigger things. He himself presumed these would involve art, probably drama. He had gained considerable acclaim for his acting, and in 1938 was named his school's finest orator. With that designation came an assignment: to give the welcoming speech for a distinguished visitor. On May 6, 1938, Prince Adam Stefan Sapieha, scion of a noble family and archbishop of Kraków, visited the high school. The great man sat in a red leather armchair and was much impressed by Lolek's words, delivery and evident charisma. After the ceremony, the archbishop asked what the boy's plans were—the seminary, perhaps? "I plan to take Polish literature and linguistics at Jagiellonian," said the confident Lolek.

"A pity," replied the archbishop.

Lolek (front row, second from right) entered Jagiellonian University in 1938, and for a week that fall and again the next July he received military training in the University Academic Legion. The Nazis were flexing their muscle, and Eastern Europe trembled. Lolek and his fellow students were exempted from military service, though their conscription would hardly have mattered. Karol Wojtyla would always remember being at Mass at Wawel Cathedral in September 1939—a Mass celebrated against the explosion of bombs and the scream of sirens. The Germans took over Kraków, took over most of Poland, closed the cathedral, closed the university and started rounding up Jews and Catholic priests before the year was out. In 1999, during his visit to his old home on Kościelna Street in Wadowice, Pope John Paul II remembered that his family's landlord had been Jewish. "I don't know what happened to him. I think he is dead," the pope said sadly. "I know that Wadowice Jews went through hard trials and many died in ghettos, then in Nazi extermination camps." For the record: The landlord, Yechiel Balamuth, was killed at Belzec along with his wife and three daughters.

The Papacy Through the Years

Non-Italian Popes

One must reach back to 1522, to Adrian VI (see below), for the last non-Italian pope to precede John Paul II. That most of the 264 recognized popes have been Italian is no surprise. But today's political lines differ from those of bygone eras; e.g., an early pope described as Greek might have been born in a Greek colony on the Italian peninsula. Given this caveat, here is how the non-Italian popes break down: 14 were French, 11 Greek, 6 German, 6 Syrian, 3 African, 3 Spanish, 1 Dutch, 1 English, 1 Polish and 1 Portuguese. The following is a sample:

22

SAINT PETER (died c. 64) This Galilean fisherman, the Prince of the Apostles, is traditionally the cofounder (with Saint Paul) and first bishop of the see of Rome. (Its claim to be the primatial see, or diocese, rests upon the dispensation given to Peter by Christ with the words, "Thou art Peter, and upon this rock I will build my church.") An endlessly endearing charm of

Peter is his human weakness. The Gospels tell the story of his denial of Christ just before the Crucifixion, while another tale—it may owe more to piety than to fact—records that Peter was fleeing Rome at the time of Nero's persecutions when he encountered Christ, going the other way. "Quo vadis?" Peter asked Him. "To Rome," said the Lord, "to be crucified again." Peter, too, returned and, according to the ecclesiastical writer Tertullian, was himself crucified there as the leader of the Roman Christians.

VICTOR I (189–198) The first of three African-born bishops of Rome, Victor is remembered as the pope who insisted that Easter be celebrated on Sunday rather than on Passover, which might fall anywhere in the week. When certain churches in Asia Minor chose to ignore the Roman bishop's edict, Victor

excommunicated them. The gesture is an early example of the prerogatives Rome claimed for itself—and of the sensitivities that have existed between the Churches of East and West ever since.

SILVESTER II (999–1003) A native of Auvergne, France, Gerbert of Aurillac was a Renaissance man *avant la lettre*. He studied science and mathematics in Spain and was versed in music, literature and philosophy. He is said to have introduced Arabic numerals to the West. The Roman populace

thought him a sorcerer, and the English chronicler William of Malmesbury says that Silvester once conjured up the devil to escape a pursuer. Small wonder he is sometimes considered the prototype for Faust.

URBAN V (1362–1370) A Benedictine monk and canon lawyer, Guillaume de Grimoard was the sixth of seven French popes to reign in Avignon, in France. In 1367 he tried to reestablish the papal presence in Rome, which popes had avoided for more than 60 years owing to the ceaseless power struggles on

CLOCKWISE FROM TOP RIGHT: BASS MUSEUM OF ART/CORBIS; REPORTERS ASSOCIATI; SCALA/ART RESOURCE N.Y. (2)

the Italian peninsula. After a stay of almost three years, Urban left Italy on September 5, 1370, despite a warning from the saintly seer Bridget of Sweden that he would not live very long if he returned to Avignon. He arrived September 27. He died December 19. He is remembered in Central Europe as the founder of the great universities located in Vienna and Kraków.

ALEXANDER VI (1492–1503) The Borgia pope, born Rodrigo de Borja y Borja in Spain, has become a byword for lust, avarice and nepotism. His papacy was corrupt from the start, having been achieved by a bribe: When chests full of gold were observed in transit from the Borgia palazzo to Cardinal Sforza's on the morning following Borgia's election, Roman cynics began to smile. Only in his death did Alexander (opposite, top) come to justice. Contemporary chroniclers said he succumbed to poison after dining at the villa of Cardinal Adriano da Corneto; it seems that Alexander accidentally drank from a tainted cup he had intended for his host.

ADRIAN VI (1522–1523) The last non-Italian pope before John Paul II was Adrian Florensz Dedal (opposite, bottom), a Flemish ship carpenter's son who had tutored the Spanish emperor Charles V and been Grand Inquisitor. Adrian's papacy was anathema to hedonistic Romans: His meals were prepared by an old Flemish retainer, and the papal laundry, so the gossip went, was hung to dry in the papal apartments. When his reign ended after 21 months, garlands of flowers were sent to the doctor at whose hands he had died.

A Woman's Touch

The ethos of the papacy is essentially male and celibate, conditions that have historically afforded little opportunity for women to appear center stage or even in the wings. Exceptional circumstances have, however, thrown certain women into the limelight, some good, some bad, some enigmatic—and one fanciful.

CATHERINE OF SIENA (1347–1380) Like Francis of Assisi and Joan of Arc, Catherine (right) was one of those holy agitators thrown up by the Middle Ages to discomfit moribund institutions and societies. A mystic and a stigmatic who was considered a saint by her fellow citizens while still in her teens, she managed to blend selfless humility and boundless arrogance. She badgered leaders with letters of advice, reserving some of her most impassioned missives for **Pope Gregory XI,** imploring him to return the papal court to Rome from Avignon, where it had languished for nearly 70 years. "Come without fear, for God is with you," the dyer's daughter assured the aristocratic pontiff. "Wait not for time because time waits for none. Answer the Holy Ghost." Catherine's exhortations were successful, and Gregory arrived in Rome in 1377,

OLYMPIA PAMFILI (1594–1657) A sister-in-law of **Pope Innocent X,** Olympia selected his cooks— and his cardinals. "She visits the Pope every other day, and the whole world turns to her," wrote one contemporary. In spite of the power accruing to her

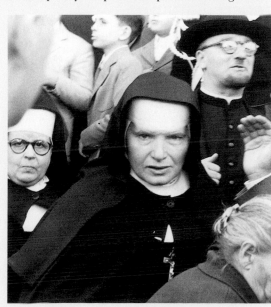

influence over Innocent, Olympia treated him with grisly disregard on his death. She claimed that she could not afford the funeral expenses, and his body lay decaying in the sacristy of St. Peter's until a canon of the basilica agreed to foot the bill. Perhaps Olympia's resources had slipped her mind: When she died two years later, she left two million scudi in gold.

JOSEFINE LEHNERT (1894–1983) A farmer's daughter from Bavaria, Sister Pascalina (as she was known in religious circles), or La Popessa (as she was known to the irreligious), was housekeeper to **Pope Pius XII** for 41 years. During that time, stories of Pascalina's power mushroomed. Perhaps the most memorable involved her encounters with the formidable French prelate Cardinal Tisserant. Once, according to Vatican observer Nino Lo Bello, Tisserant arrived in a papal antechamber demanding to talk to the Holy Father, but Pascalina (left) refused him admittance. When Tisserant insisted, Pascalina called for a detail of Swiss Guards to escort the cardinal out.

POPE JOAN (dates unknown) There was an enduring tale in the Middle Ages that the papacy had been breached by a woman, "Pope Joan." Joan, the story went, was an Englishwoman who dressed in men's clothing, became famous for her learning and was elected pope sometime between the middle of the 9th century and the end of the 11th. Her sexual identity was at last betrayed when she went into labor while on horseback. So widespread was this colorful fable that Joan's head appears among the papal busts in the cathedral of Siena. The myth was exposed—generously, it might be thought—by a Protestant scholar at the time of the Reformation.

Father Wojtyla

In his 1996 memoir, Pope John Paul II recalled the years just before he entered the priesthood. At the time, he had been forced to conceal his Catholicism, his philosophy, his involvement in a clandestine school for priests. "I was spared much of the immense and horrible drama of the Second World War," he wrote of his days as a seminarian. "I could have been arrested any day, at home, in the stone quarry, in the plant, and taken away to a concentration camp. Sometimes I would ask myself: so many young people of my own age are losing their lives, why not me? Today I know that it was not mere chance."

This was a man operating underground. Karol Wojtyla's seminary career, which lasted from 1942 to 1946, had to progress beneath Nazi radar because the Reich was bent on ridding Poland of its priests. Perhaps the most dangerous day for Wojtyla was August 6, 1944, remembered in Kraków as Black Sunday. The occupying Germans sensed unrest in the city and hauled in more than 8,000 men and boys in order to stem an uprising. The Nazis marched up Tyniecka Street, going door-to-door. In a basement apartment, the seminarian trembled and prayed. The soldiers searched the house but moved on without checking downstairs.

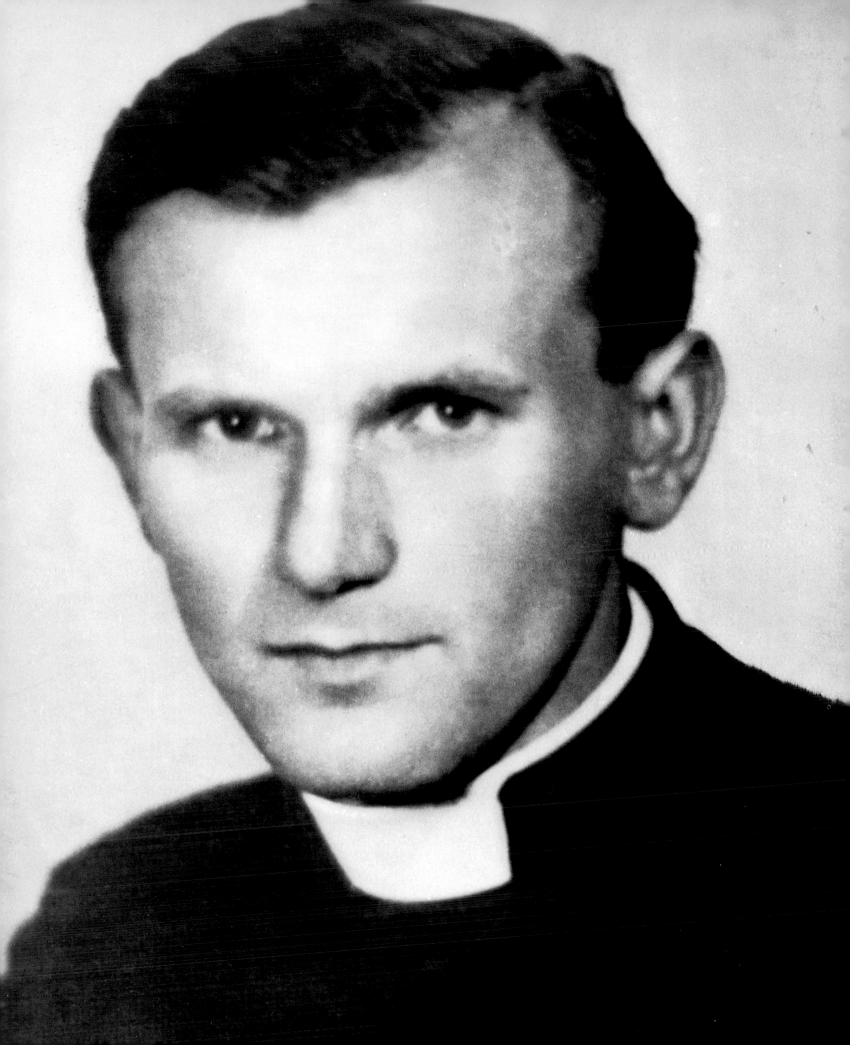

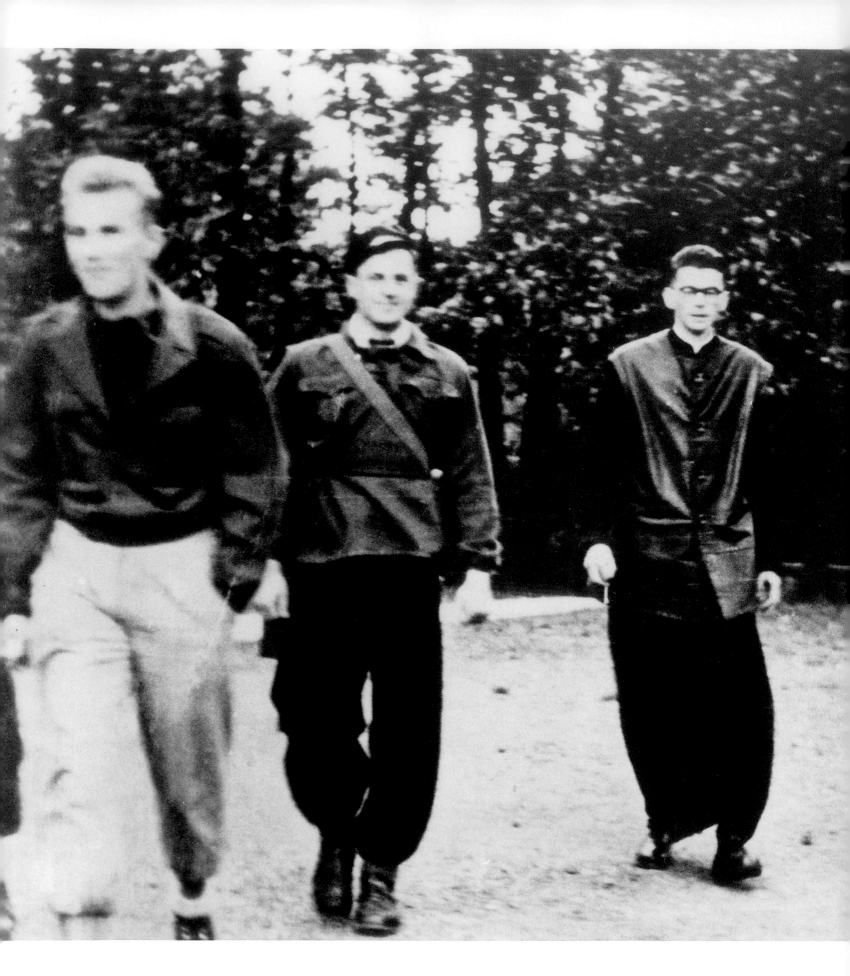

Two newly minted
priests with bright
futures: Father Karol
Wojtyla, right, and
Father Franciszek
Macharski, second
from right, would
spend hours
walking and talking.
Macharski was made
a cardinal by Pope
John Paul II in 1979.

From Wadowice it is an hour's drive to Auschwitz, and most of Wadowice's Jews died there. Others were killed at Belzec and more remote camps. Many Catholics died in those places too. Hitler may have been a Catholic on paper, but when a religion was tied to a country's sense of self as strongly as Catholicism was tied to Poland's, then the religion had to go. To eradicate a religion, first you forbade the services, then you killed the servers—the rabbis, the ministers, the priests.

"The years of German occupation in the West and Soviet occupation in the East brought about the arrest and deportation to concentration camps of an immense number of Polish priests," Pope John Paul II wrote in 1996. "In Dachau alone about three thousand were interned. There were other camps, like Auschwitz, where Saint Maximilian Maria Kolbe, the Franciscan of Niepokalanow, gave his life for Christ; he became the first priest to be canonized after the war. Among the prisoners at Dachau was Bishop Michal Kozal of Wloclawek, whom I had the joy of beatifying in Warsaw in 1987." John Paul went on at length, naming other victims of the Nazi camps and then priests who suffered and died in Soviet prisons. "Of course,

When stationed in Kraków or in the rural parish of Niegowić, 30 miles from the city, Father Wojtyla, right, would go hiking with parishioners and friends. In Niegowić, his first posting, Wojtyla defied a communist edict against church-building and in 1948 began a project for a new chapel—which was consecrated in 1958.

28 what I have said about the concentration camps represents only a part, albeit dramatic, of this 'apocalypse' of our century. I have brought it up in order to emphasize that my priesthood, even at its beginning, was in some way marked by the great sacrifice of countless men and women of my generation. Providence spared me the most difficult experiences; and so my sense of indebtedness is all the greater, both to people whom I knew and to many more whom I did not know; all of them, regardless of nationality or language, by their sacrifice on the great altar of history, helped to make my priestly vocation a reality. In a way these people guided me to this path."

It wasn't just the Jews and it wasn't just the priests. It was also the intelligentsia. In 1939 most of the faculty at hallowed, ancient Jagiellonian University were called to a lecture. They were then ordered into buses that carried them off to concentration camps.

Whichever way Karol Wojtyla turned— toward art, toward philosophy, toward God, toward the personal "liberalism" that saw Jews as brothers—was dangerous. Significantly, he turned away from none of these things, even as he moved his words and actions underground.

30 | At St. Florian's Church in Kraków in 1951, the 31-year-old Father Wojtyla was a charismatic leader of university students. He shared their taste in art, philosophy, poetry and politics, and they came to share his views on God and Catholicism. He preached a warm Christianity, not a forbidding one, and threw his mystical and intellectual ideas into the mix. All of this proved attractive to the students, and St. Florian retreats were SRO. He served the women at right as chaplain and teacher; he also started a Living Rosary prayer circle for his parishioners as well as for students. His two-and-a-half-year tenure at St. Florian's was a resounding success.

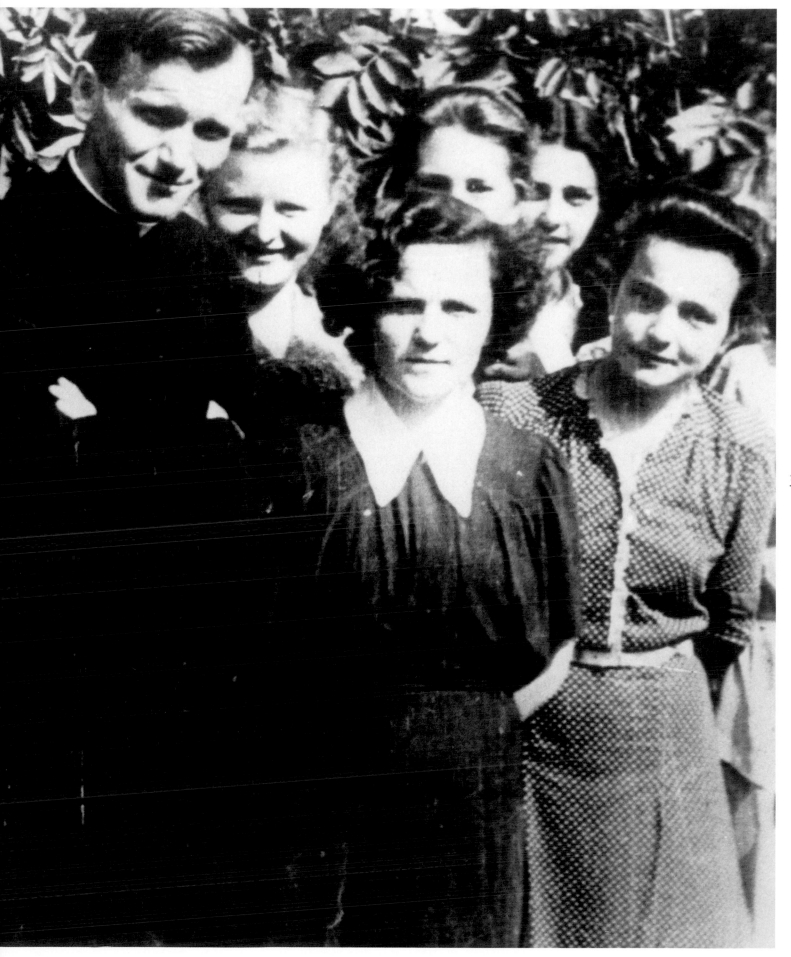

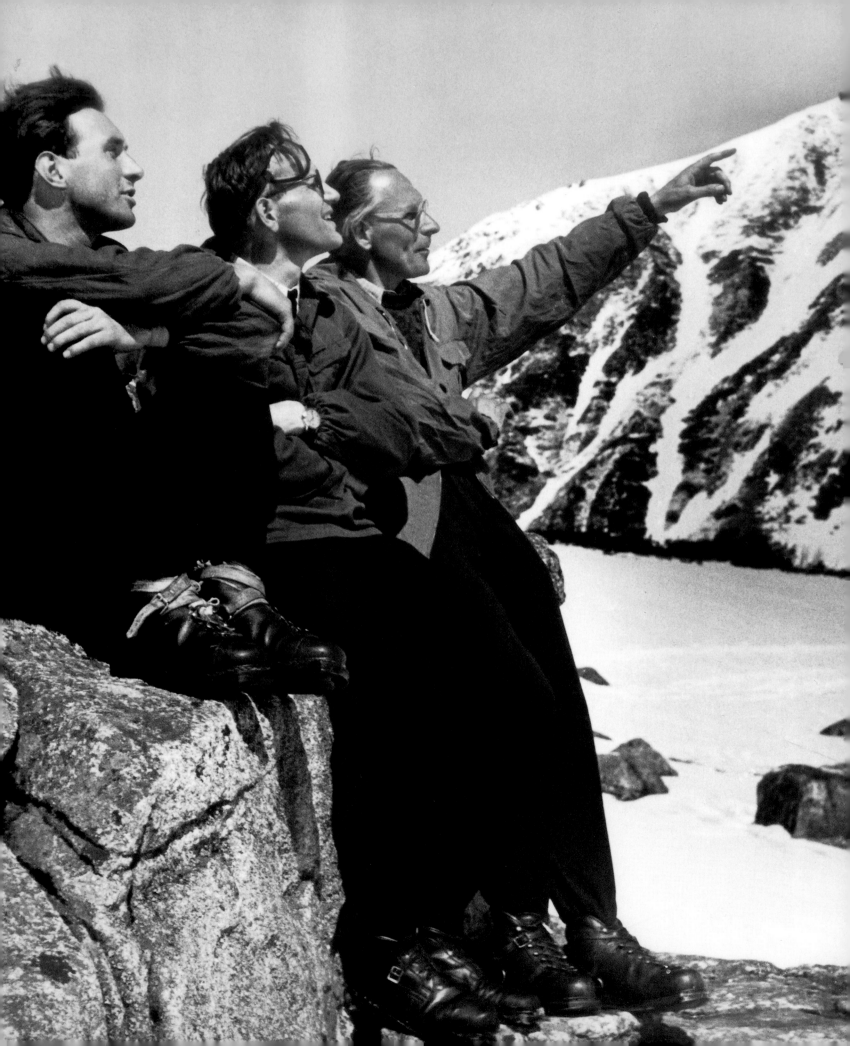

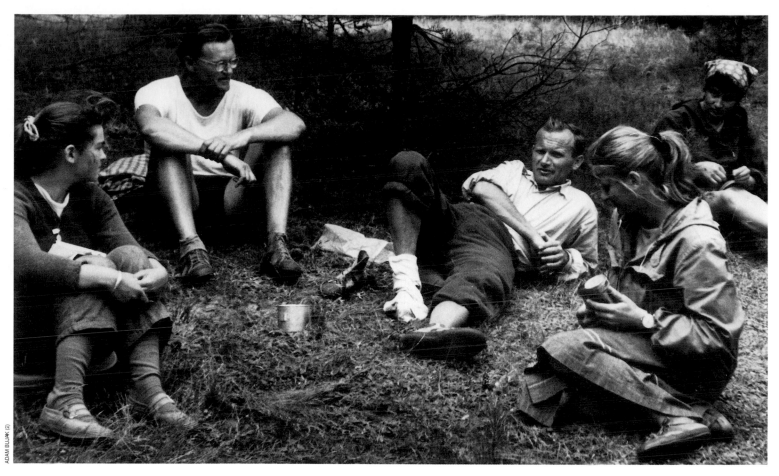

ADAM BUJAK (2)

Opposite: Father Wojtyla, center, went skiing in the resort town of Zakopane in 1953. Above: He went hiking with these students in 1954. At the time, he had no parish, which afforded him more time than ever to pursue his passion for the outdoors. Usually he would go with a group, always with the purpose of discussing religion and philosophy. Some of these trips could last three weeks and cover more than a hundred miles. The communists forbade priests to lead youth groups, so in the woods Wojtyla would go without collar. The students called him Uncle, lest prying ears hear the word "Father."

He wrote his first play, *David,* in 1939; it intermixed Bible stories and allusions to recent Polish history. In 1940 he wrote his second, *Job.* "It, too, is a biblical play," said the director Krzysztof Zanussi, who staged the still-relevant *Job* in Poland in the late 1990s. "But it is far more metaphorical than that. It is about a country that feels like Job. It has to undergo so many trials, and it doesn't understand why God does this. The message is we must stick to faith even when we don't understand why there is so much injustice in the world."

In 1941, Wojtyla and a handful of associates founded the Rhapsodic Theater, an avant-garde troupe that presented words-only performance art—no costumes, no curtain, no second bow, all done on the run in private apartments before audiences of 15 or 20. "It was essential to keep these theatrical get-togethers secret," the pope once wrote, "otherwise we risked serious punishment from the occupying forces, even deportation to the concentration camps." The plays were, of course, about injustice and the struggle of the oppressed. Wojtyla appeared in nearly all 22 performances of the Rhapsodic's wartime

productions. The theater was linked with another underground cultural movement, Unia ("Union"), which in turn was linked to Poland's military resistance. Talking with—and encouraging—all of these groups was none other than Wojtyla's mentor Adam Sapieha, himself operating clandestinely as Metropolitan Archbishop of Kraków.

Longhaired, insurrectionist, aesthete . . . but it is inadequate to categorize the young man who would become John Paul II as merely a bohemian. The term can imply a casualness, even a lassitude or a certain indolence. It summons up images of café life or saloon life. Wartime demands stronger stuff than bohemianism.

Aboveground, Wojtyla needed employment to avoid deportation to a German forced-labor camp. He was a quarryman from 1940 to 1941, then a worker in a caustic soda chemical plant in '41 and '42. Later in life, he looked back warmly on his coworkers in both places. "The managers of the quarry, who were Poles, tried to spare us students from the heaviest work. In my case, they made me the assistant to the rock-blaster: his name was Franciszek Labuś. I remember him because he would

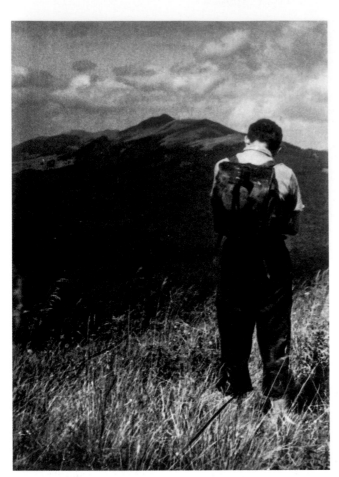

ADAM BUJAK (2)

Though he usually went on trips with companions, Father Wojtyla always sought moments of solitude. If singing went late into the night, he would still rise before dawn, bathe and spend time alone in contemplation. He would be on the water in his kayak by six, paddling and thinking. Back at camp, he'd say Mass at a makeshift altar: two overturned kayaks, with two paddles tied together to form a cross. After the final evening hymns and old Polish folk songs there were, of course, prayers.

34 occasionally say things like: 'Karol, you should be a priest. You have a good voice and will sing well; then you'll be all set . . .' He said this in all simplicity, expressing a view then widely held in society about how priests lived. These words of the old workman have stuck in my memory."

Karol's father had urged it, Archbishop Sapieha had urged it, this workman now urged it . . . and also that curious little man, the tailor in Kraków, the one who led Wojtyla to the writings of the sainted Carmelite mystics Teresa of Avila and John of the Cross. Jan Tyranowski was the man's name. He met Wojtyla at a weekly church discussion group in February 1940. Tyranowski quickly became his mentor in spiritual matters; he became the most influential person in the young man's life when on February 18, 1941, the senior Karol Wojtyla died of a heart attack, leaving his son without family. Tyranowski spent hours consoling his distraught friend, talking about life, about God. (In 1949, Father Wojtyla would remember the late Tyranowski as an "apostle . . . someone really saintly.")

After meeting Tyranowski, Wojtyla became particularly enthralled by the writings of John

of the Cross. He would later write, in a dissertation, that the 16th century Spaniard had shown prayer to be "a mystical experience" leading to an "inner union with God." At the same time that Karol Wojtyla was determining that the theater was not his true vocation, he was determining as well that he should become a contemplative friar. He petitioned Sapieha not once but thrice on this matter, and three times he was denied permission to enter a monastery. The archbishop had been impressed by Lolek Wojtyla's presence, his ability to communicate the word of God, his ability to reach and help others. Sapieha didn't want this powerful individual leading a monk's life, cloistered away. Sapieha felt God had devised a different plan for Wojtyla. Now that Wojtyla was striding toward God, he would one day perceive the plan. Or so Sapieha hoped.

Certainly, Wojtyla did not capitulate to Sapieha in pursuing the priesthood. He chose the road willingly. Later in life he told his friend and biographer, Tad Szulc, "After my father's death . . . I gradually became aware of my true path. I was working at a plant and devoting myself, as far as the terrors of the

occupation allowed, to my taste for literature and drama. My priestly vocation took shape in the midst of all that, like an inner fact of unquestionable and absolute clarity. The following year, in the autumn, I knew that I was called."

In October 1942, Sapieha organized a secret seminary, employing a few surviving faculty members from still-shuttered Jagiellonian University. Wojtyla was one of 10 men chosen to take classes in the school's first year. For two years, lectures were given at various spots throughout Kraków, but in 1944 the seminarians fled further underground when Sapieha decided he had to hide his students within the Kraków archdiocesan center for the duration of the war.

Before Wojtyla entered his sequester on February 29, he had the ironic experience of having his life saved by a German officer. While walking home from work, he was struck by a truck. He hit his head on the sidewalk and lay unconscious by the side of the road. A German command car stopped, and the officer saw to it that Wojtyla was hastened to a hospital, where he was found to have a brain concussion. He recovered, joined

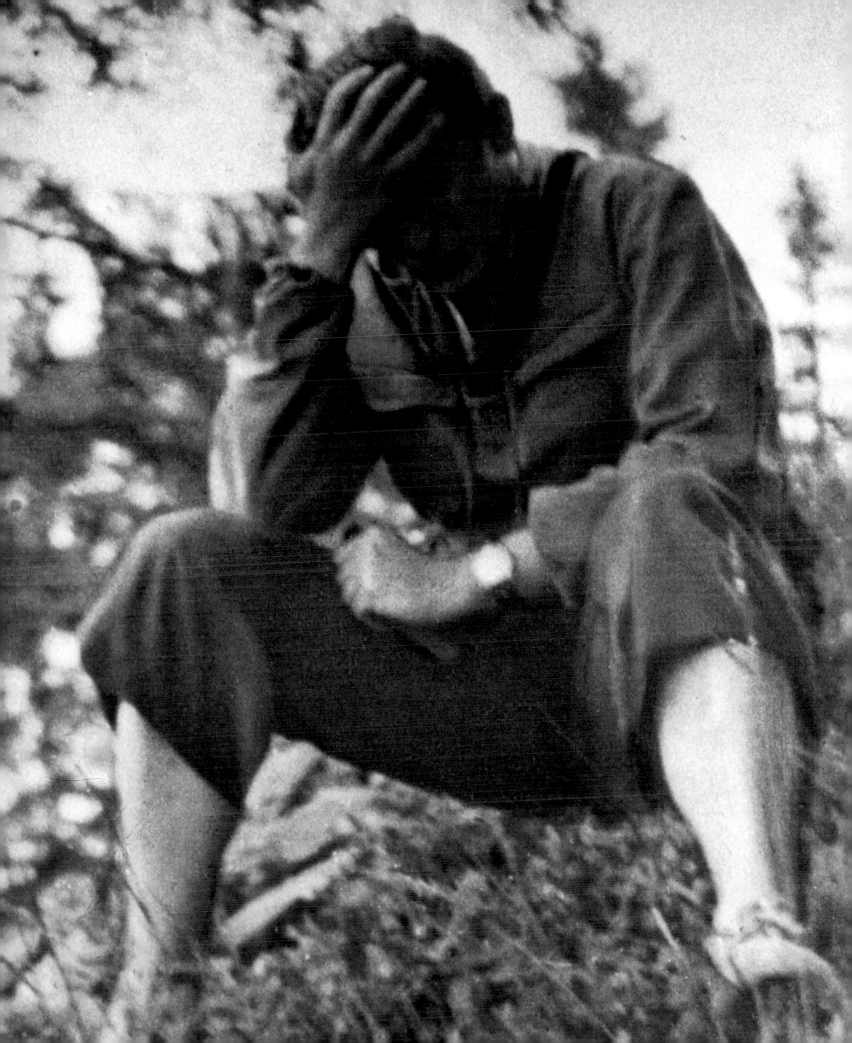

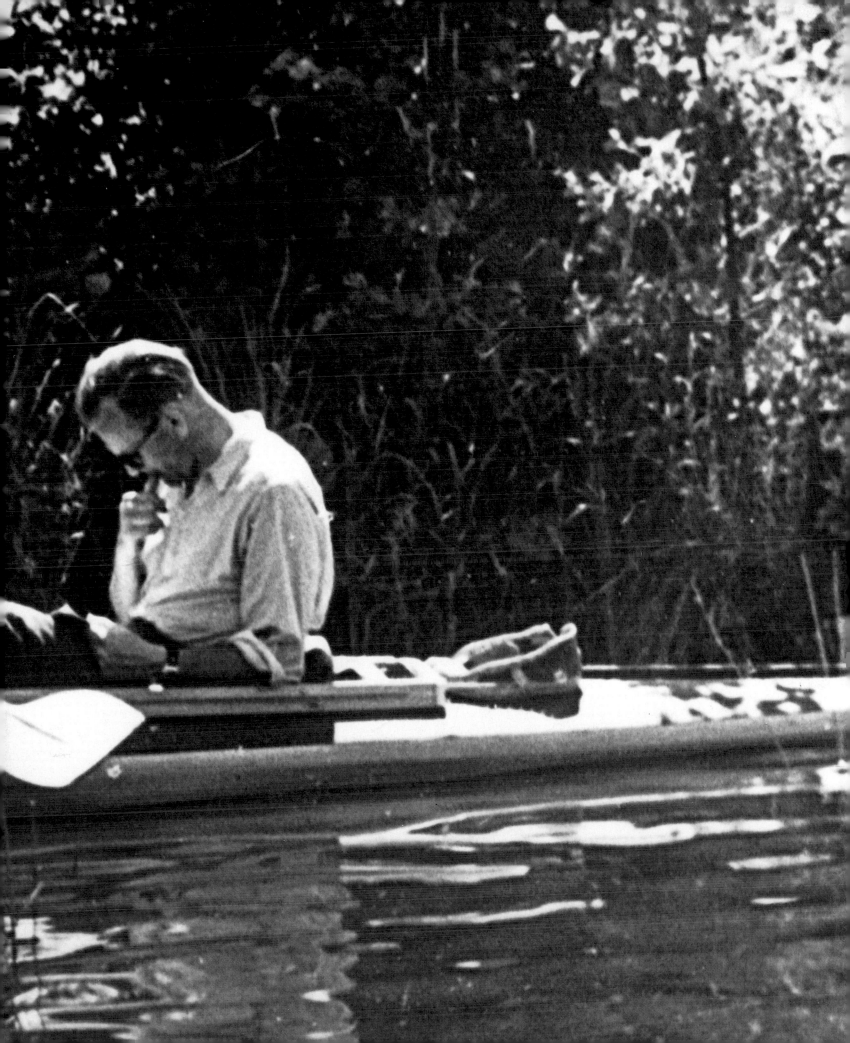

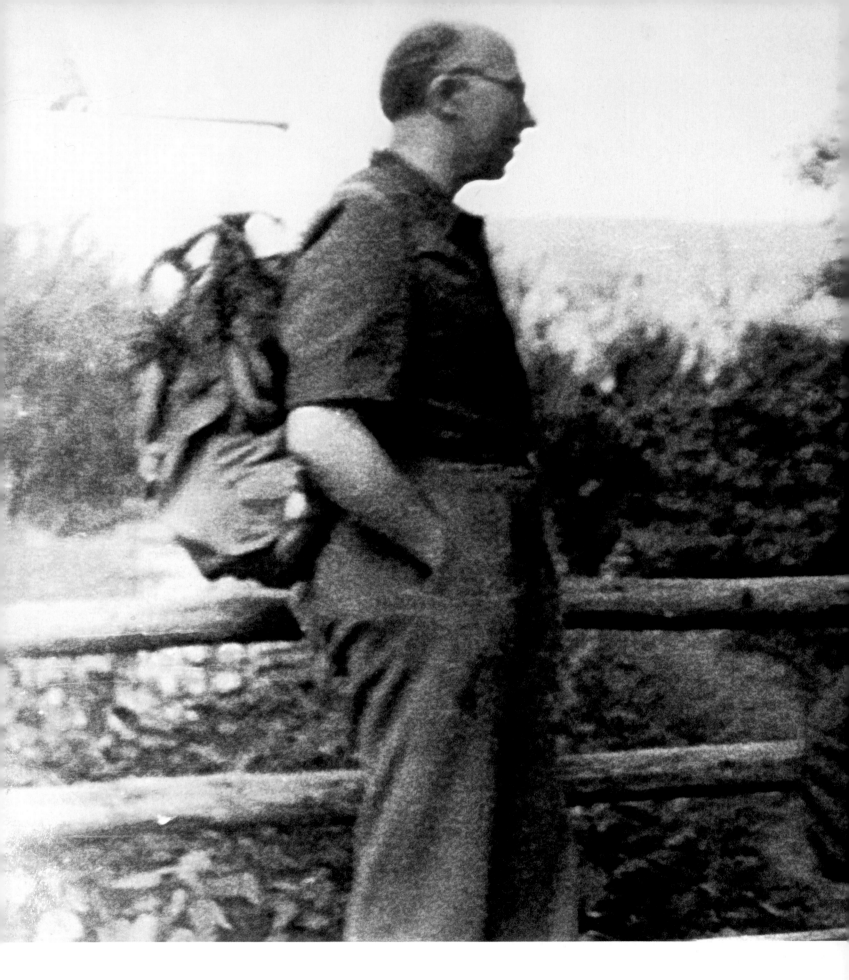

The priest accepted another role during a hike in the Gorce Mountains with Stefan Swiezawski—he agreed to become a teacher. In 1954, Swiezawski was a professor at the Catholic University of Lublin, and Wojtyla was a charismatic cleric recruited by Swiezawski's wife as spiritual counselor to their daughters. In sharing this photograph with LIFE more than a half century later, Swiezawski remembered, "Everybody was talking about Wojtyla. He was very smart, but a very normal guy, down-to-earth in his relationships, able to reach people." A perfect teacher. When Swiezawski suggested a posting at the university, Wojtyla acceded.

Sapieha and the others inside the walls and progressed toward priesthood.

The war ended for Kraków on January 19, 1945, when Soviet troops entered the city. Years later, John Paul II reflected on the war, its effect on him and on his fellows: "I think especially of my classmates in Wadowice, close friends, some of whom were Jews. A few had already enrolled for military service in 1938. I believe that the first to die in the war was the youngest member of our class. Later I came to learn in the most general terms about the fate of others who fell on the various fronts, or died in concentration camps, or fought at Tobruk and Montecassino, or were deported to the territories of the Soviet Union . . .

"As I have already said, my priestly vocation took definitive shape at the time of the Second World War, during the Nazi occupation. Was this a mere coincidence or was there a more profound connection between what was developing within me and external historical events? It is hard to answer such a question. Certainly, in God's plan, nothing happens by chance. All I can say is that the tragedy of the war had its effect on my gradual choice of a vocation. It helped me

Helena Swiezawska and Jozef Deskur wed in Kraków on April 27, 1957, with no shortage of priests at St. Anne's. Father Wojtyla (in glasses, both photos) was not the celebrant; Father Tadeusz Fedorowicz (top row, second from right) was. Wojtyla had connections with both the bride's and the groom's families. He was counselor and confessor to Helena, her mother and her sister, and he was a friend of Jozef's brother, Andrzej, also a priest. A half century later, Pope John Paul II's Sunday routine would include lunch at the Vatican with his old friend, now Andrzej Cardinal Deskur. They often talked about the gang back in Kraków.

40 to understand in a new way the value and importance of a vocation. In the face of the spread of evil and the atrocities of the war, the importance of the priesthood and its mission in the world became much clearer to me."

He was ordained a priest on November 1, 1946, the honors performed by Sapieha, who was by then a cardinal, in the private chapel of the Archbishops of Kraków. The place had a special resonance for Karol Wojtyla: "I remember that during the occupation I would often go there in the morning, to serve Mass. I also remember that for a time another clandestine seminarian, Jerzy Zachuta, would come with me. One day he did not appear. After Mass I stopped by his house in Ludwinów and learned that he had been taken away by the Gestapo during the night. Immediately afterwards, his name appeared on the list of Poles who were to be shot. Being ordained in that very chapel which had seen us together so many times, I could not help but remember this brother in the priestly vocation, whom Christ had united in a different way to the mystery of his Death and Resurrection."

On November 2, Father Wojtyla celebrated his first Mass. He chose Kraków's Wawel Cathedral "to express my special spiritual bond with the history of Poland." One week later he said Mass in Wadowice at the Church of the Presentation of the Mother of God, which a young Lolek would have known as St. Mary's. A week after that, he was off to Rome for postgraduate studies. By the middle of the following year he had passed, with flying colors, exams for his teaching certificate.

In 1948 he returned to Poland—a Poland that was soon to disappear again, this time behind the Iron Curtain.

Father Wojtyla received his first pastoral assignment from Cardinal Sapieha on July 8, 1948. He was asked to serve as pastor in Niegowić, a rural parish 30 miles east of Kraków. Niegowić was poor and underdeveloped, with no running water or electricity. "I went from Kraków to Gdów by bus," John Paul II once reminisced, "and from there a local man gave me a ride in his cart to the village of Marszowice; from there he advised me to take a shortcut through the fields on foot . . . When I finally reached the territory of Niegowić parish, I knelt down and kissed the ground." Some of Karol's friends thought the cardinal was conducting a trial by fire in sending him to Niegowić, but as this and future events would prove, Sapieha would never make a move that could slow, forestall or curtail the career of Father Wojtyla. Sapieha was nothing less than Wojtyla's angel on earth.

Sapieha's instincts—his challenge—bore fruit, as Wojtyla relished the assignment and attacked it energetically. His celebration of the Mass lured newcomers. He taught in the five elementary schools of the Niegowić parish district. "People would take me there by cart or carriage. I remember the friendliness of the teachers and parishioners." He made himself generally useful and popular around town. He started—of course—a drama circle, producing two plays himself and organizing trips to Kraków so the students could see proper theater.

He stayed only seven months in Niegowić, at Cardinal Sapieha's direction. Pleased that his protégé had performed well in a difficult posting, Sapieha gave Wojtyla a quite different assignment, at St. Florian's Church in Kraków. St. Florian's was a thriving, fashionable parish, with a solid regular attendance by university students. The Soviet influence had not yet completely stymied public intellectual or

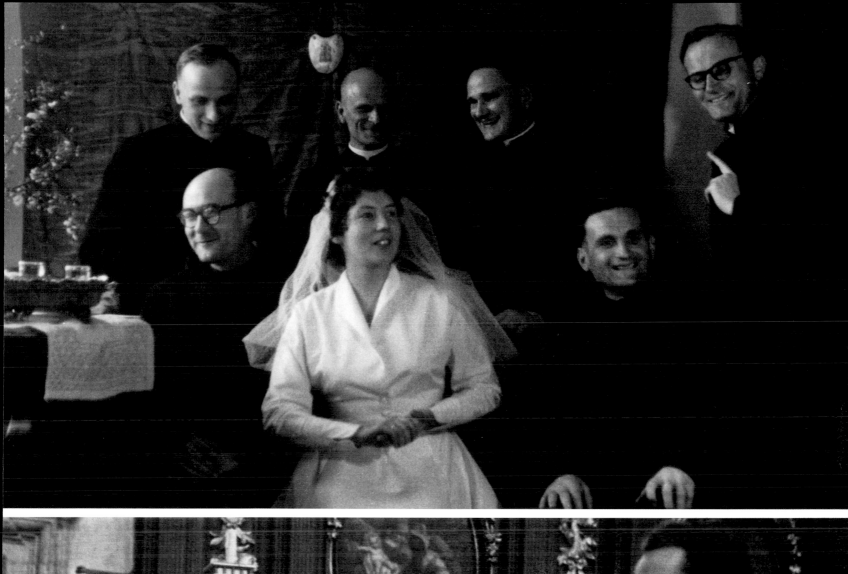

27. 4. 1957.

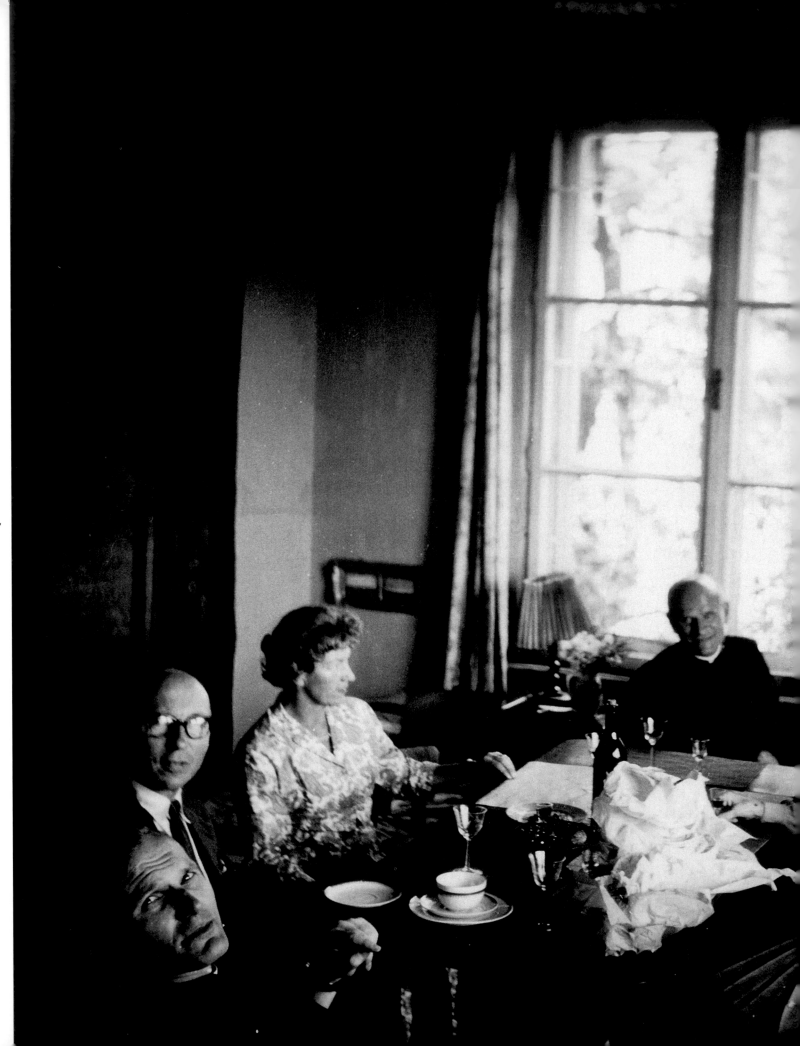

In 1957, Stefan and Maria Swiezawski (left) shared their 25th anniversary with friends, including Fathers Fedorowicz (top) and Wojtyla (bottom). Each week the Swiezawskis held open-house teas. When the discussion wasn't about God, it was about the evils of communism. "They had to be careful," granddaughter Magdalena Deskur recalled years later. "Fedorowicz, too, would go without collar when he was with us young people, sleeping in barns at night, talking philosophy and religion. Those were great days."

religious discourse, so Wojtyla was in his element. One of his charges was to offer pastoral guidance to the students, and "I began to give talks to the young people at the university; every Thursday I would speak to them about fundamental problems concerning the existence of God and the spiritual nature of the human soul. These were extremely important issues, given the militant atheism being promoted by the communist regime."

The Soviet Union was not making a friend of Father Karol Wojtyla, though it could scarcely have realized that this would come back to haunt.

For two and a half years Wojtyla served, and was revered by, St. Florian's parish. In the meantime, Cardinal Sapieha died—but not before giving explicit instructions to his assistant, Archbishop Eugeniusz Baziak, to watch over the progress of Father Wojtyla. Again there were hard times for Catholics in Poland, and in late 1951, Baziak made a difficult decision. He told Wojtyla to take a two-year leave of absence from priestly duties; he told him to go earn another degree. The Soviet regime was cracking down heavily on the Church, arresting priests and denying passports to those who wished to leave. By sending Wojtyla back to the books, Baziak could forward the young priest's career and protect him. He could keep Father Wojtyla safely out of sight.

Wojtyla studied, thought and wrote. And, without pastoral duties, he found himself with more time to hike, kayak and ski. When possible, he combined his passions. He lectured on matters that were beginning to matter greatly to him—the family, the ethics of sexuality—and engaged his audience in after-hours discussion. In September 1953 he took nine students on a five-day kayak trip on the Brda River, challenging them with life outdoors and with issues of the day. When the communists shut down the theological faculty at Jagiellonian in 1954—shades of the Nazis at the very same university—Wojtyla again began to move in the shadows. He taught social ethics at seminars in Kraków, Katowice and Czestochowa. He lectured at the Catholic University of Lublin and at St. Florian's. He became something of a traveling priest, and it agreed with him.

It's interesting that a man so buffeted by politics, and so willing to risk personal harm

ADAM BUJAK

Father Wojtyla never traveled without his breviary; no day went by without intense sessions of prayer. He prayed upon waking, he prayed rhythmically while walking, he prayed after meals and before bed. As he prayed, he found himself mystically transformed, lifted toward God: "We begin with the impression that it's our initiative, but it's always God's initiative within us." He believed God always listened, and that prayer could affect events on earth as well as in the hereafter.

44 in the face of dangerous political situations, was not politically on the line back then—at least not in public. On June 28, 1956, in the city of Poznan, riots broke out. The challenge to Soviet domination eventually brought Wladyslaw Gomulka to power as secretary of the Polish communist party. Moscow knew that meant political change, and in October, Nikita Khrushchev tried to oust him. Gomulka faced him down and proceeded to hold power for 14 years, during which time he oversaw a period of some social and economic liberalization. Under Gomulka, the Catholic Church could and did exist.

Father Wojtyla was teaching at the Catholic University of Lublin during the October crisis. In his ethics lectures, he said nothing at all about the confrontation. Instead, he spoke on moral theology and matrimonial issues. Later that year he was named the college's chairman of ethics.

And then, in 1958, a vacancy opened for a new auxiliary bishop in Kraków. Archbishop Baziak, still following the instructions of the late Cardinal Sapieha—onetime scout and eternal protector of Lolek Wojtyla—put forward his nominee.

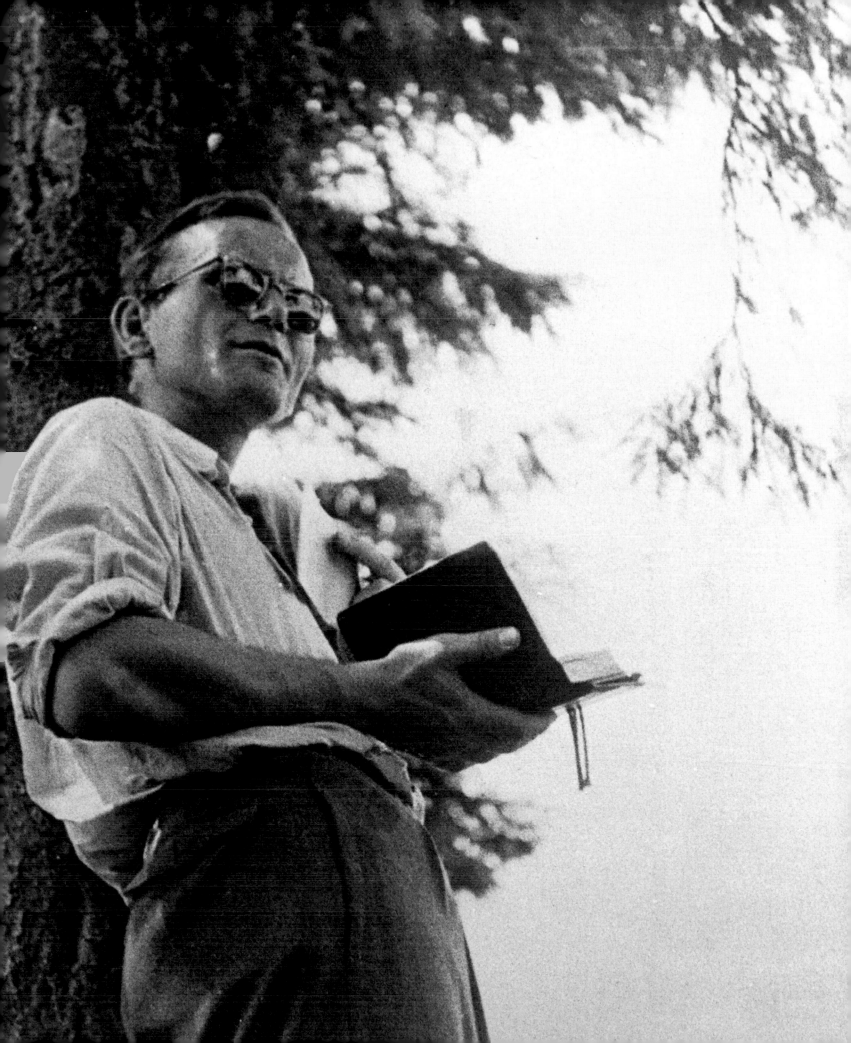

Secular Diversions

Theology and politics—not necessarily in that order—have been the daily diet of most popes. But many, such as the outdoorsman John Paul II, have found time during their formative years as well as their reigns to pursue other interests. In the Middle Ages and the Renaissance especially, some pontiffs enjoyed the relaxations savored by secular princes, including hunting, gambling and falconry, while others occupied themselves with elaborate building programs and art collections. Some extracurricular amusements:

JULIUS II (1503–1513) When he was not waging war, probably his favorite pastime, Julius (below) liked to be near water— sailing, watching ships or fishing. Angling with the pope was not, however, the average outing. Once, on a military expedition to Bologna, Julius decided he wanted to fish Lake Trasimene. His party embarked in five boats and consisted of cardinals, prelates, some of the papal household and a detachment of Swiss infantry.

there enjoyed the show, Leo's idiosyncrasy was not universally appreciated. In Germany, one dissident cleric held up the pontiff and his "cavorting" pachyderm as a symbol of papal decadence. The naysayer's name was Martin Luther.

CLEMENT IX (1667–1669) When Clement (right) endorsed the opening of a new opera house in Rome, few at the papal court were surprised. As Giulio Rospigliosi, he had been the librettist for several operas, among them what may be the first comic opera, *Chi soffre speri.* But not everyone was sanguine about these musical forays. At the conclave that elected Rospigliosi, one cardinal was heard to remark, "He will emasculate the Sacred College by giving the [cardinal's] hat to all the castrated singers in Europe."

PIUS XI (1922–1939) Achille Ratti was probably best known on his election to the papacy as prefect of the Vatican Library, but he also had a reputation as a mountaineer. He wrote accounts of his ascents of the Matterhorn and Mont Blanc for the bulletin of the Alpine Club, and even though he could no longer climb after becoming pope, he encouraged members of one pre-WWII Everest attempt with the words "May God, who dwells in the heights, bless your expedition."

LEO X (1513–1521) Several popes have enjoyed the company of exotic pets—Martin V and Pius II had parrots; Julius III elevated his former monkey-keeper to the rank of cardinal—but Leo X outshone them all zoologically. His trophy was a pet white elephant, Hanno. Leo liked to parade Hanno through the streets of Rome, and though the citizens

46

Urbi et Orbi . . .

"To the city and the world," is the pope's traditional blessing. As Humanae Vitae (Paul VI's encyclical condemning birth control) and John Paul II's opinions on atheistic communism made clear, the pope's words are heard—if not always heeded—around the globe. The following popes made their impact in some memorable way:

ADRIAN IV (1154–1159) Born Nicholas Breakspear, Adrian (right-center, in miter) was the only Englishman ever to sit on the throne of Peter. His 1155 papal bull, Laudabiliter, conferred the overlordship of Ireland on the English king Henry II. The consequences of that concession resonate in headlines to this day.

GREGORY XIII (1572–1585) Shakespeare and Cervantes both died on April 23, 1616—but 10 days apart. The man responsible for this apparent discrepancy was Gregory XIII (top right), who decreed in 1582 that 10 days be dropped from that calendar year to compensate for a flaw in the then extant Julian calendar. Gregory's edict was accepted immediately by Catholic countries such as Spain, where Cervantes died, and less quickly by Protestant countries such as England (1752), where Shakespeare died . . . 10 days later.

LEO XIII (1878–1903) Leo is chiefly remembered for his encyclical Rerum Novarum ("Of New Things"), which insisted, among other issues, on the right of workers to earn decent wages and to form unions. This, along with his promotion of scientific study and the opening of Vatican archives to scholars, did much to quiet criticism of the Vatican incurred by his reactionary predecessor, Pius IX, in whose reign the doctrine of papal infallibility in matters of faith and morals was promulgated.

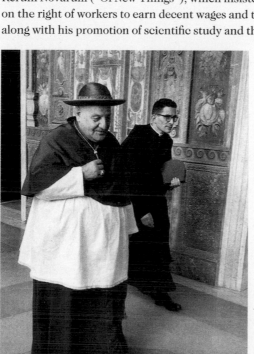

JOHN XXIII (1958–1963) His smile was a beatitude, and his personality inspired. But John (left) was not content to be passively charismatic. He wanted to change the Church and the world with it. He began a dialogue with the Soviet regime and told Jews around the globe, "I am Joseph, your brother." His encyclical on government's responsibility to address social as well as political problems, Mater et Magistra ("Mother and Teacher"), was considered so liberal by some conservative Catholics that one was prompted to respond: "Mater, Si!; Magistra, No!"

Karol Cardinal Wojtyla

John Paul II remembered how it was, back in 1958, breaking the news to the campers. It was summer, and Father Wojtyla needed a break. He went with students to Poland's lakes region. A telegram soon arrived, summoning him back to Kraków. There, Archbishop Baziak told Wojtyla he was to be made a bishop, contingent on the approval of the Polish primate, Cardinal Wyszynski, and of Pope Pius XII. Father Wojtyla expressed his appreciation, then begged leave to return to the lakes to say Sunday Mass for the students. The campers were thrilled for him, to be sure, but as John Paul recalled, "They asked me if I was no longer to be their 'uncle.' I reassured them."

In May 1977, Cardinal Wojtyla stood atop the new church in Nowa Huta, a suburb of Kraków, having earlier that day consecrated the chapel. The church was a monument to Wojtyla's career as bishop, archbishop and cardinal. Nowa Huta had been conceived by the communist regime as a town of workers, a "socialist city." It had one small church. Bishop Wojtyla urged the forming of congregations within the community, each with a priest at its head, and began to lobby authorities for permission to build a bigger church. The communists said no. They had no desire to see a large house of God rise in this model of Marxist industry. Wojtyla persevered, and in October 1967, after he had become a cardinal, a permit was granted.

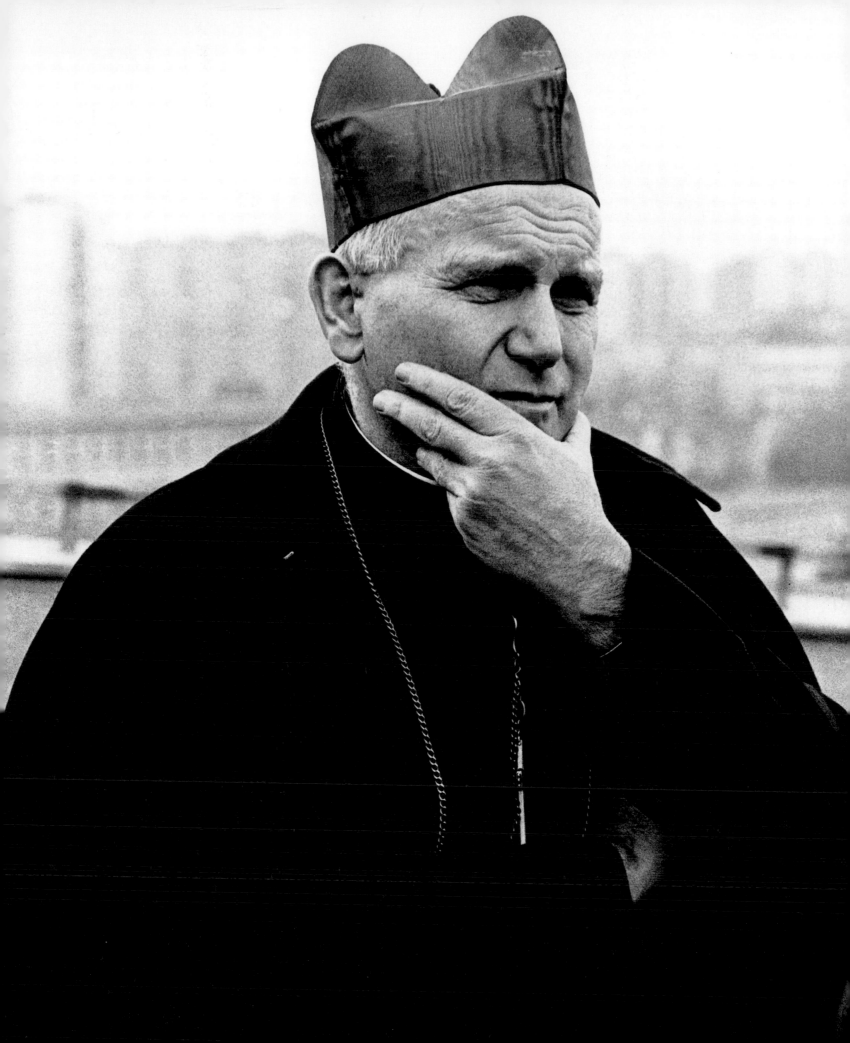

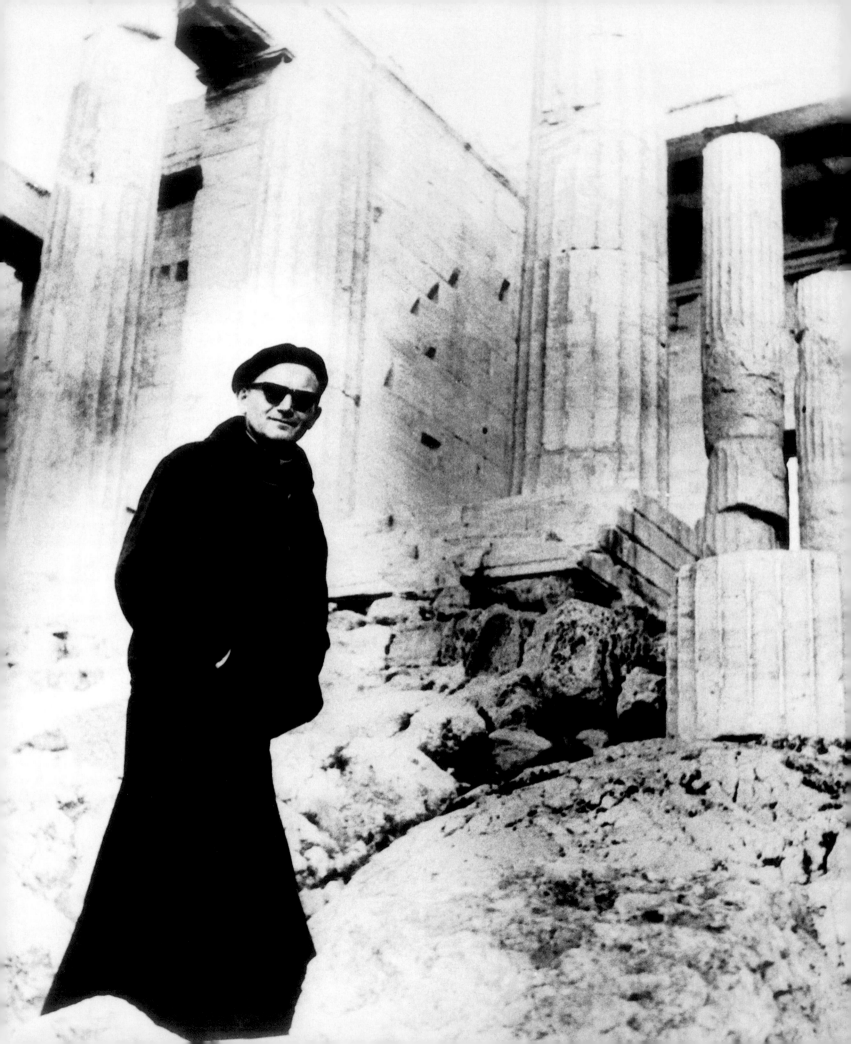

The things that smart young Karol Wojtyla had read about and dreamed of—the world's great historical sites, the museums, the cathedrals, the Vatican itself—became accessible to the prelate Wojtyla as he rose in the Church. On a trip from Rome to the Holy Land, how could he resist stopping in Athens and walking amidst the ruins of the Parthenon?

Stefan Cardinal Wyszynski played a crucial, not always helpful, role in the career of Karol Wojtyla. A strident anticommunist, Wyszynski was imprisoned for his views in 1953. Because 90 percent of Poland is Catholic, holding the country's primate behind bars was a political as well as religious action. Wyszynski's legend grew during his three years' incarceration, and upon his release he drew a hero's welcome wherever he traveled. He, even more than the Vatican, was where Poland's Catholics looked for direction during the tense years of Stalin's rule. Wyszynski's exile and subsequent release made it clear—indeed, made it everything but official—that the Church was an enemy of the communist regime.

Wyszynski, once freed, could maneuver the country's priests like chess pieces. If there was an auxiliary bishopric available in Kraków, it was for Wyszynski, not Wojtyla's patron, Baziak, to send the nomination to Pius, and Baziak and Wojtyla realized this. Moreover, Wyszynski did not seem to share the high regard for Wojtyla that Baziak did. There was some thought that Wyszynski preferred insubstantial men as his deputies, perhaps to fend off competition. Others felt that he preferred pastoral priests to intellectuals.

So why did Wyszynski accede to Baziak and send Wojtyla's name to Rome? Maybe he didn't. According to various biographers of John Paul, either Wyszynski wasn't paying attention when he gave his O.K. or Baziak committed the political equivalent of a cardinal sin by going behind the archbishop's back and contacting Rome directly. In any event, the nomination received the papal seal, and on September 28, 1958, Wojtyla was consecrated a bishop at Wawel Cathedral, with Baziak presiding and theater folk, former underground seminarians and parishioners from the village of Niegowić filling the pews.

Less than two weeks later, Pope Pius died, and three weeks after that, Angelo Giuseppe Roncalli of Venice was elected pope. He took the name John XXIII, and as such he would, in his five years on the throne, build a reputation as the most important pope of the century, if not the millennium. John's reformation movement would make a star of a young Polish suffragan whose own papacy would, in the minds of some, eventually eclipse even John's in terms of influence on the Church and the world at large.

There hadn't been a major Vatican colloquium called in nearly a century when, in January 1959, John XXIII announced plans for the Second Vatican Council (Vatican II). The Church's goal would be an *aggiornamento,* or "bringing up to date." These conferences of cardinals and bishops are designed to set the Church aright, to reconsider and redefine doctrine and philosophy. In the 90 years since Vatican I, Roman Catholicism had without question become moribund in some parts of the world, dormant in others. There had been questions about Pius's reluctance to criticize the fascists and Nazis, and many wondered what the Church stood for. John XXIII, a pastoralist—one who loves caring for the soul—sought to strengthen his Church, reassert its viability as a moral force and make it relevant to a modern world. His goal was as open-ended as that. When he called the council, he had no idea what it might yield in terms of specifics. He maintained simply, "The Holy Spirit will provide."

One can imagine how this charge would excite someone of Wojtyla's energy, philosophical bent and intellectual acuity. He was among the first bishops to send his recommendations for an agenda to Rome.

In the fall of 1962, two events indicated that the communists still harbored no suspicions about Wojtyla. Each would greatly enhance the bishop's stature within his Church. First, the government moved to take over Kraków's seminary for use as the Superior Teachers'

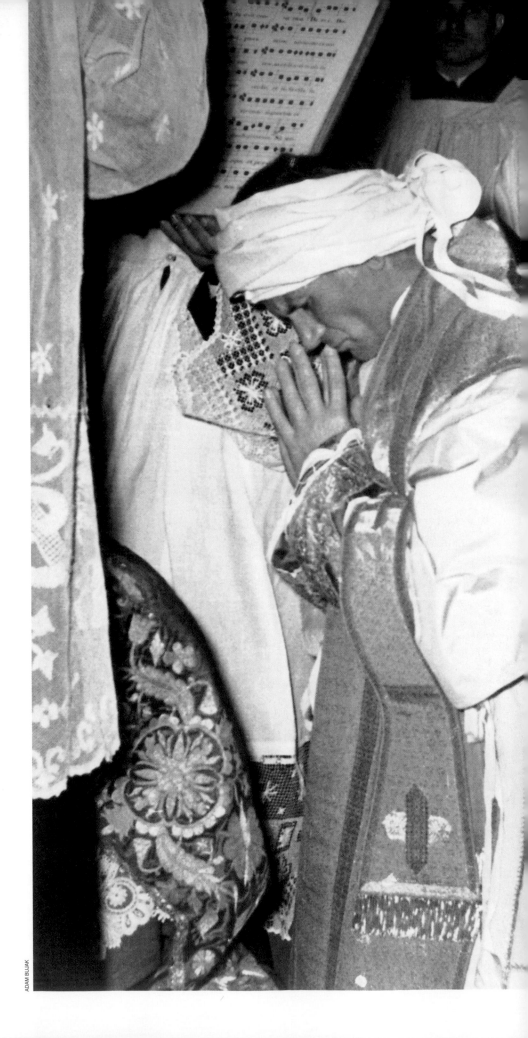

Archbishop Baziak
placed the immaculate
white miter, a liturgical
headdress worn by
bishops and abbots,
upon Father Wojtyla's
head on September 28,
1958, in Wawel Cathedral.
Thereby was Wojtyla
made a bishop. Those
who were there that day
said that when the miter
was in place, the sun
broke through clouds,
creating a splendid
effect when refracted
by the cathedral's
stained-glass windows.

52 College. Wojtyla went directly to the
communists and, astonishingly, was given a
negotiated settlement: The seminary was safe,
and the college got one floor of the building.
Second, 25 Polish bishops applied for
passports to travel to Rome for Vatican II,
scheduled to commence October 11. Fifteen
were denied permission, but Wojtyla was one
of the 10 who got a permit.

Sessions of the Second Vatican Council
would be convened four times between 1962
and 1965; they would reshape and reenergize
the Church to a degree unseen since the
Council of Trent in the 16th century. Bishop
Wojtyla sided with the reformers on many
issues, and during the council he looked nearly
radical. In the autumn of 1963 he brought
to Rome two Polish women as research
associates; a young woman having any input
at a Vatican conference was an altogether
remarkable thing. That same fall Wojtyla
delivered a speech (called "an intervention")
to the council supporting the controversial
idea that the faithful, not the clergy, should be
the Church's principal interest. "The Church
appears authoritarian," he said, when it insists
priests are like military officers and the people
in the pews are noncoms who must follow
orders. Wojtyla endorsed measures to revamp
the Vatican's censorship policies. Thousands of

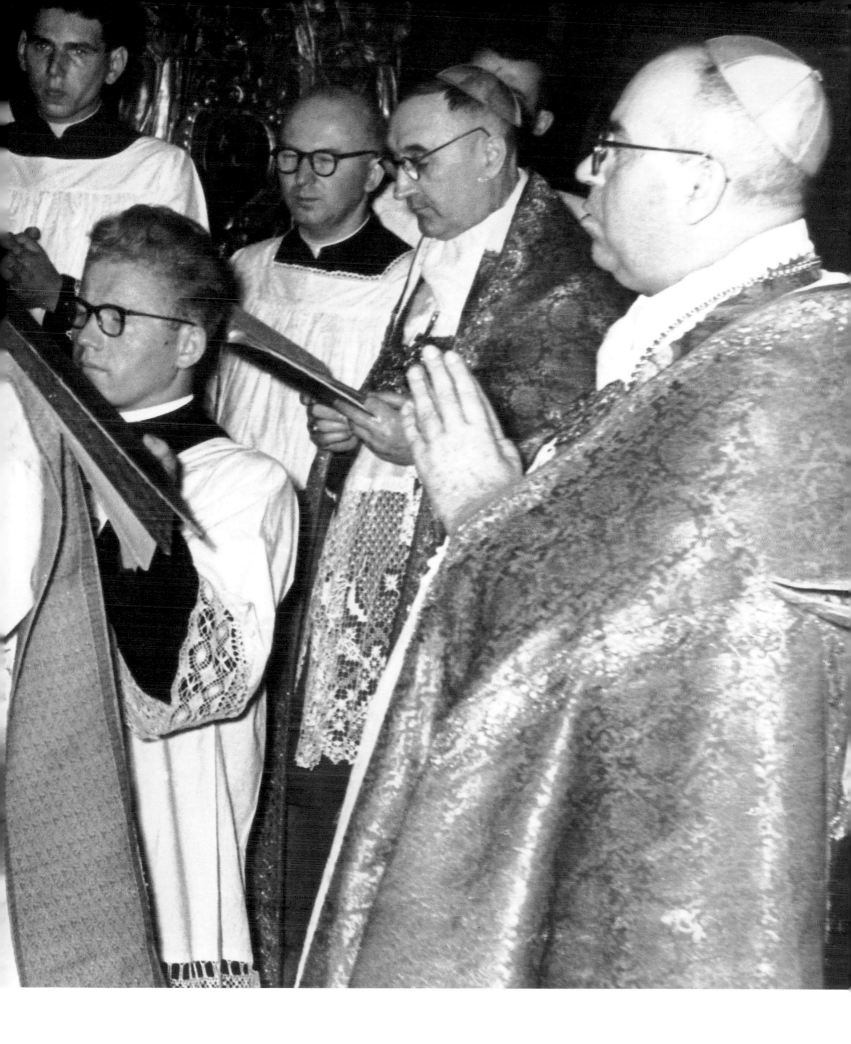

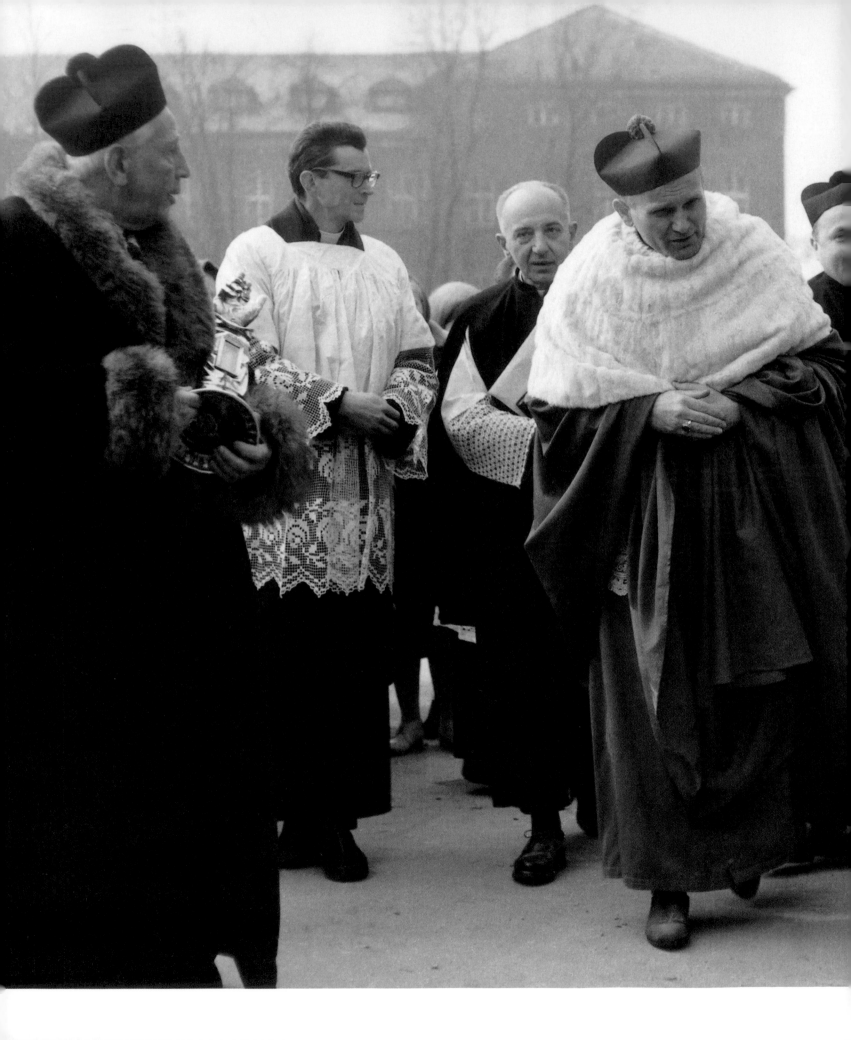

On March 3, 1964, the newly invested, ermine-shawled Metropolitan Archbishop of Kraków made his way into Wawel Cathedral. The communists sanctioned the investiture because they thought they were getting an apolitical cleric. It was a crucial mistake. Without this appointment, Wojtyla would never have become pope. Wojtyla was a sturdy five foot eleven—an Australian newspaper once likened him to a rugby player—but after being run down in the streets of Kraków when he was a seminarian, he sometimes walked with a slouch. Upside: It gave the religious man a humble air.

55

books that had been condemned, including works of intellectual value by such writers as Kant, Milton and Defoe, were once again available to the faithful.

The issue that placed Wojtyla squarely in the limelight was debated by Vatican II in 1964. This was ecumenism: the Church's relation to the world at large and to all other world religions. Wojtyla urged the Church to stand for human rights, not just for Catholics but for all. He said that in order for that stand to mean anything, the Church needed the respect—and the ear—of other religions. He called for talking, listening, reaching out between faiths, and warned against "a soliloquy of an isolated Church." In his speech of October 21, 1964, he said, "The Church should speak so that the world sees that we are not so much teaching . . . but rather, along with the world, seeking a . . . just solution to difficult human problems." It is unsurprising that in the famous Nostra Aetate ("In Our Time") document adopted by Vatican II, Bishop Wojtyla was an author of the section exonerating Jews of collective responsibility in Christ's death.

In these years, as was his lifelong habit, Wojtyla continued to exercise physically as well as intellectually. He tried to find new mates in Rome to ski with but was told—

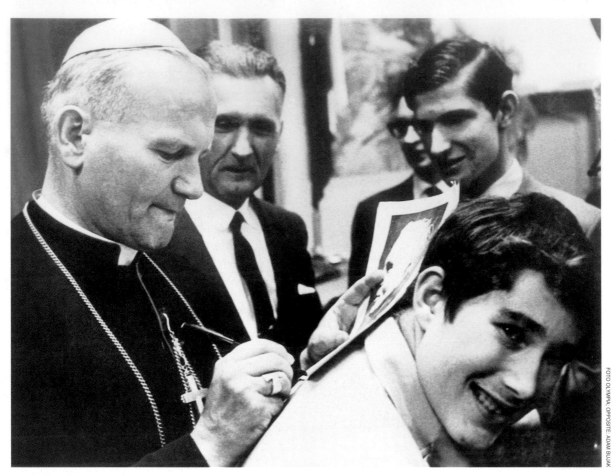

Wojtyla always liked people and was eager to serve as an ambassador for his Church. In the '60s he made like a politician, signing an autograph for an American boy with his ever-changing signature (Karol Wojtyla became Father Wojtyla who became Bishop Wojtyla . . . Archbishop Wojtyla . . . Karol Cardinal Wojtyla . . .) and patting a baby outside Wawel Cathedral's Zygmuntowska Chapel. His lifelong habit was to choose a favorite corner of a small chapel within a larger church for daily prayer. In the Vatican, the cardinal had a multitude of chapels to choose from.

56

heaven forbid!—that not one Italian cardinal skied. So he did his skiing back in Poland, where, in summer, he also found the mountains a good amphitheater for his wood-smoke seminars with college students.

Bishop Uncle Wojtyla knew what was on the young people's minds, and as their spiritual guide he challenged them. Some of the discussion was about politics, and some of Wojtyla's acolytes would eventually find their way into the anticommunist Solidarity movement. Many of the talks involved the ethics of sexuality. The students confided their sexual activity, and Wojtyla, liberal otherwise but conservative on love and marriage, told them they were on the wrong course. His moral standards were clear, high, unbending. He said achieving abstinence before marriage was like winning a sports contest, as both required commitment and discipline.

During this time, Wojtyla continued to write. If anything, he increased his output. In 1960 he published *Love and Responsibility,* which codified his thinking on sexual ethics. During the Second Vatican Council's initial session, he acted as a journalist, sending long reports home from Rome to a Catholic

newspaper while also completing a cycle of inspirational poems. He wrote scripts for Vatican Radio shows. In 1964 he published an essay, "Reflections About Fatherhood," and in 1965, a poem about the Holy Land. *At the Sources of Renewal* was a summation of the achievements of Vatican II. His drama criticism under the byline "Andrzej Jawien" included appraisals—usually praise—of old friends in the avant-garde theater. This was, perhaps, the only instance of fibbing in Wojtyla's life, as he hid behind various pseudonyms in the liberal press. "Jawien" was Wojtyla's most prominent nom de plume.

Wojtyla, as Jawien, wrote two plays in the 1960s, *The Radiation of Fatherhood—A Mystery* and *The Jeweler's Shop.* The latter work appeared in a Catholic magazine in December 1960, and though it wasn't performed until its author became pope, it is an accomplished, difficult, affecting work. Its subtitle is "A Meditation on the Sacrament of Matrimony, Passing on Occasion into a Drama," and its three acts are a mix of monologue, mysticism and poetic imagery—what Wojtyla called "the 'rhapsodic style,' which seems to me to serve meditation rather

than drama." The play is a rumination on the marital bond, the hopes and difficulties engendered therein. How can we know if love is real? Will love endure? The jeweler, God's stand-in, deals in wedding rings, and when one young woman tries to return her band, the jeweler will not take it: Such a token is without worth unless it is part of a pair. A subsidiary theme in the play is man's nature; the philosophy of a Polish Catholic who has witnessed repression but kept complete faith is apparent in a speech by the jeweler:

> Ah, the proper weight of man!
> This rift, this tangle, this ultimate depth—
> this clinging, when it is so hard
> to unstick heart and thought.
> And in all this—freedom,
> a freedom, and sometimes frenzy,
> the frenzy of freedom trapped in this tangle.
> And in all this—love,
> which springs from freedom,
> as water springs from an oblique rift in the earth.

In light of such works as *The Jeweler's Shop,* it is easy to see why communist authorities, when they bothered to think of Wojtyla at all,

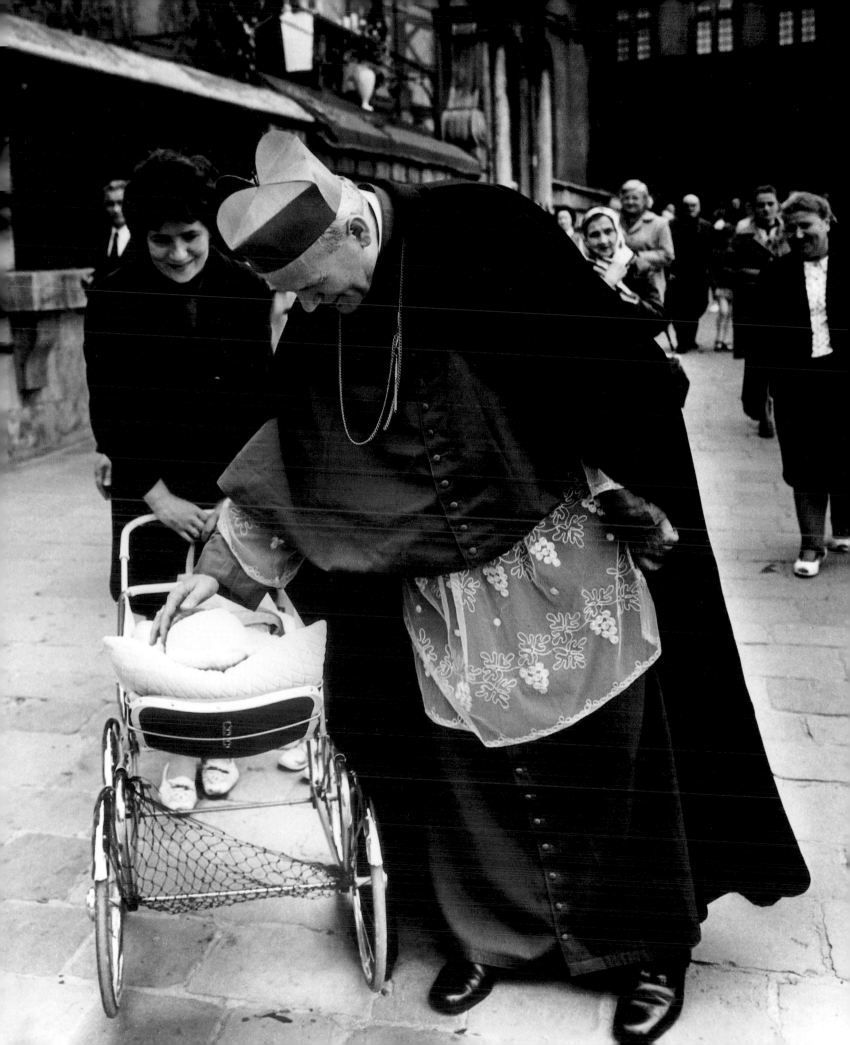

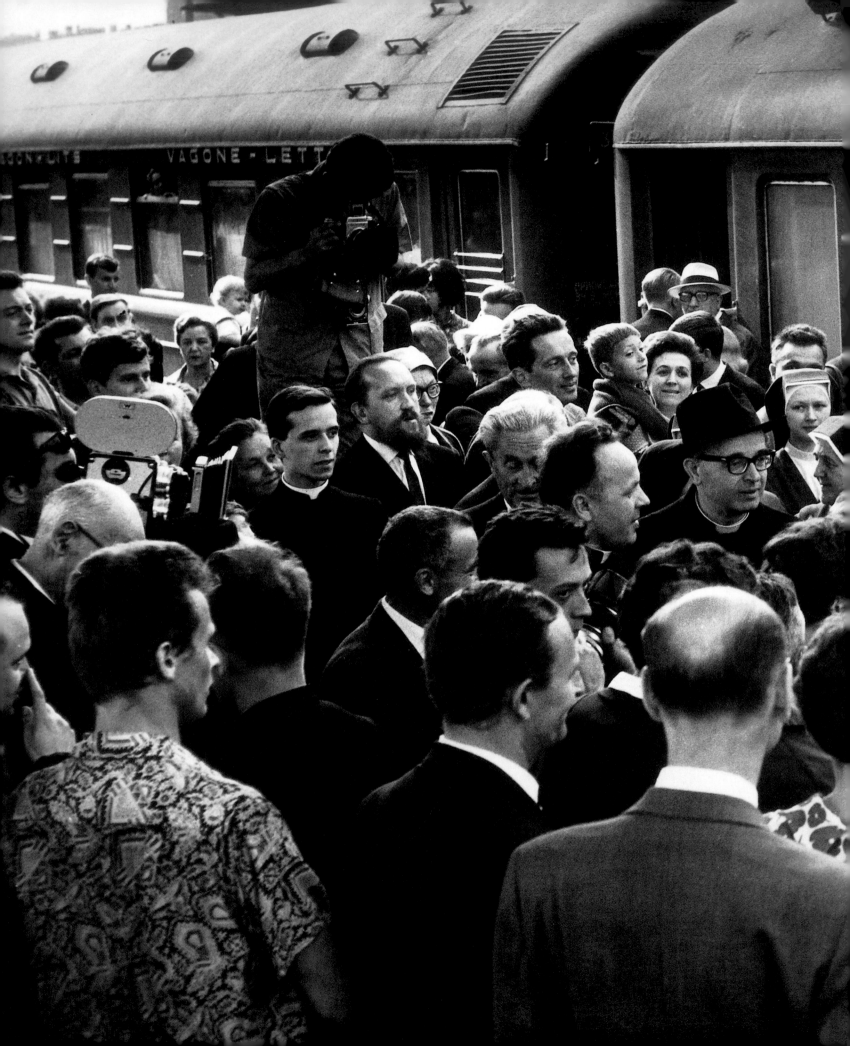

59

The world had no idea who he was, but by the time Wojtyla departed Wadowice for Rome in 1969, he was a hero in Poland. During the cold war, Catholicism in Poland represented culture as much as it did religion, and culture equated, in turn, with resistance to the communist government. Thus the country's two cardinals, Wyszynski and Wojtyla, were de facto political leaders. The hope and belief was that if there were any future beyond communism, the Church would lead the way. The communist regime was aware of this sentiment but wary of too strong a crackdown on the Church, fearing insurrection.

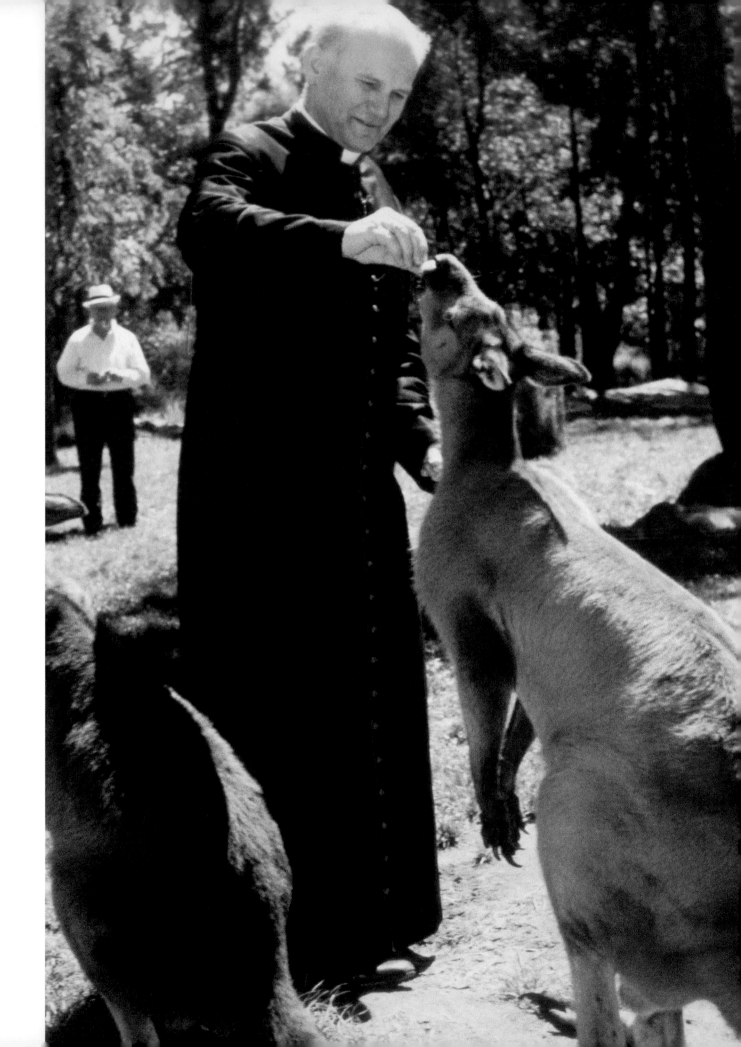

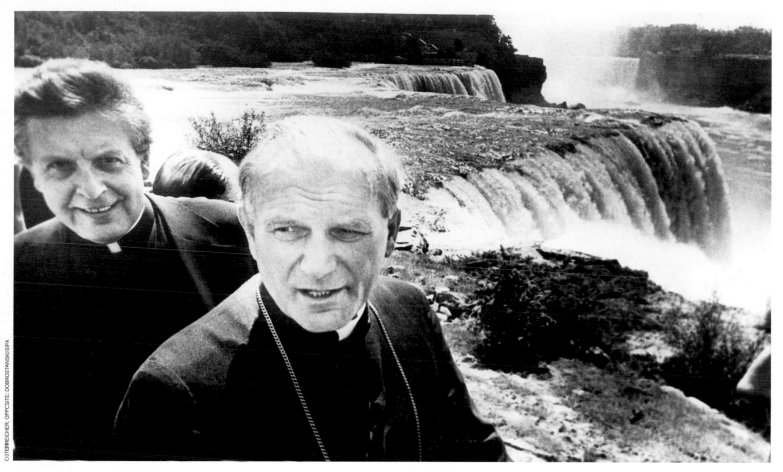

The extraordinarily well traveled John Paul II got a late start. Wojtyla was 42 years old when, on June 14, 1962, he first flew in an airplane on a trip to Kraków from Warsaw. He was 49 when a trip to Canada marked his first transatlantic voyage. In the 1970s he was off to Australia (opposite) and then to the U.S. (above, visiting Niagara Falls) for separate Eucharistic Congresses.

still thought him an intellectual aesthete rather than a politico: a poet in priest's clothing. This blindness on the part of the communists, which had earlier allowed Wojtyla to attend Vatican II, now allowed for his elevation in 1963 to Metropolitan Archbishop of Kraków, a major stepping-stone on his path to the papacy.

Archbishop Baziak had died in June 1962. Cardinal Wyszynski was told by the Vatican that Kraków, almost exclusively Catholic, needed a bishop—at once. Wyszynski's problems with Wojtyla had only been exacerbated by the debate over Vatican II reforms: The older man favored the Latin Mass, the younger thought vernacular Masses would be a good thing; the older man didn't buy into the younger man's ecumenism. Wyszynski ran no fewer than six nominees past the Polish government's Department of Religious Denominations before the communist decisionmaker there, Zenon Kliszko, rubber-stamped the apparently apolitical Wojtyla. (It was later reported that Kliszko, realizing he had abetted Wojtyla's ascent to the throne, regretted that he had not selected one of Wyszynski's lackeys.)

John XXIII died in 1963 and was succeeded as pontiff by Giovanni Battista Montini, who took the name Paul VI. Wojtyla's influence in Rome only increased. He worked on mastering new languages—in time he would become fluent in eight—and became an ambassador for the Vatican. In December he toured the Holy Land with a group of other bishops. He became a friend and confidant of the new pope and had substantial influence on his leader's thinking. Paul's reward was to install him as cardinal in 1967.

Paul was at that time preparing what would be his most famous and controversial encyclical, Humanae Vitae ("Of Human Life"). The issues confronted therein had been fluid within the Church since the start of Vatican II. John XXIII had named a commission to study the issue of birth control, and that panel had told Paul that a ban on contraception "could not be sustained by reasoned argument."

Humanae Vitae rejected such notions in unequivocal terms. The encyclical condemned abortion and all artificial means of contraception. It threw down the gauntlet between the Vatican and modernists who argued the case for an individual's right to

63

As a bishop and then a cardinal, Wojtyla still went on oxcursions when he could. In 1959 (above) and in '72 (left) he went to the mountains of Poland for sustenance. Once, he and his friends came to the aid of a New Hampshire woman who had broken her leg skiing. They comforted her with songs. The deskbound duties of an archbishop did, sometimes, get in the way. During an interview with *Time* magazine, Wojtyla gazed out his window and said wistfully, "I wish I could be out there now somewhere in the mountains, racing down into a valley. It's an extraordinary sensation."

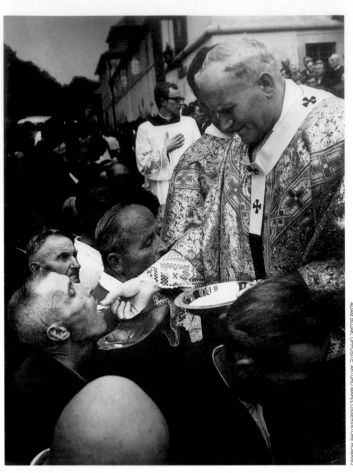

ADAM BUJAK; OPPOSITE: ARTURO MARI/L'OSSERVATORE ROMANO

64

choose. Political scientists argued that the burgeoning birthrate in the third world was a far greater immorality than birth control. In the United States and other developed countries, the Roman Catholic Church became the enemy of contemporary ideas of planned parenthood.

Wojtyla helped Paul VI write Humanae Vitae. He gave its precepts rock-solid support and worked on drafts of the document. Even as he was leading the liberals toward ecumenism and a possible rapprochement with Jews, he was holding the line on issues of sexuality.

His views on this subject, though they were consistent over time, seemed, to some, inconsistent in a personality so sophisticated. It wasn't just his attitude toward abortion: In *Love and Responsibility,* for instance, Wojtyla wrote of homosexuality as an abomination akin to bestiality. Yet meanwhile, in Poland, he founded and ran a marriage institute that dealt with family planning, illegitimate births, venereal disease, alcoholism, wife-beating and child abuse. Clearly, despite what some felt, Wojtyla was operating in the real world. He just had his own views of what that world should be.

Wojtyla was not afraid to bring those views into theaters where they would draw fire. In 1969, Polish communities in Canada and the U.S. invited Cardinal Wyszynski to visit, and when he declined, Wojtyla signed on for the trip. Whether schmoozing at cocktail parties or declaiming at press conferences, he seemed to enjoy himself. He grew bolder at home. When riots in Gdansk led to the ouster of Wladyslaw Gomulka in 1970, the insurgents got clear support, if not direction, from the Church. Gomulka's successor, Edward Gierek, kept pressure on the bishops but knew better than to shut them down.

In 1976, Wojtyla was revealed to all within the Vatican as someone very special, a papal favorite. Paul asked him to lead the pope's Lenten retreat. There had already been speculation that Paul wanted Wojtyla as his successor. (John Paul II later confided to his old friend from Wadowice, Jerzy Kluger, that there had been firm personal hints in this direction.) Now, as Paul's health waned with the '70s, Wojtyla looked like a candidate. Aspects of the man that would become hallmarks of his papacy were on the record. This cardinal was an intellectual, a missionary

and a leader. He held strong conservative opinions about doctrine, which were leavened by an ecumenical spirit. (In 1978 he hosted American evangelist Billy Graham in Kraków; Reverend Graham took to the pulpit of St. Anne's, and Poles streamed in, packing the pews.) Wojtyla had built a résumé that any fellow cardinal was free to examine.

In August 1978, Cardinal Wojtyla was at a lakeside retreat near Rome. He was tired and enjoying a much-needed vacation—not unlike that getaway with the campers of two decades previous. Pope Paul VI, meanwhile, was resting at the papal summer residence of Castel Gandolfo in the Alban Hills, also just outside Rome. Paul VI was 80 and hadn't been well. His arthritis was bothering him terribly, and he had lately been talking about the imminency of death. On August 6, while listening to a Mass being said in the papal apartment, he suffered a heart attack. He survived for three hours, constantly repeating his prayers. Then the lights were extinguished throughout Castel Gandolfo, a heavy chain was drawn across the entrance, and word was sent to all members of the Sacred College of Cardinals to hasten themselves to the Vatican.

Old home, new home: In 1975, Cardinal Wojtyla administered Holy Communion in Kalwaria Zebrzydowska, a wooded retreat outside Wadowice, and in the fateful summer of 1978 he conferred (opposite) with Laurean Cardinal Rugambwa of Tanzania as they strolled through the Vatican. Kalwaria Zebrzydowska had deep resonance for the prelate. After his mother died, Lolek Wojtyla traveled with his father and brother to pray at the sanctuary. When he was called to be a cardinal in 1967, he meditated there before heading for Rome.

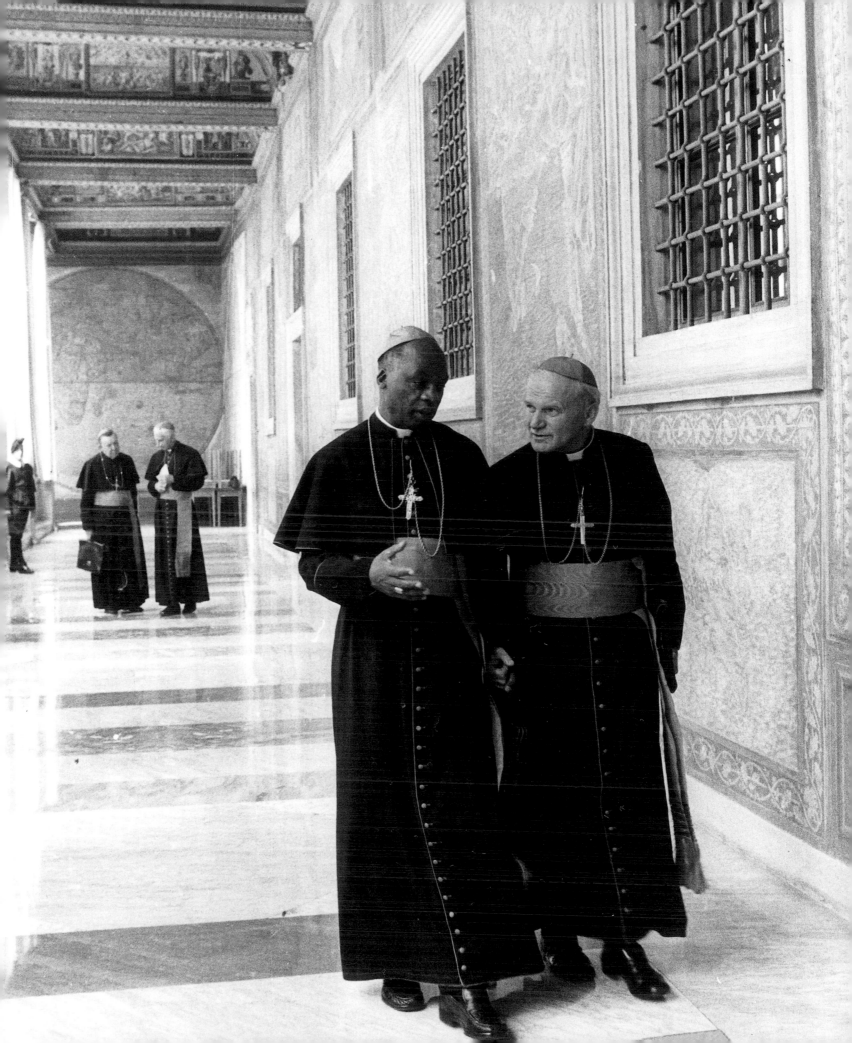

The Papacy Through the Years

The Dark Side

The shocking assassination attempt on John Paul II was only one in a litany of violent incidents that have beset popes through the ages. Ever since Saint Peter was put to death during Nero's persecutions, Bishops of Rome have been kidnapped (Silverius, 536–537), strangled (Leo V, 903), suffocated (John X, 914–928), poisoned (John XIV, 983–984, et al.), forcibly deposed (Gregory VI, 1045–1046, et al.) and otherwise disposed of (Benedict XI, 1303–1304, is reported to have died from powdered glass mixed in with his figs). Some other dire doings:

MARTIN I (649–655) By the middle of the 5th century, papal elections were not valid unless approved by the Byzantine emperor in Constantinople. Martin was consecrated without this sanction, a defiance that was worsened when the emperor's viceroy came in on Martin's side. A second viceroy arrived, arrested the ailing pontiff (he had gout) and forcibly removed him to Constantinople, where he was chained, publicly flogged and exiled to the Crimea. He died from his harsh treatment soon after. Martin is the most recent pope to be revered as a martyr.

LEO X (1513–1521) The assassination attempt on Leo X (right) featured clichés familiar in Renaissance conspiracies: family pride, poison and revenge. In 1517, Leo was being treated for

piles. His physician fell ill, and Alfonso Cardinal Petrucci offered a substitute—a pawn of Petrucci's who would poison the ointment being used on the papal disorder—but the modest Leo declined the doctor's attentions. Petrucci was found out, arrested and tortured, and he implicated other cardinals. Magnanimously, Leo let the coconspirators go (with huge fines); less generously, he had Petrucci strangled, albeit with a rope of crimson silk.

PIUS VI (1775–1799) Pius was one of two popes to be abducted from Rome to France by Bonapartist forces (the other was his successor, Pius VII). When he was arrested, age 80 and dying, he refused to remove the papal ring—the Ring of the Fisherman, a symbol of papal sovereignty—and asked to be allowed to die in

66

CLOCKWISE FROM TOP RIGHT: GRANGER; FRANCIS G. MAYER/CORBIS; ERICH LESSING/ART RESOURCE, NY; PIX INC.

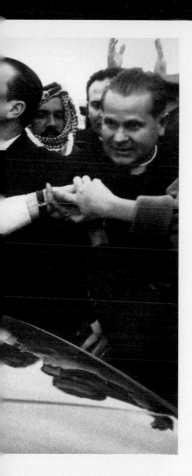

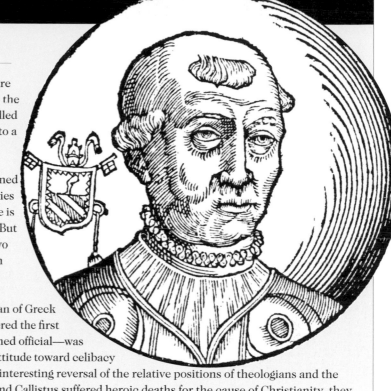

Antipopes

Visitors to the baptistery in Florence are occasionally bewildered to come upon the tomb of an early 15th century pope called John XXIII. Surely that name belongs to a beloved pontiff of the 20th century? Canonically—officially, in Church terms—it does. The John XXIII enshrined in Florence is an antipope, one of a series of Bishops of Rome whose papal tenure is not accepted as valid by the Holy See. But antipope does not mean Antichrist. Two antipopes are revered as saints, though others led less edifying lives . . .

HIPPOLYTUS (217–235) A theologian of Greek descent, Hippolytus (below) is considered the first antipope. His rival—and the man deemed official—was **Callistus I** (217–222), whose liberal attitude toward celibacy and abortion Hippolytus abhorred, an interesting reversal of the relative positions of theologians and the papacy today. Since both Hippolytus and Callistus suffered heroic deaths for the cause of Christianity, they have presumably found harmony in being enshrined in the Church's catalogue of saints.

ANACLETUS II (1130–1138) Born Pietro Pierleone, he was descended from an illustrious Jewish banking family, many of whom converted to Christianity on Easter Sunday in 1030 and one of whom became a canonically accepted pope, **Gregory VI** (1045–1046). Anacletus's claim was opposed by two emperors—the Holy Roman and the Byzantine—but most importantly by the Middle Ages' great scourge of unorthodoxy, Bernard of Clairvaux, who alluded to Pierleone's Jewish ancestry as a reason for denying him the papal chair.

Rome. He was told, according to historian Christopher Hibbert, "People die anywhere." Pius's "anywhere" was Valence, France, where he was imprisoned. French officials called him Citizen Pope.

PAUL VI (1963–1978) During a visit to the Philippines in 1970, Paul (above) was nearly stabbed by a Bolivian, but the attack was thwarted by a solidly built cleric. The story grew that the hero was the Illinois-born bishop Paul Marcinkus, whose six-foot-four stature and athletic reputation had made him a familiar media figure. However, reported Vatican correspondent Peter Hebblethwaite, the attacker had actually been overwhelmed by an English bishop—a mere six feet tall—who was traveling in the papal party.

JOHN XXIII (1410–1415) The Neapolitan Baldassare Cossa (above), a serial womanizer and one of the last antipopes, flourished during the Great Western Schism (1378–1417), a period of such confusion that during Cossa's "reign" there were three claimants to the papal throne. After he was—unwillingly—deposed by the Council of Constance, the universally acknowledged **Martin V** (1417–1431) appointed him Cardinal Bishop of Tusculum.

Pope John Paul II: Toward Freedom

Juliusz Slowacki wrote in 1848, "Behold the Slavic pope is coming, a brother of the people;/He already pours the world's balm into our breasts,/And the angel choirs sweep the throne for him, with flowers." Slowacki was a Polish poet of the Romantic Era, and his was a romantic notion. But he might as well have been a herald in the books of the Prophets. It took tumultuous events and a divided assembly of cardinals to get it done, but in 1978 a Pole was enthroned. At that time, another bit of prophecy went all but unnoticed. "A Pole has become pope," said Poland's communist leader Edward Gierek as the country exulted around him. "It is a great event for the Polish people, and a great complication for us."

That a Pole of humble origins could become Bishop of Rome, Primate of Italy, Patriarch of the West, Supreme Pontiff of the Universal Church was an altogether remarkable thing.

Paul's body lay in state for two days at Castel Gandolfo, then, on August 9, was transported with motorcycle escort to the Vatican. In St. Peter's Basilica, opposite, the body was visited over the next three days by a steady stream of Romans and tourists who whispered the rosary as guards hustled them along. Paul had asked that photos not be taken of his body, but this wish was ignored. In his will he asked for a "pious and simple" funeral, saying he wished to die "like a poor man." On Saturday, August 12, 1978, plainchant filled St. Peter's Square, a homily was said, Communion was given to the multitudes, and Paul's body was borne into the cathedral and buried in the crypt beneath Donatello's statue of Our Lady.

The papal historian Peter Hebblethwaite called 1978 the Year of Three Popes. But the crucial events of that time could, perhaps, be more accurately rendered as the Late Summer of Three Popes, so swiftly did affairs spin at the Vatican.

With Paul's death, the Sacred College of Cardinals was faced with the critical responsibility of electing a successor, a duty it hadn't executed in 15 years. Such procedures in Rome are always fraught with suspense and barnacled with gossip and speculation. Secular and nonsecular observers fall over themselves trying to gauge the political and philosophical mind of the electorate, even as they assess the late pope's impact on the Church.

With Paul VI, who had enjoyed a good, long tenure, this was difficult to do with accuracy. On three issues that were emerging as flash points of the modern age—the ordination of women as priests, the ordination of married men and the myriad controversies surrounding procreation—he looked conservative and doctrinaire, particularly as he succeeded the genial, apparently open-minded John XXIII, who lived too short a time as pontiff to put his stamp on these matters. But in other ways, Paul was progressive. It was

he who ruled over the three final sessions of Vatican II, which delivered fresh-air initiatives like vernacular Masses and steps toward ecumenism. Paul, early on, was energetic and boosterish as he strove to unify his lieutenants. He wanted in the aftermath of Vatican II a feeling of *"pas de vaincus, mais de convaincus"*—a feeling that no faction had been defeated, that the Church itself had won. Paul established the Synod of Bishops, which met and discussed such varied subjects as canon law, ecumenical, or "mixed," marriages and a recommitment of "collegiality" within the Church after Humanae Vitae caused fractures in 1969. The purpose of the synods was as much to give the bishops a sense of empowerment and responsibility as it was to get real work done.

Paul sought to be a "pilgrim pope." He traveled to a degree no pontiff ever had. He reached out to non-Catholics. He embraced the spiritual leader of the Anglican Church, Dr. Michael Ramsey, and talked of rebuilding "a bridge which for centuries has lain fallen between the Church of Rome and Canterbury."

But even as Paul was looking outward, his Church, in the latter part of his administration, started coming apart internally. Liberal theologians and priests, many of them in the United States, wouldn't let

go of Humanae Vitae and constantly assailed what they considered a hidebound institution. By the end of 1975, Paul pleaded in an exhortation: "The power of evangelization will find itself considerably reduced if those who proclaim the Gospel are divided among themselves in all sorts of ways. Is this not perhaps one of the great sicknesses of evangelization today? Indeed, if the Gospel which we proclaim is seen to be rent by doctrinal disputes, ideological polarizations or mutual condemnations among Christians . . . how can those to whom we address our preaching fail to be disturbed, disorientated or even scandalized?"

Paul turned insular toward the end, and his indecisiveness—in everything but doctrine, it sometimes seemed—grew worse. One Vatican official suggested Paul VI was as good as retired: "They treat him as though he were already dead."

And then he was.

While his passing was hardly unexpected, it nevertheless, after a decade and a half of one administration, rocked the Vatican. Who would be chosen to continue the balancing act of modernization begun by John and Paul? Who would knit an increasingly divided Church?

Only one thing seemed certain as the

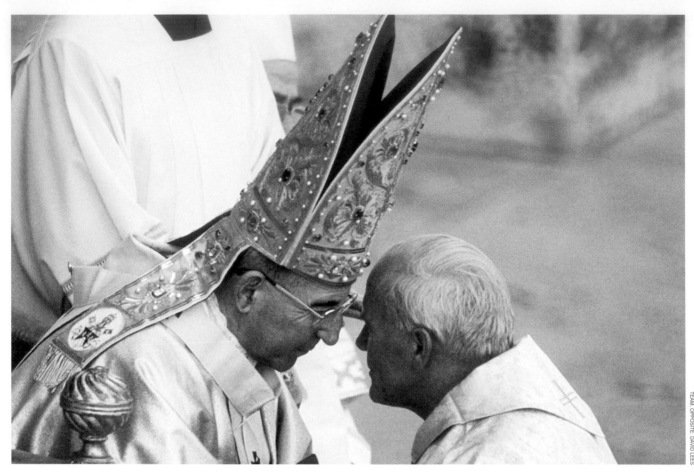

72 cardinals gathered in the Pauline Chapel in the late afternoon of August 25, 1978: An Italian would be chosen. The Italian cardinals were still a formidable faction; although they no longer held an absolute majority, they still had a 456-year tradition of not failing to select from among themselves. Even such an impressive candidate as Paul VI's favorite, 58-year-old Cardinal Wojtyla of Poland, had to be considered an extreme long shot.

Gathered in the sacred room before Michelangelo's frescoes, the cardinals swore "to observe with the greatest fidelity . . . the secret concerning what takes place in the conclave . . . not to break this secret in any way, either during the conclave or after the election of the new Pontiff." They repaired to their rooms and reconvened the next morning to fill in their ballots under the words "I elect as Supreme Pontiff," each of them laboring to disguise his handwriting. Not that it mattered in this instance; there would be no recrimination. Albino Cardinal Luciani was elected during the first day's sessions, gaining the 75 votes needed—two thirds of the electorate plus one vote. Such quick consensus was rare in the Vatican. What made it the more remarkable was that Luciani was a surprise winner. No papal handicapper had tabbed the modest, well-liked Patriarch of

Venice, and still no one knows what really happened in the conclave. It can be speculated that Luciani was acceptable to nearly all his countrymen cardinals, and that was enough.

When it became clear how the vote was going, one of Luciani's colleagues whispered to him, "Courage. If the Lord gives a burden, he also gives the strength to carry it." Another said, "Don't be afraid. The whole world is praying for the new pope." When the last ballot of the final round was read aloud by the scrutineer, the cardinals burst into applause. Luciani reportedly said, jokingly, "God will forgive you for what you have done to me."

Luciani was 65, and not a robust man. He took as his papal name John Paul I in tribute to his immediate predecessors, but whether he could continue their legacy was a question. He had never been a diplomat, so he would not extend the pilgrim-pope tradition begun by Paul. He was a centrist, and a centrist was probably not going to be an innovator.

What John Paul I might have become is moot. Elected as pope to great joy on August 26, he died in his sleep on September 28; his papal tenure of 34 days was the shortest since Pope Leo XI ruled for 18 days in 1605. Immediately, there were rumors that the pope had been murdered. Reports of foul play gained such currency that the Vatican was

After his investiture ceremony (opposite), John Paul I was greeted by his cardinals, including Wojtyla of Poland (above). The new pope surely recognized that his colleague possessed leadership qualities and a strong intellect, and he moved quickly to enlist him as an adviser. One of his first invitations for private counsel went to Wojtyla.

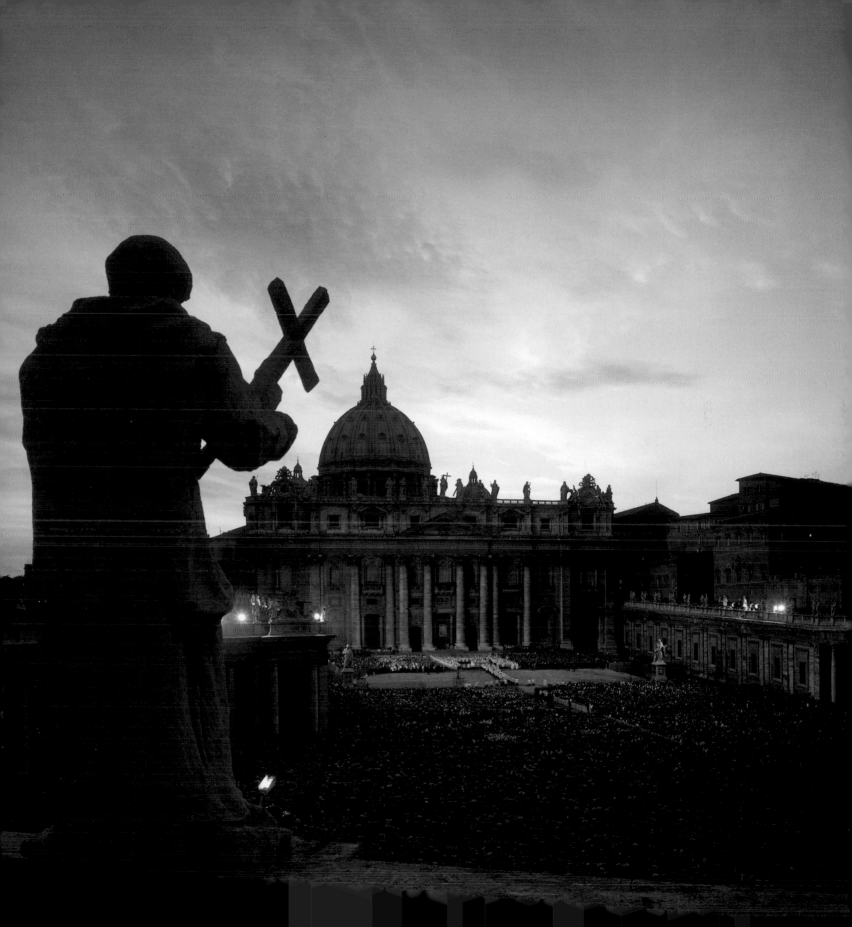

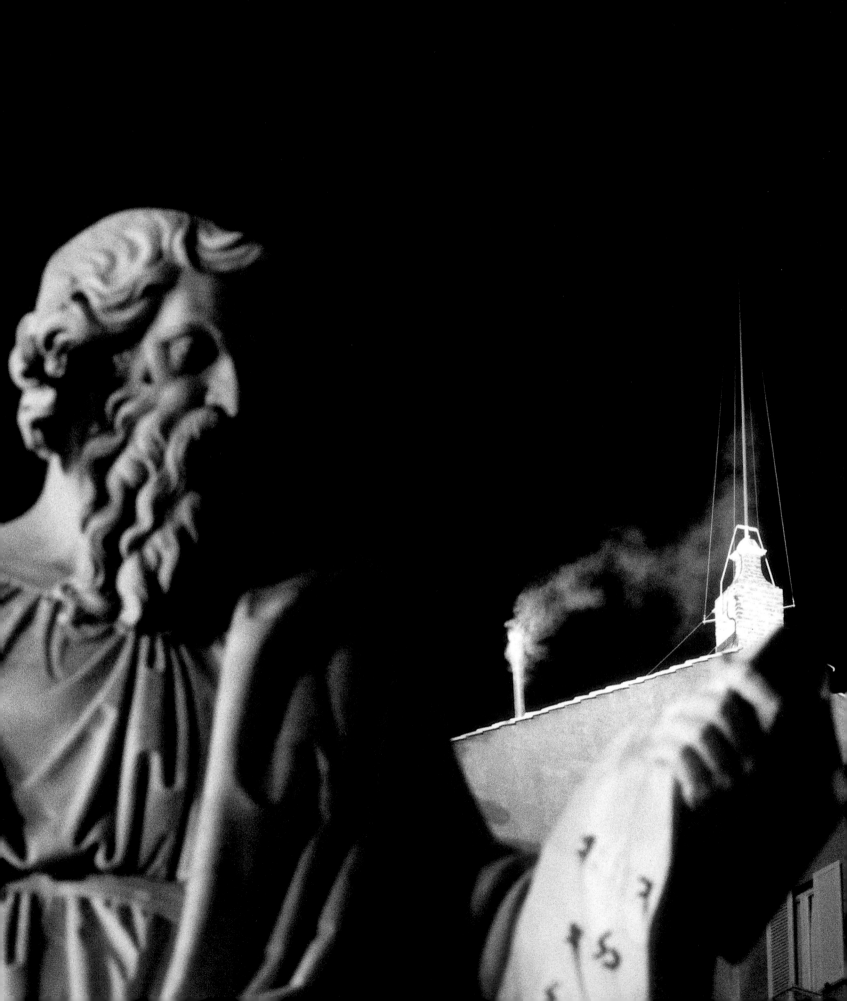

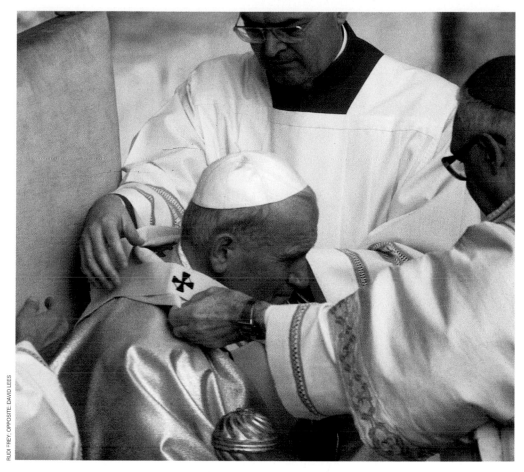

RUDI FREY; OPPOSITE: DAVID LEES

For 48 hours, all of Rome—indeed, all the world—wondered what the October conclave was up to. Then, finally, after nightfall on the second day, white smoke streamed from the Sistine Chapel chimney: A pope had been chosen. It had taken eight ballots and a radical change of mind on the part of the Sacred College of Cardinals, but by the time of John Paul II's investiture (right), six days after his election, it was clear to all that the electors had done a bold, smart thing. By bravely breaking "the Dutch curse" that eliminated other worthies in favor of Italians, the Vatican got itself an intelligent, strong, energetic young leader, a take-charge pope.

moved to denounce them in mid-October. Two doctors said the cause of death had been a heart attack.

Some context: There have been several very short reigns on St. Peter's throne; there were no fewer than five popes during 896 and 897, and careers of, say, four or five years have been more common than those of a decade or more. The reason for this was always as clear to the cardinals as it was to others: Elected popes were usually old men who had gained respect and support over many years. They were retirement-age gentlemen ascending to the top job.

Now, having suffered the declining administration of Paul VI and a successor who lived but a month on the throne, the cardinals realized their next vote would be critical. There could not be another pro forma election of one of their friends, and furthermore, they had to consider younger, more vital priests— priests who would last.

Paul VI had decreed before his death that cardinals over 80 be barred from future papal elections. Of the 111 members of the college eligible to vote in the fall of 1978, 56 were from Western Europe. That still represented a

majority but not such an overwhelming one that an outsider mightn't be considered. Finally, without the popular Luciani to unite behind, the Italian faction was split between a conservative and a progressive. In other words, there was now an open field.

Wojtyla returned to the Vatican from Poland for a resumption of the conclave. His old friend from Kraków, Bishop Deskur, hosted a few informal gatherings for Wojtyla and selected cardinals. Then, on October 13, the day before the conclave, Bishop Deskur suffered a stroke and was rushed to the hospital. Wojtyla prayed at his friend's bedside until duties forced him to return to the Sistine Chapel.

Wojtyla had some backers from the very beginning of the conclave, but in the four rounds of voting that first day, no cardinal came close to the required 75 votes. Outside the chapel that evening, St. Peter's Square filled with people hoping to see the puff of white smoke, indicating a new pope had been chosen. Instead, black smoke poured from the chimney: a deadlock.

That night the cardinals, independently and in small groups, entertained radical

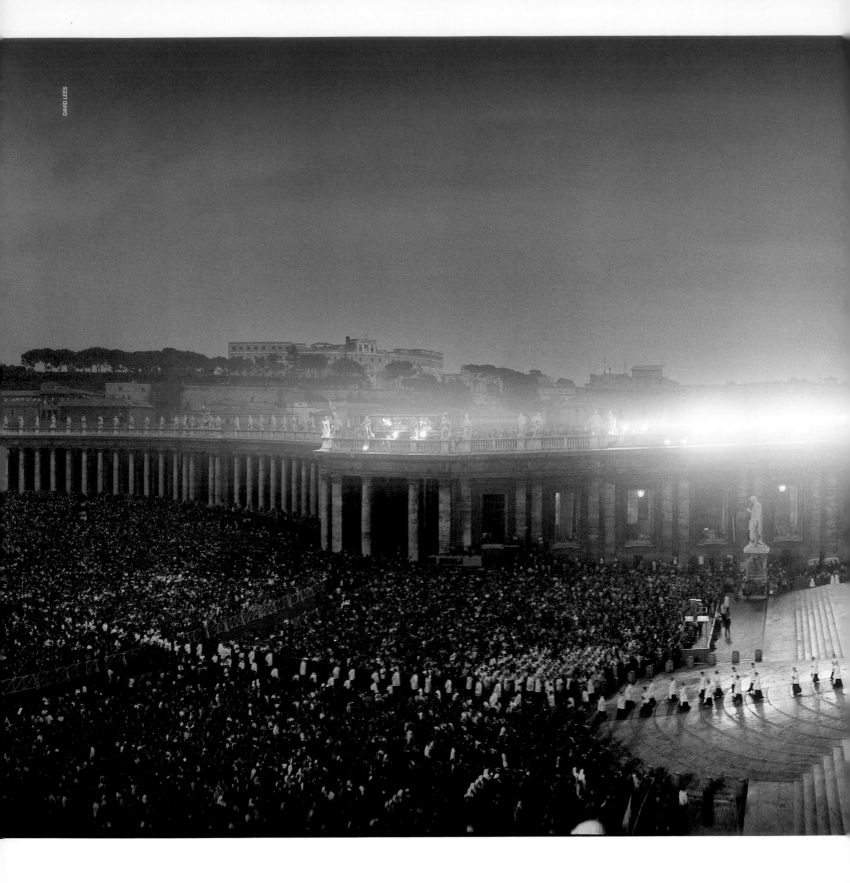

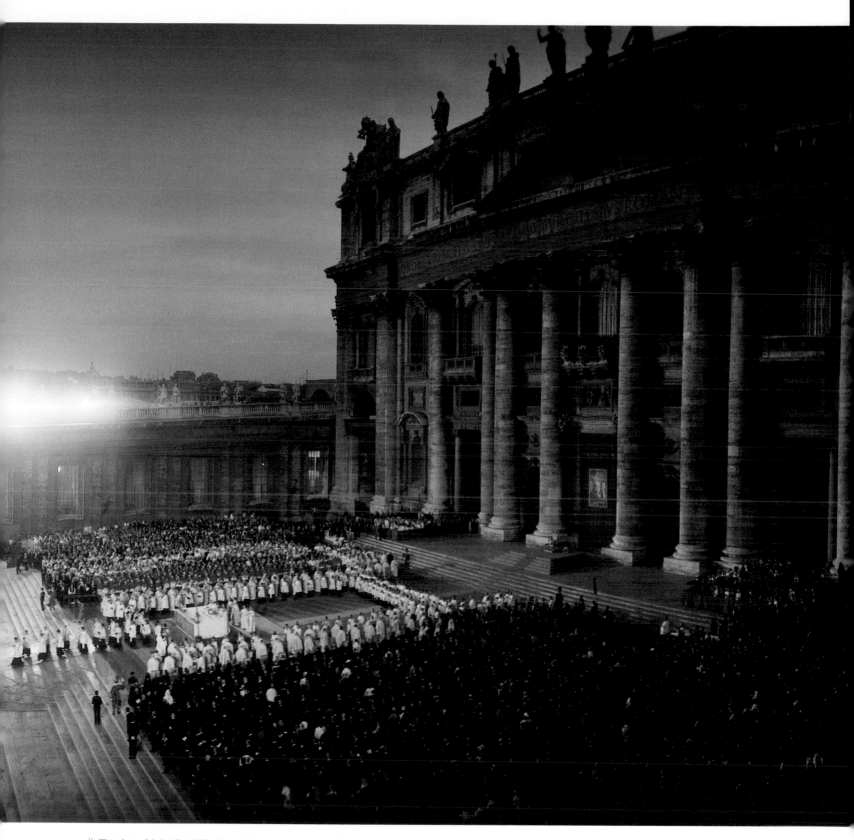

The day of John Paul II's investiture was thrilling in Rome (above), but it was more thrilling in a country farther east. On October 22, 1978, all of Poland was riveted to the three-hour installation Mass and ceremony. "I have never seen my place so empty," said the manager of a restaurant on Marszalkowska Street in Warsaw. "It looks as if everyone left town." Quite a few did: The communist government had relaxed travel restrictions to allow more Poles to pilgrimage to St. Peter's Square for the great day's events.

For Cardinal Wyszynski, the embrace of his countryman—two decades his junior, now his leader—on the day after Wojtyla's installation must have been difficult. Wyszynski had done little to forward Wojtyla's career, and the men disagreed on many issues.

78

solutions, and as these solutions were being entertained, the strong, smart, diplomatic, young—58!—cardinal from Poland evolved from candidate into strong contender. On the second day of voting, the Italians still couldn't agree among themselves. Support for the outsider built. On the fourth ballot that day, Karol Cardinal Wojtyla was elected to fill the shoes of the fisherman. He buried his face in his hands.

As soon as white smoke began to billow, a crowd flocked to the square. Pericle Cardinal Felice said from the balcony, "I announce to you a great joy. We have a pope!" One hundred thousand people roared and cheered. A moment later they were silenced by the name, something pronounced *Voy-tih-wuh*. What was going on here? *"Un Papa straniero!"* someone shouted: a foreign pope!

Well, they had to hear him out. "Blessed be Jesus Christ," he said in Italian. The crowd responded warily: "May He always be blessed."

"Even if I am not sure that I can express myself well in your—*our*—Italian language, you will correct me if I make a mistake." Laughter and applause greeted this, as the new pope's Italian was clearly perfect. When it was explained that he was choosing the name John Paul II in tribute to the three popes who had preceded him, the deal was cinched. "Why

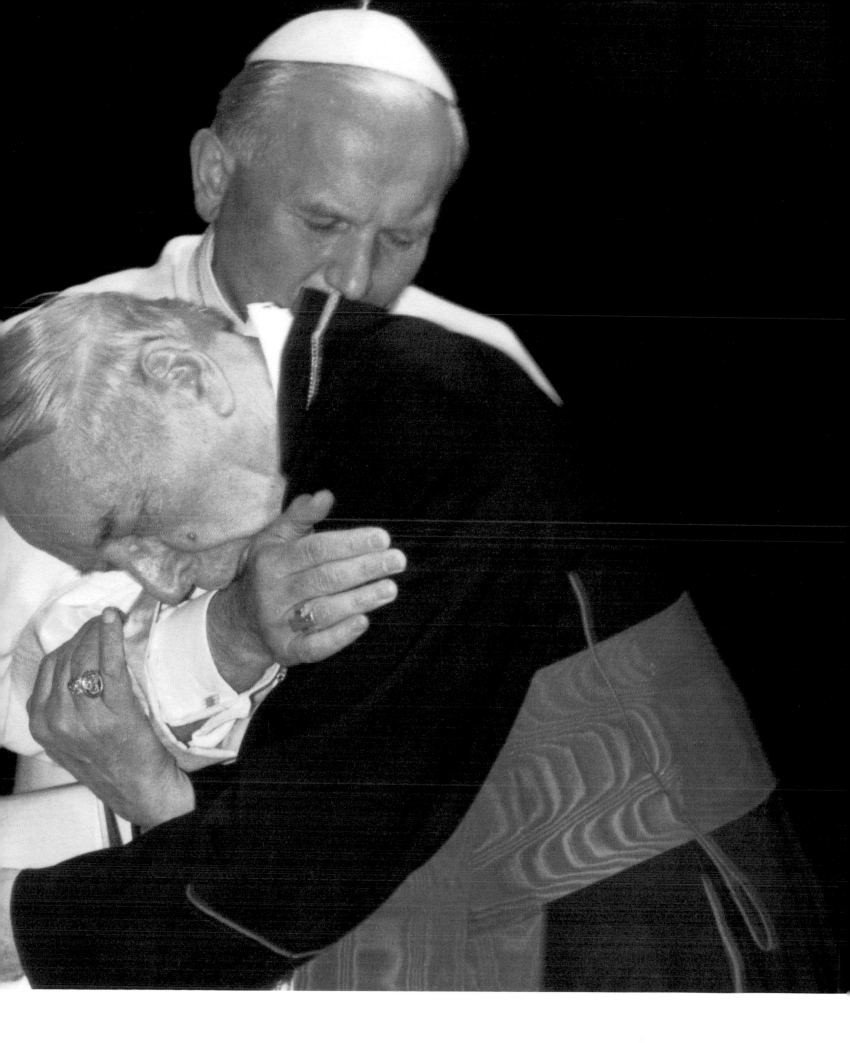

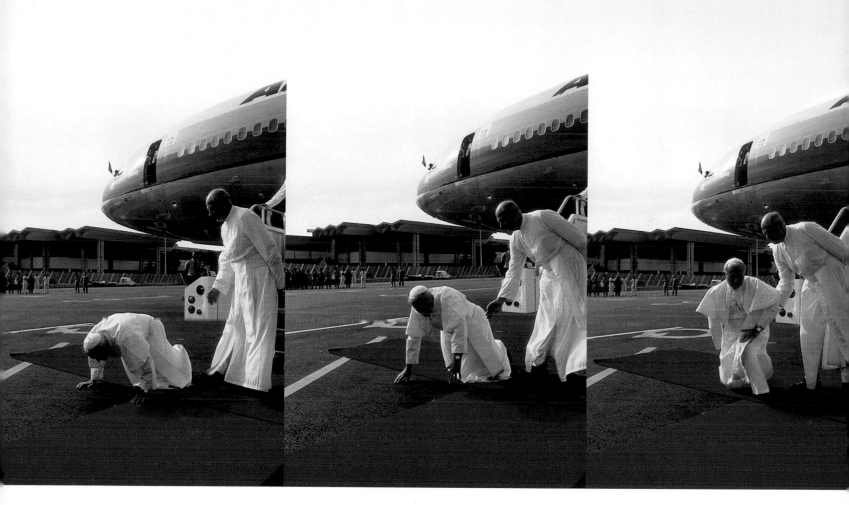

Just as Father Wojtyla had when arriving at his first parish in Nagowić, Poland, in 1948, Pope John Paul II knelt and kissed the ground in Abidjan, Ivory Coast, in 1980. The pope's missionary zeal never flagged. It's not that he traveled more than any pope before, it's that he traveled more than all the previous popes put together. In the early days of the Church, Catholicism was by no means an international religion, and a pope's purview was Rome and Western Europe. From 1309 to 1377, the papacy was exiled in Avignon, France, safe from Italy's unrest, but exile hardly counts as travel. When the French seized Rome in 1808, Napoleon had Pius VII banished to France, but banishment hardly counts as travel. From 1870 to 1929, popes were "prisoners of the Vatican" and wouldn't set foot outside the walls. It was Paul VI who started the evangelization that John Paul II took to extremes, toting up, finally, more miles than a round-trip to the moon.

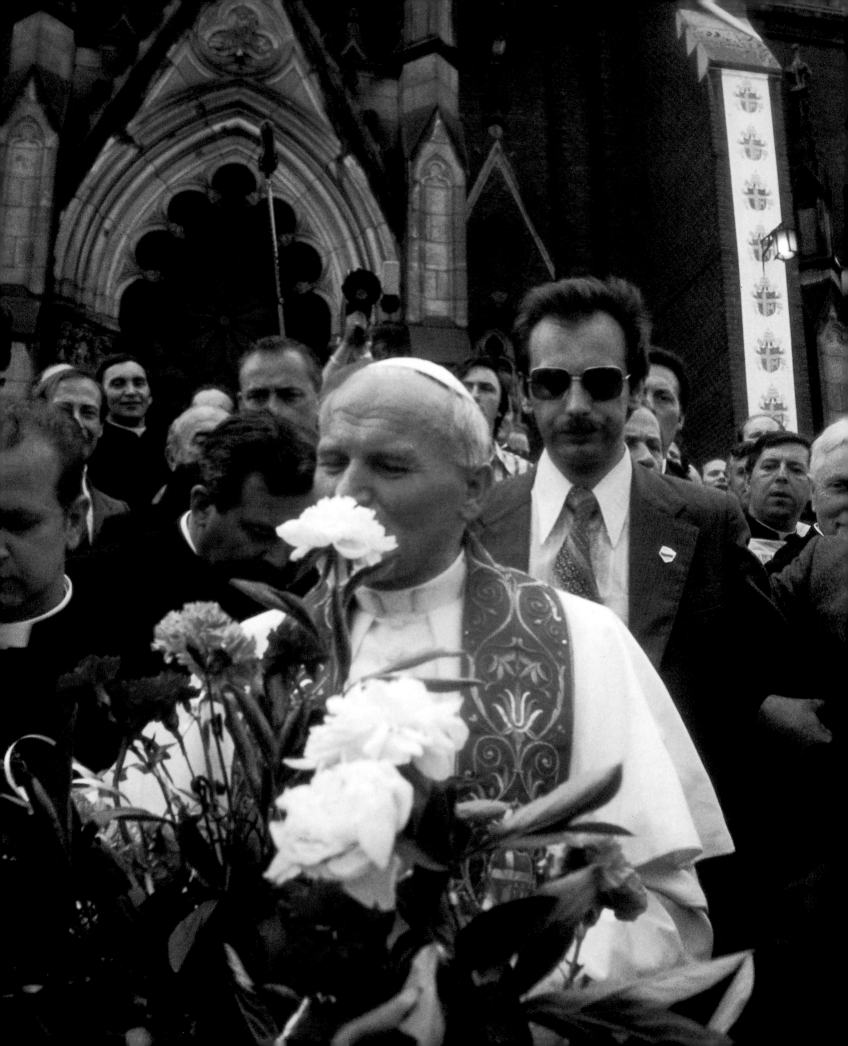

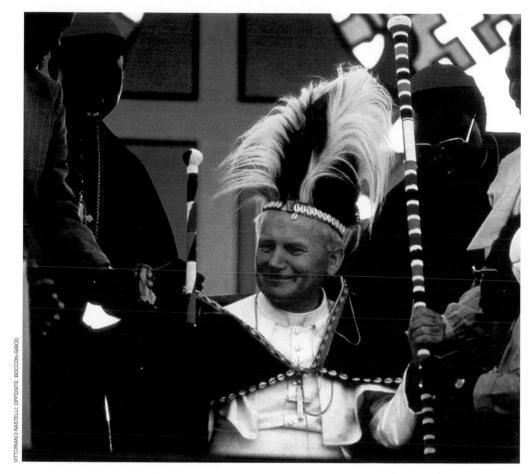

VITTORIANO RASTELLI; OPPOSITE: BOCCON-GIBOD

shouldn't we have a foreign pope?" mused a Roman cabbie at the end of the strange, thrilling day. "After all, Saint Peter was one."

If Rome shrugged, Poland erupted. On the day of the pope's investiture, people in Kraków who did not have television gathered at the hotels. Ninety percent of Warsaw's 1.4 million people watched. Carmelite friars broke their institutional law to watch on TV. Churches throughout Poland rescheduled Mass so parishioners could be home to watch. In Kraków, the enormous 450-year-old Sigismund bell at the Royal Castle Cathedral tolled for only the second time since World War II. The first time had been the previous Monday, when Wojtyla was chosen.

John Paul II was the youngest pope since 1846, and in the Vatican he was an immediate breath of fresh air. The winter of 1978-79 was cold in Rome, but the pontiff insisted on open windows. The outdoorsy pope wore a cardigan between his cassock and cape; his associates grumbled about "Polish air conditioning."

He was fun, but no-nonsense. It was a certain prelate's job to silence popes when they carried on too long in public. When he tried this with John Paul II, the pontiff turned on the man: "I'm the pope, and I know how to behave." The Swiss Guard was told to keep its distance during the pope's constitutionals, and the Curia—the Vatican's government bureaucracy—was told not to even try to push him around. "The Curia told my predecessor what he should do and when," John Paul said to a friend from Poland in the first weeks of his tenure. "This may have led to his death. They will not tell me what to do. I will decide. They will not kill me."

If there was any difficulty in the early days of his pontificate, it was in practicing the diplomacy that he would eventually excel at. "The only strain I find is that here I am constantly switching languages. I may be reading a document in Italian, then I receive people in German, then more papers in French and English, or an audience in these languages. I suppose I will get used to it." He would.

A personal matter heartened him in these days: Bishop Deskur survived his stroke. He would travel by wheelchair from here on but would be able to get to the Vatican for Sunday lunch with the pope for years to come.

John Paul started quickly. He went on the record with his first encyclical faster than any pope ever. He issued the hundred-page Redemptor Hominis ("Redeemer of Man") within five months of his investiture. It contained no bold initiatives, while backing the idea of priestly celibacy and mentioning that Paul VI's positions on hot-button issues like birth control, abortion, divorce and female priests were sound.

He was named one of People magazine's 25 most intriguing people of 1978. He shared space on the special-issue cover with John Belushi, John Travolta, Brooke Shields, Jimmy Carter and Farrah Fawcett. He had no comment on the selection.

He took to the skies. John Paul II's first pilgrimage was to Puebla, Mexico, in January 1979, in fulfillment of a promise Paul VI had made. In June, he went back to Poland to fulfill a promise he himself had made to his people. He used as an excuse the 900th anniversary of patron saint Stanislaus's martyrdom, but the trip was all about Karol Wojtyla, triumphant. One third of the Polish people saw him in person during the nine days. He went home to Wadowice. He went to Auschwitz, the first pope to visit a Nazi death camp.

On September 29 he went on pilgrimage to

83

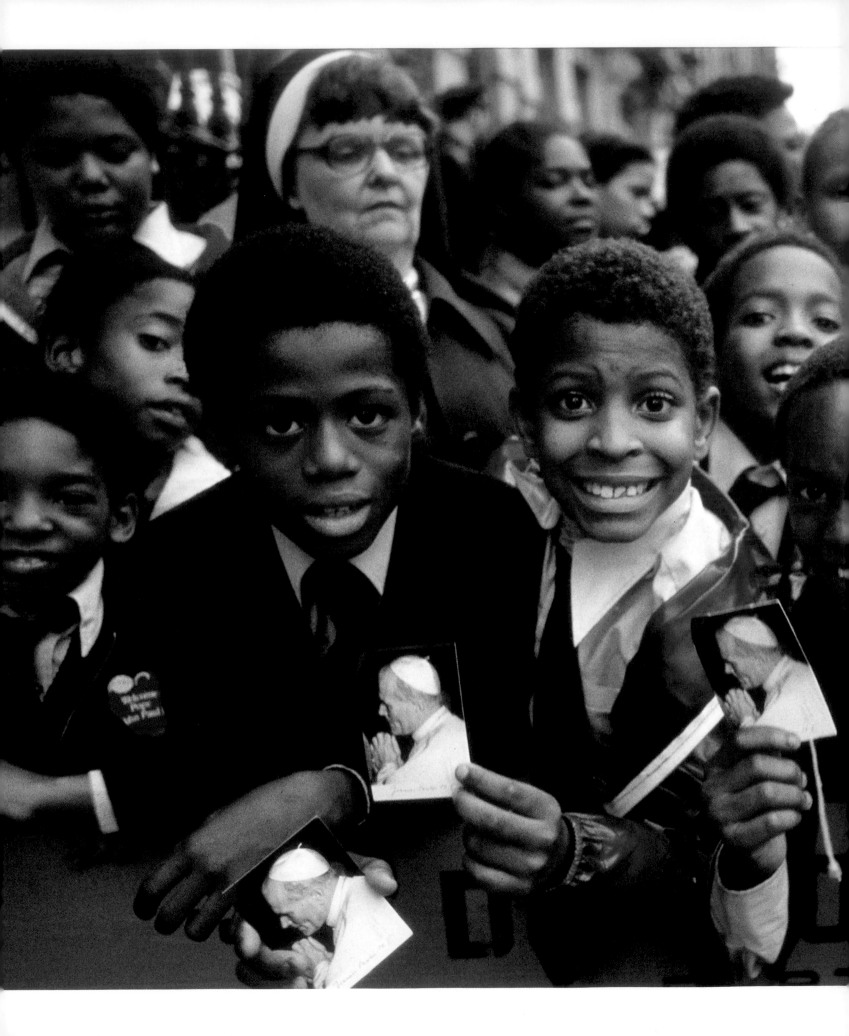

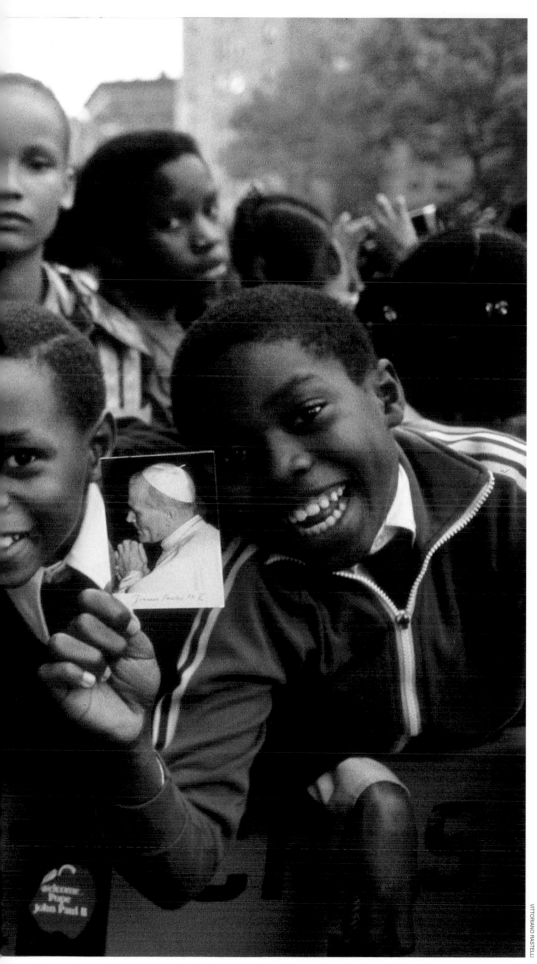

In the fall of 1979, John Paul made his first tour of the U.S. as pope and was met by parades, overflowing churches and, in Chicago, these enthusiastic kids. He spoke there to a closed meeting of 250 bishops, laying down the Church's position on birth control, divorce, abortion, homosexuality and extramarital sex. Two days later, in Washington, D.C., he learned that America's Catholics would not unquestioningly adhere to doctrine. At a meeting of 5,000 nuns, John Paul listened as Sister Mary Theresa Kane, head of the Leadership Conference of Women Religious, asked the pope to open "all ministries of our Church to women." All ministries, including the priesthood.

Ireland and the United States and waded into rapturous crowds. He addressed the United Nations and met with President Carter; he was the first pope to visit the White House.

In November he went to Turkey to break bread with Patriarch Dimitrios I, leader of the Eastern Orthodox Church. The next May he traveled 11,200 miles by airplane, river barge and limousine to and through Africa. He went to France that month too—the first pope there since 1814—and a month later began a 17,500-mile trip to South America that made him the first pontiff ever in Brazil. Later in the year he went to West Germany, the first time a pope had visited the homeland of Martin Luther since 1782. His goal in all these places was to present the Catholic message, to build bridges for Catholics and to make new Catholics.

Meanwhile, there was politics. He censured the Swiss theologian Hans Küng for questioning papal infallibility. John Paul said Roman Catholic priests couldn't hold public office; the liberal Father Robert Drinan of Massachusetts had to retire from Congress. Initially, John Paul was mum when riots broke out in Poland and a labor movement named Solidarity was born. A 37-year-old unemployed Lech Walesa was the leader of the insurrection, but was he really? Strikers put

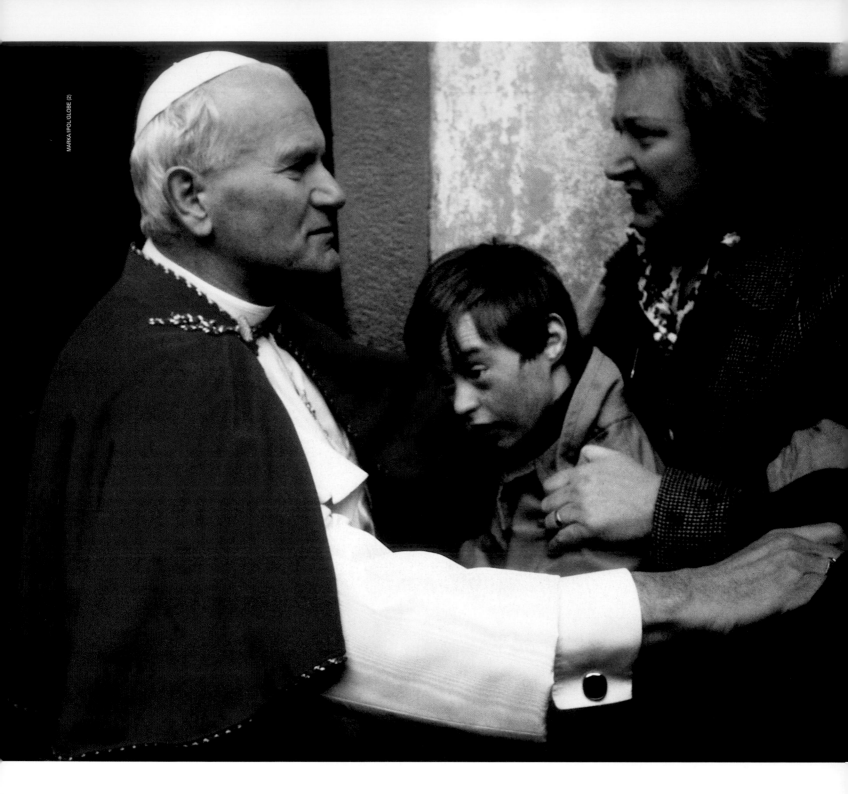

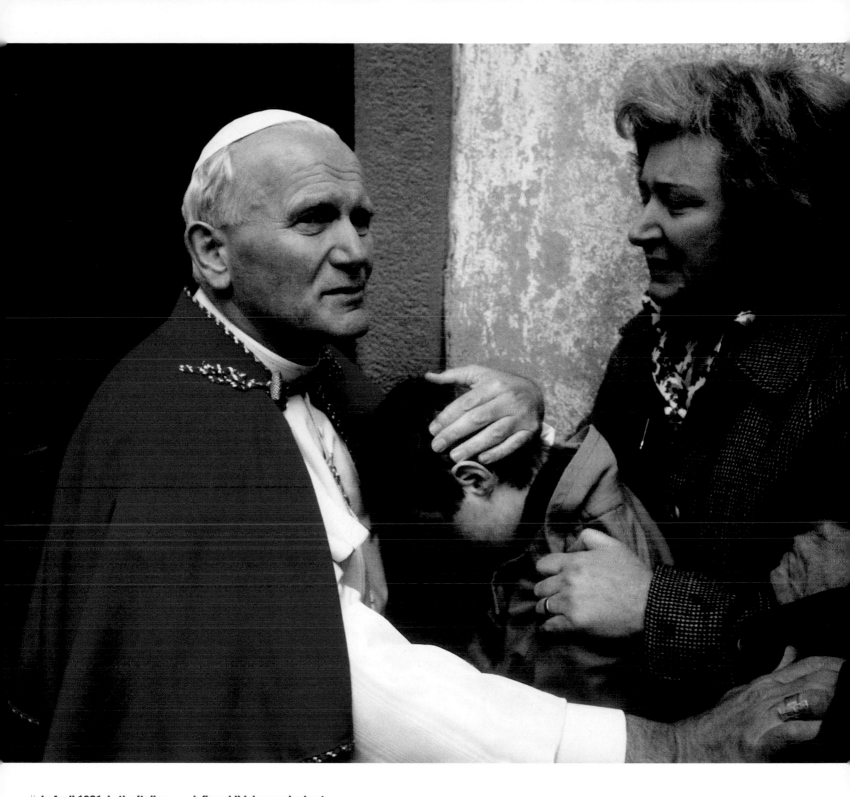

In April 1981, in the Italian town of Sotto il Monte, the pope comforted a mother and her son, who suffered from Down syndrome. This would be one of John Paul's last visits among the people before the attempt on his life. The embrace was characteristic of John Paul; whenever he saw an infirm child, he reached out. "Although God allows suffering to exist in the world, He does not enjoy it," John Paul said. "Indeed, our Lord Jesus Christ, the Son of God made man, loved the sick; He devoted a great part of his earthly ministry to healing the sick and comforting the afflicted."

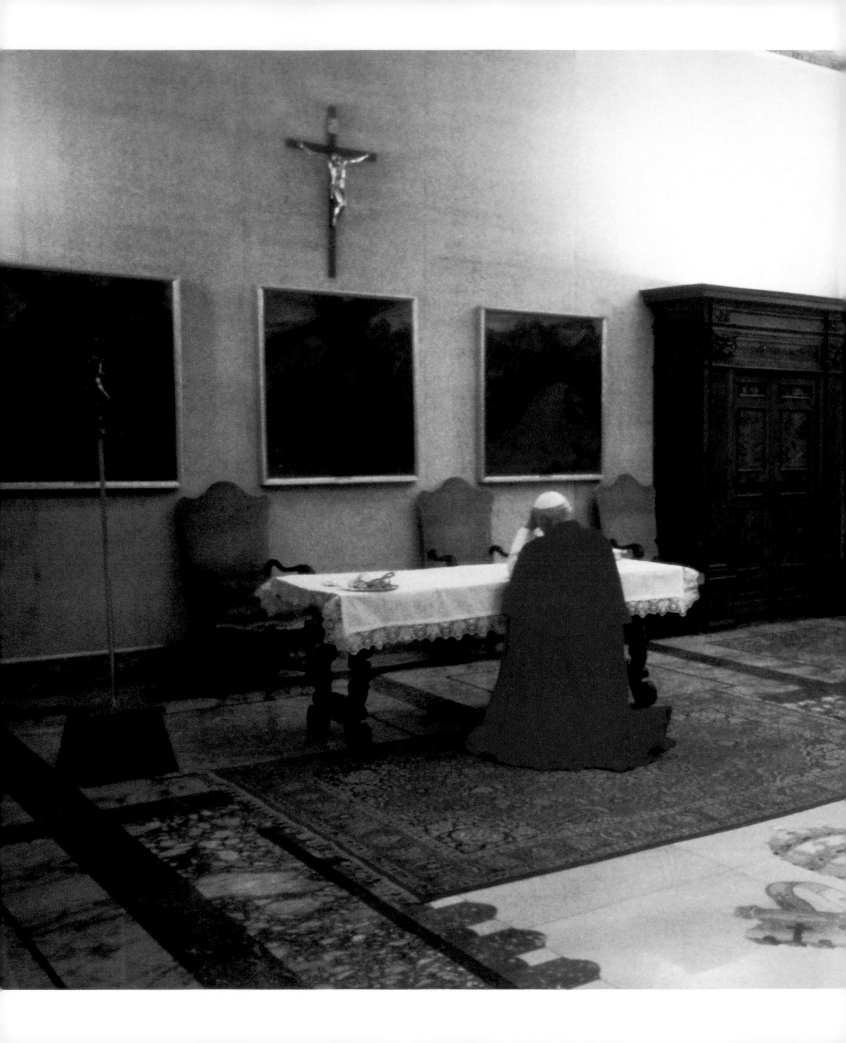

"He used to pray in that characteristic stance of his, leaning forward, his head resting on one hand, the palm covering his face, or with his head resting on both hands. He used to stay in the same position for long periods at a time." Mieczyslaw Malinski, who knew Wojtyla back in Wadowice, wrote those words in a memoir, *My Old Friend Karol.* Nothing had changed except the setting by the time John Paul II was saying daily prayers while kneeling on a carpet in the Vatican's opulent Hall of Investiture, the room where Cardinal Wojtyla had first received his papal vestments.

the pope's photograph on their posters. On August 20, John Paul told a crowd in St. Peter's Square, "We, now present in Rome, are united with our compatriots in the motherland." Within a month, Edward Gierek—so prescient in perceiving that the Polish pope meant trouble for communism—stepped down. In January 1981, members of Solidarity visited the Vatican; Walesa met with the pope twice.

The pope was involved, fully in charge, powerful, seemingly indomitable.

And then, on May 13, 1981, an escaped 23-year-old Turkish killer named Mehmet Ali Agca moved through St. Peter's Square toward the pope's vehicle with a large Browning handgun. He opened fire. John Paul was critically wounded. Agca tried to run, but a small nun named Sister Letizia grabbed his arm and hung on. "Not me! Not me!" Agca screamed, but Letizia would not let go: "Yes, you! It was you!" Agca was subdued and arrested.

This sequence of events was pieced together, as was the conspiracy behind the shooting, by Claire Sterling, a journalist hired by *Reader's Digest* to ferret out the truth when it was announced that Agca had acted alone. Surprising no one, Sterling learned that the communists were behind the assault. Agca was on assignment to kill the pope and, if he could, Lech Walesa, too. It was lucky for Agca, who

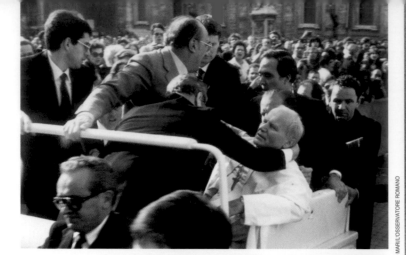

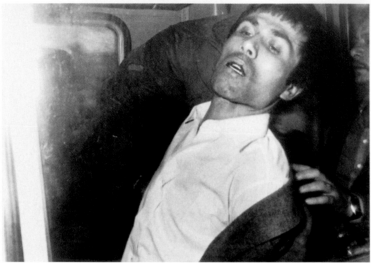

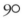

On May 13, 1981, Mehmet Ali Agca, a far-rightist being sought for murdering a newspaper editor in his native Turkey, attempted to assassinate John Paul II in St. Peter's Square. He was seized by authorities after being grabbed by a nun. Four days after the shooting, while still in critical condition, the pope forgave his assailant. The absolution was reiterated in 1983 during a visit to the prisoner's jail cell in Rome.

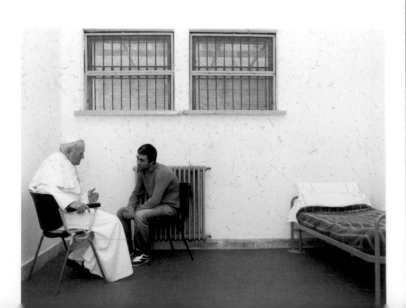

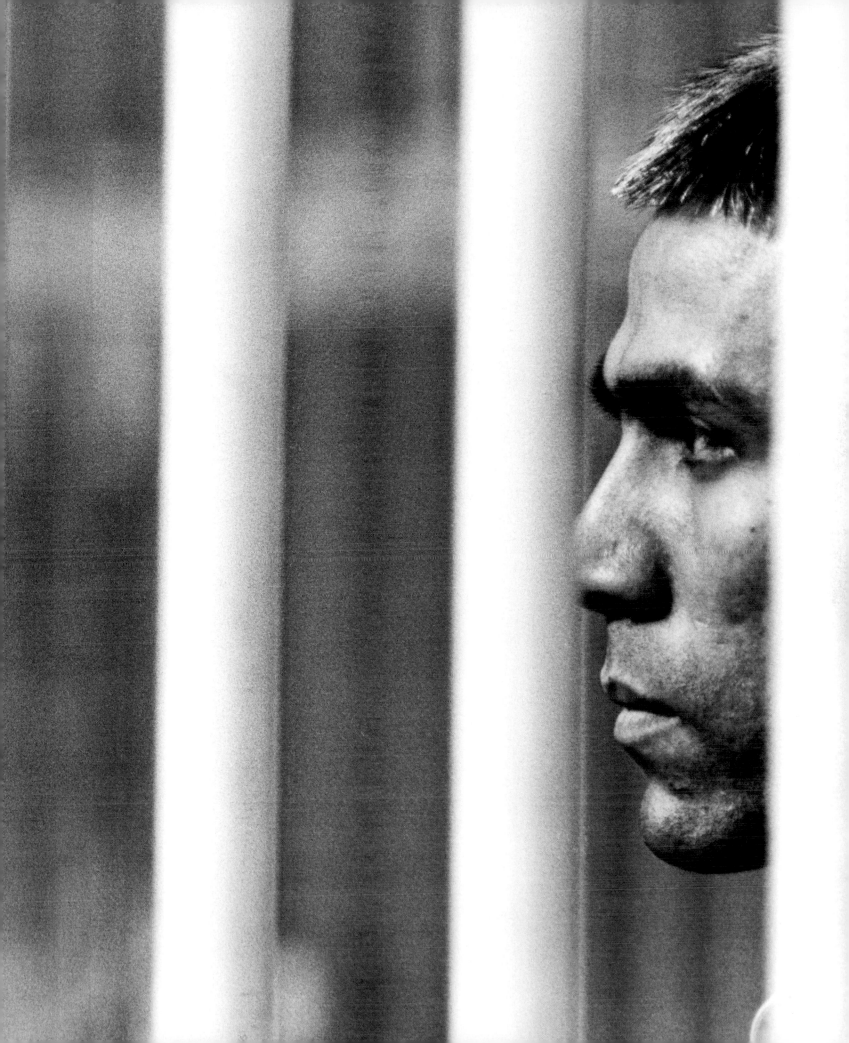

In 1986 the pope addressed a coed group of Scouts at a celebration of World Youth Day in Abruzzo, Italy. During many of his pilgrimages around the world, he held youth-only ministries. For parents and their children, he saw love as the essential ingredient in education: "The parents' love turns from being source into soul, thence into norm, inspiring and guiding the whole of the concrete work of education, and enriching it with those values of gentleness, constance, goodness, service, disinterestedness, spirit of sacrifice, which are the most precious fruit of love."

92 was sentenced to life in prison, that the little nun grabbed him: His clients had other shooters in the square, assigned to take him out should he elude the police.

The pope's sturdy constitution served him well, and his convalescence from a grave condition was relatively quick, though at one point he suffered an infection that nearly killed him. By fall he was back on the job, issuing his third encyclical, Laborem Exercens ("On Human Work"), which dealt with the rights of laborers. Soon thereafter, martial law was imposed in Poland. Solidarity went underground as thousands, Walesa included, were arrested.

What, really, were the relationships between the Vatican, the United States, the Soviet Union, the Polish state and the Polish insurrection? Complicated, certainly, not always what they seemed.

And what was John Paul's impact on the fall of communism? Hard to measure.

Some papal historians have sketched a "holy alliance" between the pope and Ronald Reagan to bring down the U.S.S.R. Certainly Reagan and the pope shared the opinion that Moscow's rule was unjust and antireligious. And certainly the two had a talking relationship: In 1982 the President visited the pope, leading to the reestablishment of full

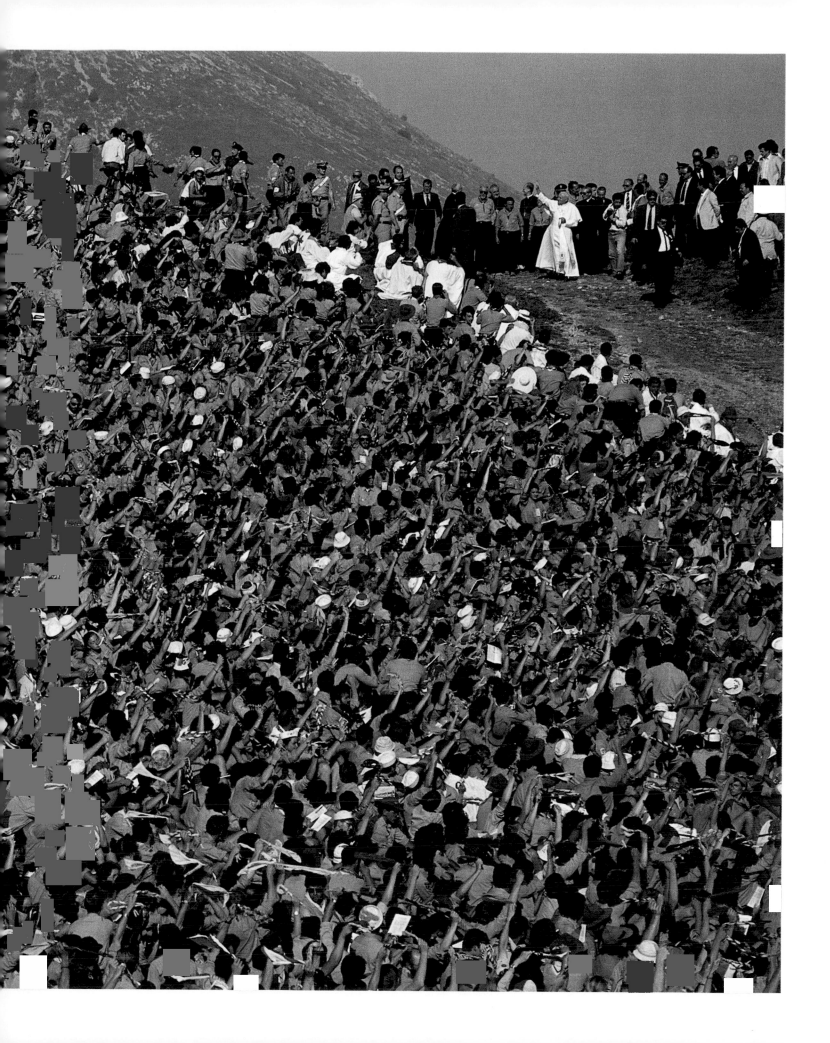

In the Vatican, John Paul's morning
ritual included rising at 5:30, a
bit of exercise and then seven a.m.
Mass in his private chapel.
Sometimes, guests would be invited,
having received a phone call a
few days before: "This is Monsignor
Stanislaw, the pope's private
secretary. Would you please be at
the Bronze Gate at 5:30 a.m.?"
Here, a youth group in costume
filed into the chapel as the pope
continued his prayers just before
saying Mass.

94 diplomatic relations between the U.S. and the
Vatican (suspended in 1867 when Congress
voted against funds for a Vatican ambassador).
Undoubtedly the two men discussed Walesa,
Solidarity and Moscow, but that they might
have hatched a plot—devised a strategy—to
bring down communism seems far-fetched.

Tad Szulc, a friend of the pope's as well as
his biographer, pointed to a more inscrutable
relationship. This was between the pontiff and
the communist chief in Poland, General
Wojciech Jaruzelski. Szulc wrote that when
Jaruzelski cracked down on Solidarity, he did
so because 1) extremists had gained control of
the movement and civil war loomed, and 2)
the U.S.S.R. was threatening to take over the
country. Jaruzelski saw his action as the least
of three evils, and according to Szulc, the pope
agreed with him. Even as the U.S., clearly
unaware of the shared sentiments between
those two men, hammered Jaruzelski with
economic sanctions, the pope was writing to
Warsaw and suggesting that, yes, this policy
might be the best way. Szulc wrote that John
Paul and Jaruzelski developed "a very special
and subtle relationship that at the end of the
decade would render possible the historical
transition from communism to democracy."

Where does John Paul's relationship with
Lech Walesa fit into all this? Not to mention
his relationship with Mikhail Gorbachev?

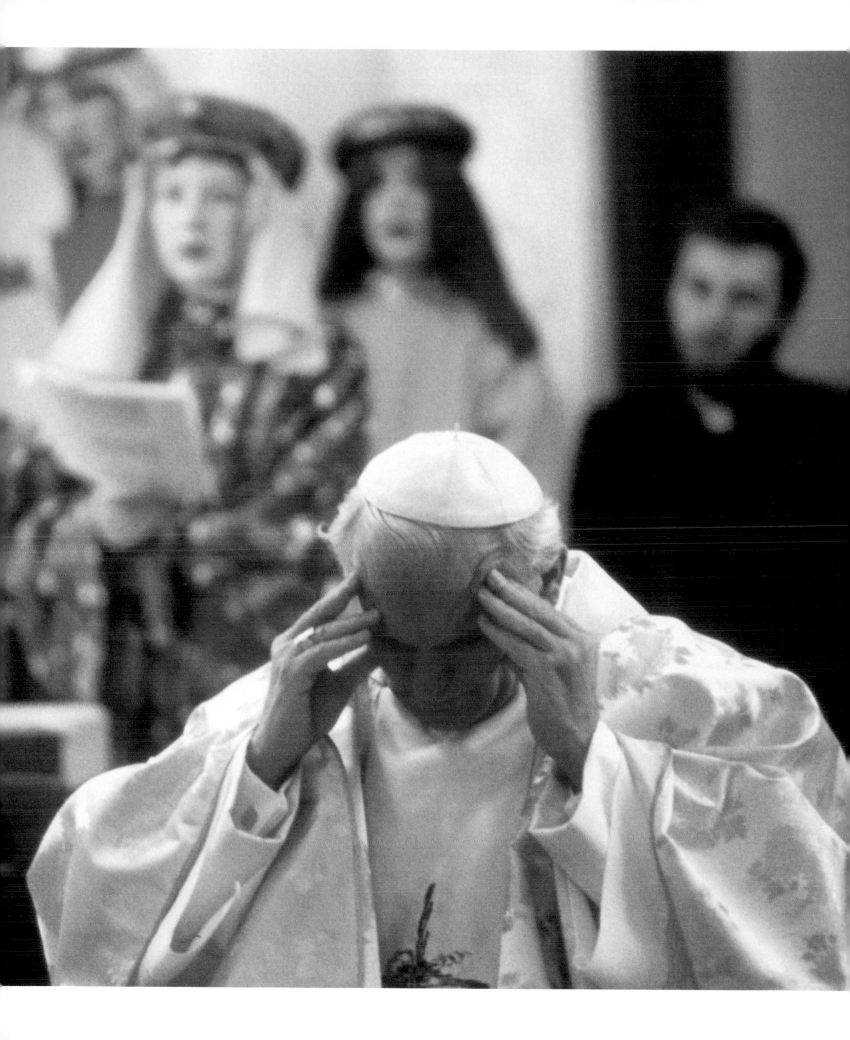

Left: The pope visited the shrine at Lourdes, France, where in 1858 an apparition of the Virgin Mary was seen by a 14-year-old girl. Right: In the top right corner of every page he wrote, John Paul inscribed his papal motto, *Totus tuus* ("All yours"—referring to Mary). The mother of Christ is important to greater or lesser degrees in various Catholic cultures, but she is a dominant figure in Poland. When he survived Agca's bullets and when communism fell, the pope credited Mary.

96

They were forged on the run. As he took to traveling again, heading, for instance, to Great Britain to see the Archbishop of Canterbury, John Paul kept track of events in Poland and elsewhere in Eastern Europe. Leonid Brezhnev died and Jaruzelski announced the suspension of martial law and the release of Walesa. John Paul, during his 1983 pilgrimage to Poland, visited with Jaruzelski in Warsaw. ("An astonishing feeling of liking and trust soon developed between them," wrote Szulc. "Their meeting . . . marked a major turning point in Poland's postwar history.") In 1985 the pope received extraordinary visitors at the Vatican: Israeli Prime Minister Shimon Peres, only the second head of Israel to meet a pope, and Soviet Foreign Minister Andrei Gromyko. It was said that John Paul and Gromyko discussed the fate and future of Catholicism in the U.S.S.R., but whatever the gist, Gromyko was gone shortly thereafter when Gorbachev was chosen his country's leader.

The pope visited India, Colombia, France, Bangladesh, Singapore, Fiji, New Zealand, Australia, the Seychelles . . .

The clock was ticking in Eastern Europe. Jaruzelski met the pope at the Vatican on January 13, 1987, told the pope what kind of man Gorbachev was and said he had told

Gorbachev about the pope. Szulc wrote that it was ultimately a "John Paul II-Jaruzelski-Gorbachev Triangle" that led to communism's demise in Poland.

In 1988 the pope made his 37th foreign trip and his ninth to Latin America, visiting Peru, Uruguay, Bolivia and Paraguay. He went back to Africa for a fourth time, visiting Zimbabwe, Botswana, Swaziland, Lesotho . . .

And he talked with Gorbachev, all but confessing the man. These two communists, Jaruzelski and Gorbachev, were neither soft nor ready to be co-opted, but they were different and their societies were evolving—out of failure, surely, but evolving nonetheless. John Paul offered a kind of dignity as communism faced eclipse. A way out.

In 1989, even as 163 eminent Catholic theologians were criticizing him for "authoritarianism" in his dealings with his own Church and its laypeople, John Paul looked on proudly as Poland held its first free elections since 1938. Solidarity candidates won overwhelmingly, and Walesa rose. Diplomatic relations were established between Warsaw and the Vatican. By year's end, walls everywhere were tumbling.

And the pope was on his way to Madagascar, Zambia, Malawi and a French island named Réunion . . .

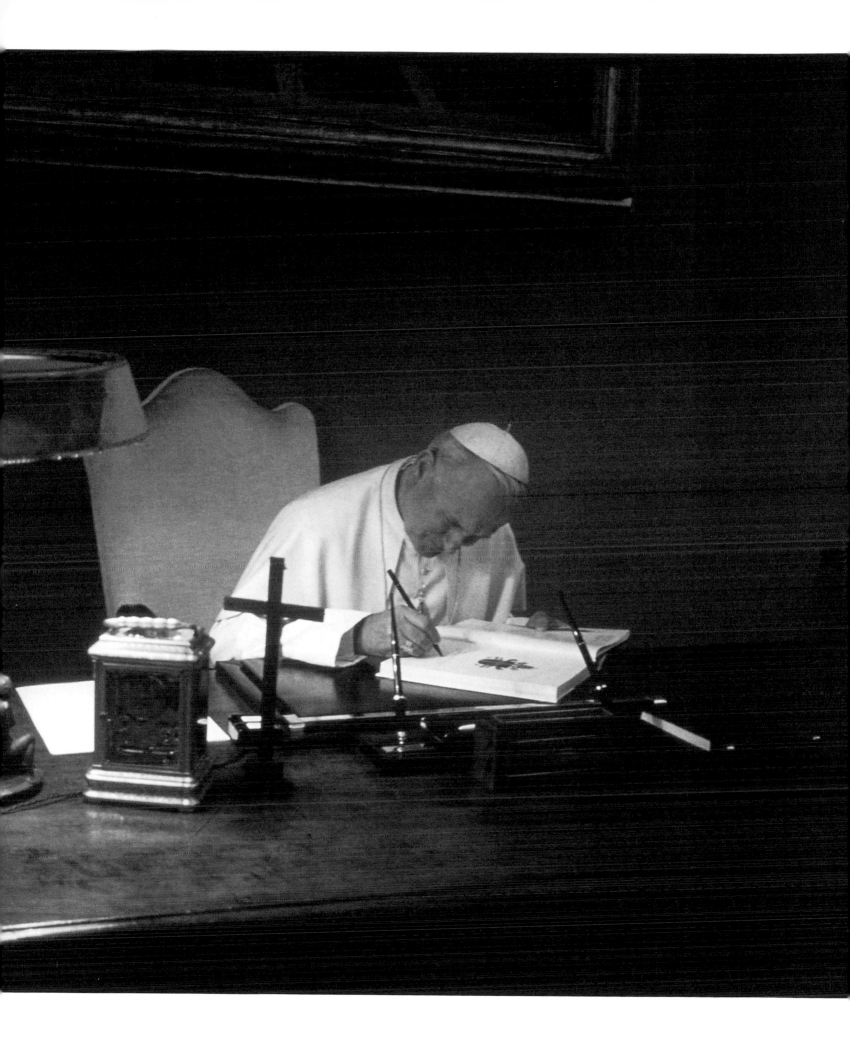

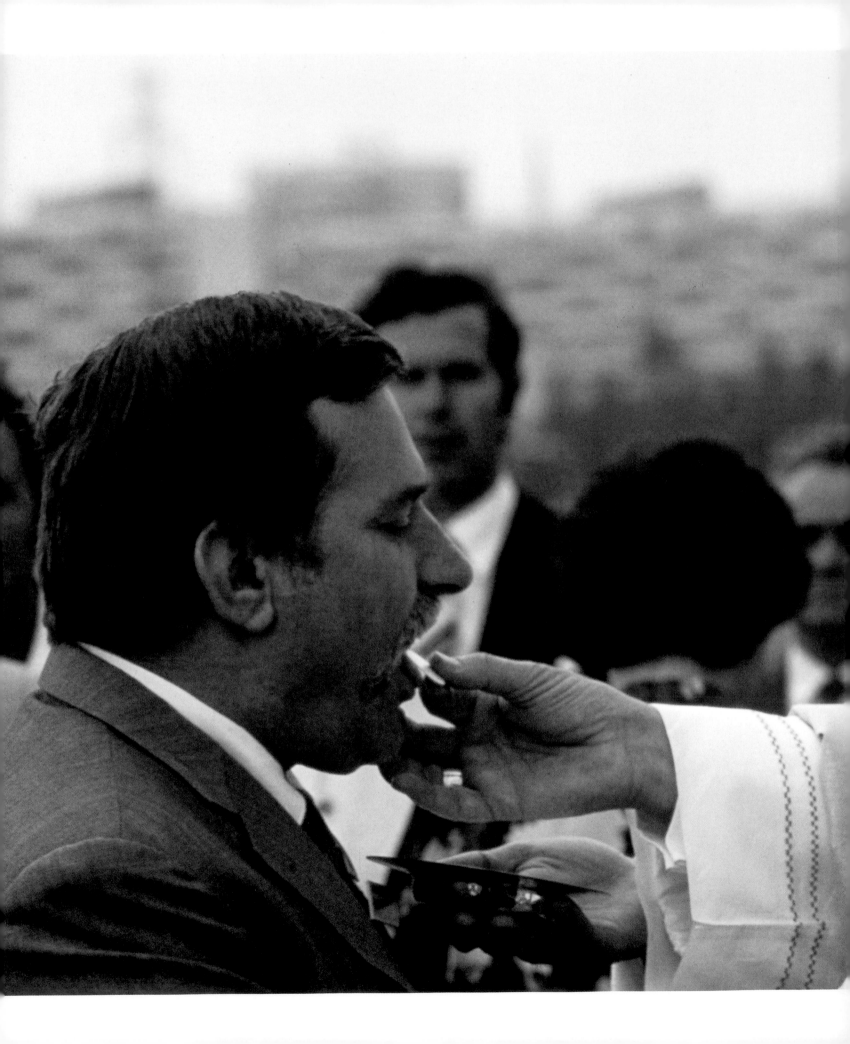

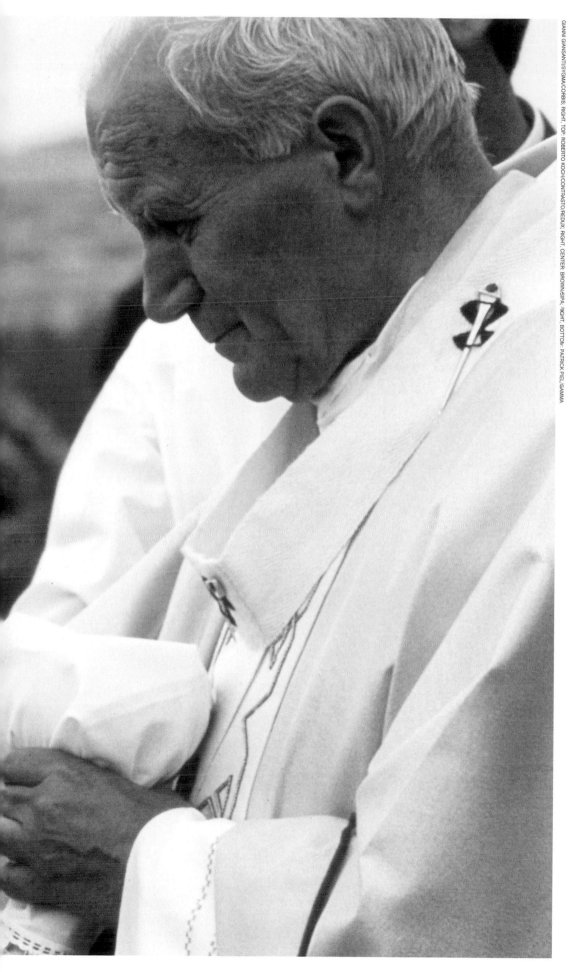

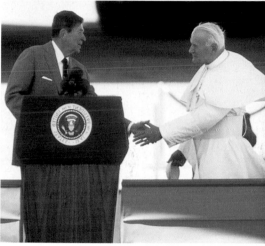

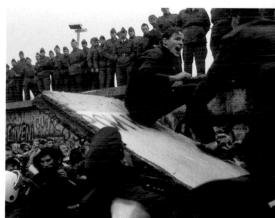

Left: Walesa received moral support—and, in 1987, Holy Communion—from the pope. Top: Gorbachev's U.S.S.R. unraveled as unrest in Poland spread across Eastern Europe. Above: Reagan's anticommunist crusade benefited from John Paul's support of Polish workers. Below: The Berlin Wall fell in 1989. Gorbachev said the demise of the communist bloc would not have been possible without John Paul.

99

Convergences

Let's all dress up as soccer players," a cardinal was heard to remark in the reign of Pius XII (1939–1958). "Then we'll certainly be received [by the Holy Father] right away." Early accounts of meetings with popes tell of such figures as the six-year-old English prince who would become King Alfred the Great being received by Benedict III in 855, and the Scottish warlord Macbeth by the sainted Leo IX in the 1050s. Recent popes, however, have been open not just to princes and chieftains but also to prison inmates, firefighters and celebrities of various persuasions. A few colorful encounters down the ages:

LEO I (440–461) and ATTILA THE HUN History does not record what Leo said to Attila when he and the invader met near Mantua in 452, but it does record that as a result of the encounter, Attila, "the Scourge of God," as he became known, left Italy, thus sparing Rome and the Holy See. Leo was not the only prelate to disarm the notorious military leader. The French Bishop Lupus of Troyes managed to persuade him to spare the province of Champagne. "I can conquer men," Attila is supposed to have said, "but not the lion and the wolf." *Leo* is Latin for lion; *lupus* is Latin for wolf.

JULIUS II (1503–1513) and MICHELANGELO Top right: The notoriously bad tempered Julius II (Il Papa Terribile, as

some of his contemporaries referred to him) liked to visit the utterly unsociable Michelangelo ("Lonely as a hangman," Raphael said of him) while the Florentine genius was painting the ceiling of the Sistine Chapel. Once, joining the artist on the scaffolding, the pope inquired as to when he would finish. "When I can," said Michelangelo. The pope seized on

the opportunity to live up to his name, asking, "Would you care to be thrown off the scaffold?"

PIUS XII (1939–1958) and CLARK GABLE To anyone familiar with the mien of Pius, it surely amazes that the austere-looking pope was a movie buff. Yet such was his esteem for Clark Gable that the pope kept another visitor waiting for two hours while he talked with the King of

Hollywood. Whether Pius's subsequent caller showed any impatience while he cooled his heels is not recorded, but it is unlikely: He was the much loved Bishop Angelo Giuseppe Roncalli, later Pope John XXIII.

PAUL VI (1963–1978) and GRAHAM GREENE Paul's regard for Greene took the theologically unorthodox writer by surprise, since several of his novels had

Saints and Blesseds

John Paul II made canonizations and beatifications a hallmark of his papacy. By the end of the century, he had created hundreds of saints and nearly a thousand "blesseds," an astonishing number, given that only 302 saints and just 2,000-odd blesseds were acknowledged in the previous 400 years. From John Paul's roster, five stand out, three because of the celebrity—or notoriety—that has accrued to their names and two because they were victims of the tyrannies that have haunted what John Paul, with sublime understatement, called "this difficult century."

JUAN DIEGO (1474–1548) Diego is the hero of a famous tradition in Guadalupe, Mexico, in which the Virgin Mary is said to have appeared to the Aztec (or Chichimec) layman and to have left her image miraculously imprinted on his cloak as evidence for doubters. Diego's beatification in 1990 helped John Paul achieve two goals: to promote devotion to Mary and also to demonstrate—by honoring different ethnic traditions—that the Church is catholic as well as Catholic.

PADRE PIO (1887–1968) Even while he lived, Francesco Forgione (above) was the object of a flourishing cult. In 1918 he was said to have received the stigmata—that is, wounds identical to those of Christ on the cross. Other stories told of his power of healing and of his ability to be in two places at once. But some Church authorities were unimpressed, and for several years before World War II the Vatican forbade him to say Mass publicly or hear confessions. Nevertheless, the young Father Karol Wojtyla visited Padre Pio in 1947 (after the ban had been lifted); according to one report, the friar told his guest that he would hold "the highest post in the Church." Padre Pio was beatified in 1999.

TITUS BRANDSMA (1881–1942) In 1935 this Dutch Carmelite, dubbed by the Nazis "the dangerous little friar," stated bluntly that Catholic papers could not in good conscience publish Nazi propaganda, an affront for which the Germans sent him to Dachau following their occupation of the Netherlands. "They who want to win the world for Christ must have the courage to come into conflict with it," said Titus. This uncomfortable conviction cost him his life. He was killed by lethal injection on July 16, 1942, and beatified in 1985.

EDITH STEIN (1891–1942) A Carmelite nun who converted to Catholicism in 1922, Sister Teresa Benedicta of the Cross (below) was the daughter of a Jewish family in Breslau, Germany. Sent by her order to Holland in 1938, she was arrested in 1942 by the Gestapo and deported to Auschwitz, where she soon perished in the gas chamber. Her beatification (in 1987) and canonization (in 1998) were resented by some Jewish critics who

been banned by the Church, as Greene pointed out to the pope at their audience (left). Paul was apparently unperturbed and told Greene he had recommended his work to Pius XII. Pius, unknown perhaps to Paul, had not been enthusiastic and told Father John Heenan (later Cardinal Archbishop of Westminster), "I think this man is in trouble. If ever he comes to you, you must listen."

claimed it was her Jewish origins, not her Catholic faith, that led to her death. One of her nephews, however, told *Time* magazine that her recognition by Rome was "a spiritual monument to all those killed by the Nazis."

JOSEMARÍA ESCRIVÁ DE BALAGUER (1902–1975) Escrivá was the founder of Opus Dei, an institute designed to induce laypeople to integrate spirituality with their everyday lives. Although Escrivá and his organization have been criticized by some Catholics who compare their methods to those of the Reverend Moon, John Paul's admiration was always staunch and demonstrative. In 1982 he made the institute a personal prelature, meaning that it was answerable not to local bishops but directly to the Supreme Pontiff, and in 1992 he raised Escrivá to the ranks of the blessed.

Toward Jubilee . . . And Sainthood

At the end of the second millennium, John Paul II was home again. Poles filled Pilsudski Square; it felt like 1979. But the issues were different. The pope had been calling, with increasing stridency, for reflection, atonement and a rejection of the "culture of death" that infested society. He had been urging his flock to prepare for the Jubilee Year 2000. The people wondered if they could change—or even wanted to. A woman, standing where she had 20 years ago, looked back: "Everybody thought of freedom when he spoke. We were so joyful. Now there is freedom, and many think only about their own business. We need to think about the poor. We need to use our freedom to understand each other better."

As John Paul entered his third decade as pope, leading his Church toward the Jubilee Year 2000, the beginning of Catholicism's third millennium, his papal tenure was already longer than all but 10 other popes'. He had traveled 670,878 miles as pontiff; he had made 84 pilgrimages abroad and 134 pastoral trips inside Italy, not to mention 700 visits within the diocese of Rome; he had written 13 encyclicals, 45 apostolic letters and constitutions, 14 epistles, nine exhortations, more than 600 formal speeches and countless sermons (theological teachings that, bound, covered 10 feet of shelf space); he had held 877 general audiences in Rome, attended by nearly 14 million people, plus 15,000 private papal audiences, an average of five a day; he had canonized 280 new saints and beatified 798 other men and women; he had consecrated 2,650 bishops, more than half the world's total. And he was not done.

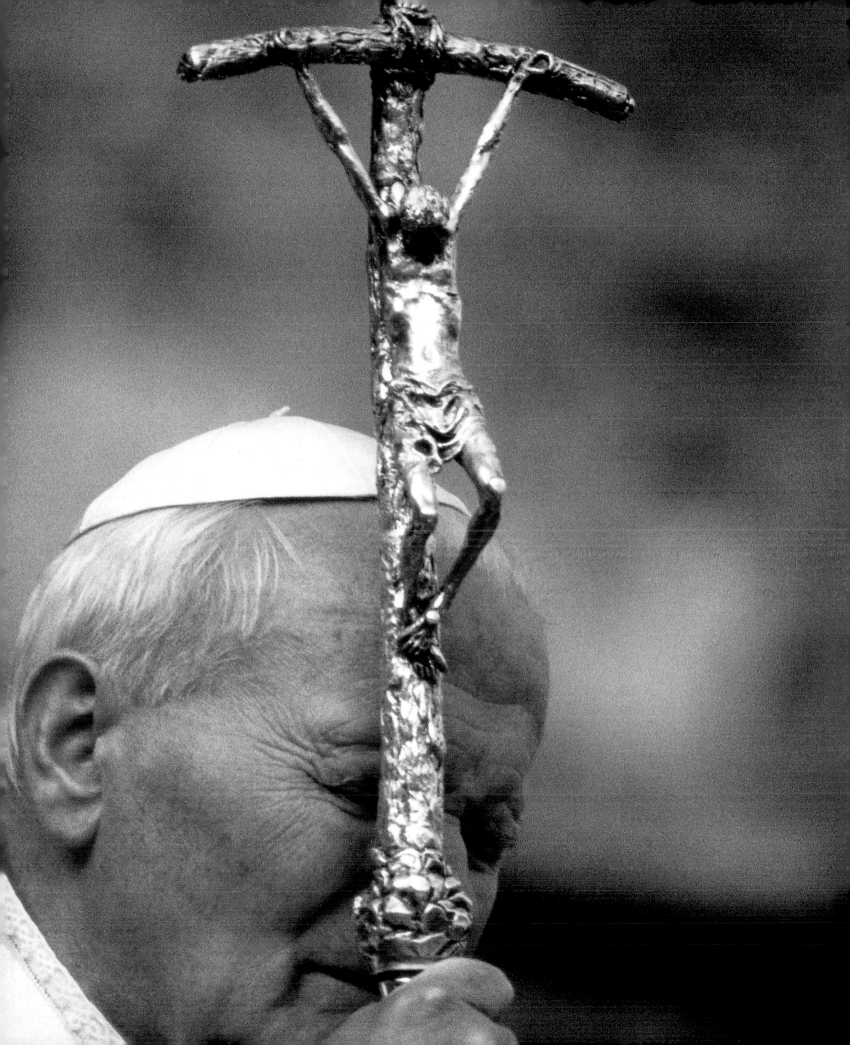

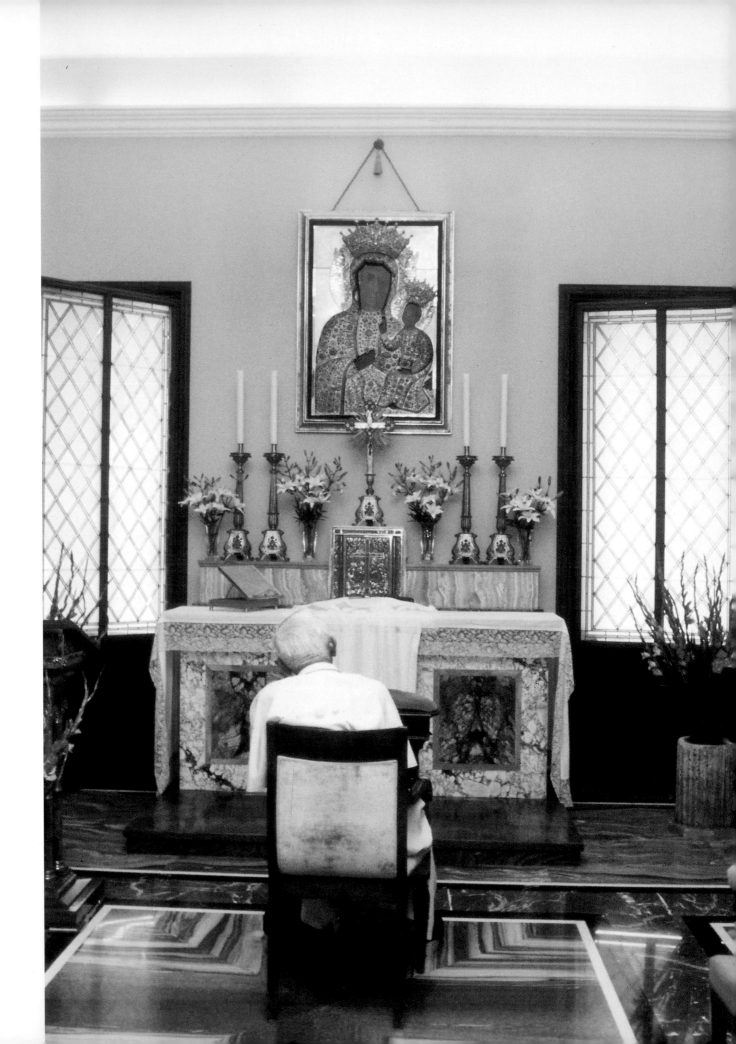

Each summer, John Paul went to the papal retreat at Castel Gandolfo, where he prayed daily in the chapel. Such sessions not only transported him spiritually but represented a trip home, as the portrait at the altar was a replica of Poland's Black Madonna. Poles believe the Virgin Mary saved their nation at a battle in Czestochowa during a Swedish invasion in 1655. Czestochowa, in our time, is an ancient city with a monastery at the summit of Jasna Gora—"the Luminous Mountain." In that monastery is the original icon of Mary, her face blackened by the years. Young Lolek Wojtyla was taken to the shrine in his boyhood. To John Paul and his countrymen, the Black Madonna is "Queen of Poland," defender of the country, symbol of the faith, a strong link between church and state. Following pages: On the pilgrim road in Santiago de Compostela, Spain, in 1989.

Pope John Paul II sometimes seemed, during the final decade of the 20th century, frustrated by his flock's lack of heed. They behaved as if they failed to understand the importance of the message, as if they just didn't get it. They worried whether the Sistine Chapel restorers had done a good job rather than whether abortion was immoral, whether euthanasia was murder.

The pope had a temper; this was always understood in the privacy of the papal apartments. Now he sometimes seemed angry in public—in a homily or in his published preachings. In June 1990 the Vatican told Catholic theologians that they were to stop quarreling with Church doctrine in public. The Vatican said that any Catholic philosopher unable to accept a certain doctrine should keep his views to himself. In June of the following year, speaking in Poland, he turned up the volume on the abortion debate in a way that couldn't be misread by his countrymen. Using a fierce metaphor, he equated abortion with the Nazi death camps: "That cemetery of the victims of human cruelty in our century is extended to include yet another vast cemetery, that of the unborn, of the defenseless whose faces even their own mothers had not seen."

Not just by word but by deed, he let people know where he stood. In May 1992 he did an extraordinary thing, beatifying Monsignor Josemaría Escrivá de Balaguer not even 17 years after his death. The pope was, of course, famous as a maker of saints: He had canonized hundreds and beatified hundreds more. But Escrivá, founder of the ultraconservative Opus Dei movement, a society of laymen whose goal was to steer Catholics away from liberalism and immorality, was a controversial figure, and his beatification was fraught with message. The pope was saying that Opus Dei, criticized as extreme by many within the Church, was sound on matters of doctrinal orthodoxy and discipline.

In the 1990s, the pope's conservatism sometimes hindered his crusades. The bridge-building between the Catholic and Anglican churches continued apace—even reunification seemed possible—until it became clear that there wouldn't be agreement on women priests. Polite words continued to be said about ecumenism, but progress was stopped.

In the U.S., the pope, whose allies included conservatives like John Cardinal O'Connor of New York and Bernard Cardinal Law of Boston, alienated progressives. As if to show who was who, whenever a bishopric opened in the U.S., Rome appointed a hard-line replacement. Edmund Szoka replaced John Dearden as Bishop of Detroit; Roger Mahony succeeded Timothy Manning in Los Angeles; Thomas Dailey (whose credo was, "You never say no to the Church") followed Francis Mugavero as Bishop of Brooklyn, the nation's largest diocese. Writing about the Dailey appointment in a *New York Times* op-ed piece, Father Richard P. McBrien, chairman of Notre Dame's theology department, said, "The Vatican's pattern of episcopal appointments is lowering the morale of the church's most engaged and effective priests, nuns and lay members, many of whom are edging to the conclusion that the church's present leadership is irrelevant, if not even inimical, to their deepest religious and human concerns."

One whose morale was lowered was Father Andrew Greeley, the sociologist and novelist from Chicago. In 1996 he complained in LIFE that John Paul "visits Mary shrines but says women can't be priests. He's an Eastern European romantic intellectual. They operate under different logical rules than North American persons like me."

As Greeley's and even McBrien's tone implied, criticism from within was pointed but cordial. John Paul's hard work, honesty and forthrightness had brought credibility and respect, even from detractors. Moreover, as he became increasingly infirm, he garnered sympathy. Though the Vatican would never

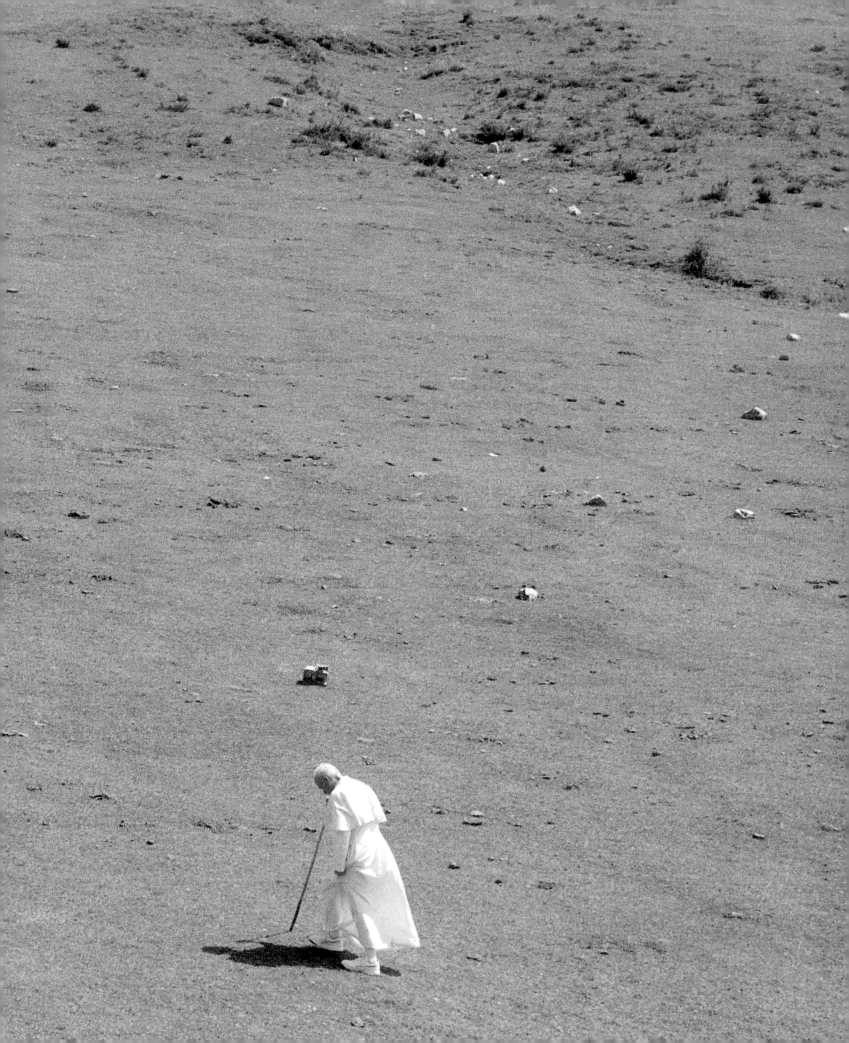

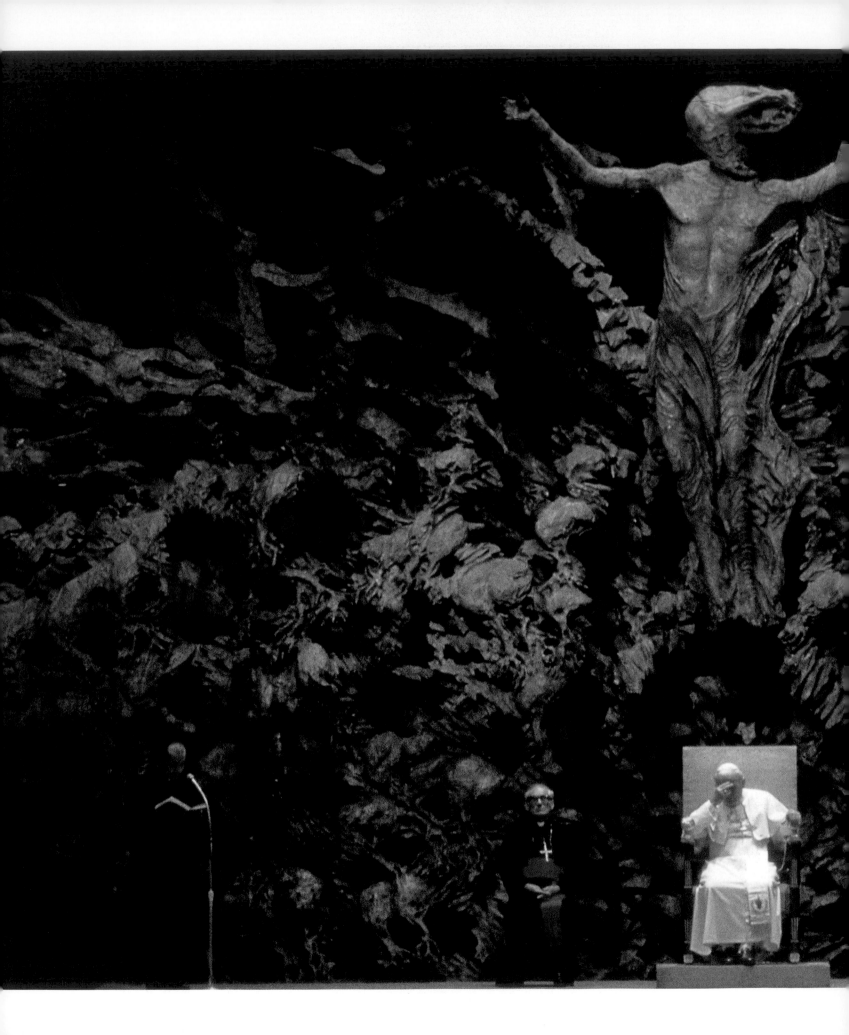

In 1994 the pope presided at a general audience while flanked by bishops who were in Rome for a synod. During these every-Wednesday appearances in the Vatican's modern Nervi Hall (named for its architect), the pope would appear before Pericle Fazzini's elaborate sculpture of Christ and greet 6,000 people in dozens of languages. He would then give a short speech on subjects ranging from current affairs to the devil—whatever was on his mind.

109

confirm it—they said it was aftershocks of the assassination attempt—the pope developed Parkinson's disease (or a related disorder). In the summer of '92 he was taken to the hospital after complaining of stomach pain. In a four-hour operation, his gallbladder was removed. A large precancerous tumor was also taken from his colon. In November 1993 he dislocated a shoulder after tripping on the hem of his robes.

Paradoxes developed. As he grew older, the pope grew increasingly stern and dogmatic; yet he was increasingly beloved. As he became increasingly emphatic about obedience, he was increasingly disobeyed. He's "the beloved grandfather, the one everyone dotes upon," said a Jesuit based in Rome in 1995. "But in the end, the children and grandchildren just go out and do what they want."

The world was evolving around him, not with him. In April 1997 the pope lamented that modern moral standards recalled "the epoch of the Roman Empire's decadence," and later that spring, in Warsaw, he challenged his homeland, which was debating the abortion issue. He condemned the practice anew and urged all Polish Catholics to join his side in the battle between "the civilization of life and the civilization of death . . . A nation which kills its own children is a nation without a future . . . A civilization which rejects the defenseless

Even as John Paul seemed
to harden in his opinions,
a very special tenderness
developed with his flock.
In 1998 he visited the
Piedmontese city of
Vercelli in northern Italy,
where he gave comfort
to the people and was
comforted in turn.

would deserve to be called a barbarian
civilization." He knew that with these words
he was venturing from the religious directly
into the political fray: "It was not easy for me
to say this, because I think about my nation,
about its future." Poland continued to debate
the issue, alternately loosening and tightening
restrictions on abortion.

John Paul's crusades did little to effect legal
change—in Poland, in Italy or elsewhere. In
America politicians paid their respects to the
pope, then continued to go their own way. In
one instance, in 1997, John Paul, Mother
Teresa and the Italian government took up the
case of convicted murderer Joseph Roger
O'Dell III, who was on Virginia's death row. On
July 23 the U.S. Supreme Court rejected a final
appeal. Virginia Gov. George Allen said one
last time that he would not be swayed by the
Vatican. At 9:16 p.m., O'Dell was put to death.

In the Republic of Ireland divorce was
legalized despite pleas from John Paul "to
reflect on the importance for society of the
indissoluble character of the marriage bond."
In Germany and Austria hundreds of
thousands of Catholics signed petitions urging
the Church to ordain women and to allow
priests to marry.

As John Paul's conservative voice grew
harsher, some Vatican regulars wondered

GRZEGORZ GALAZKA

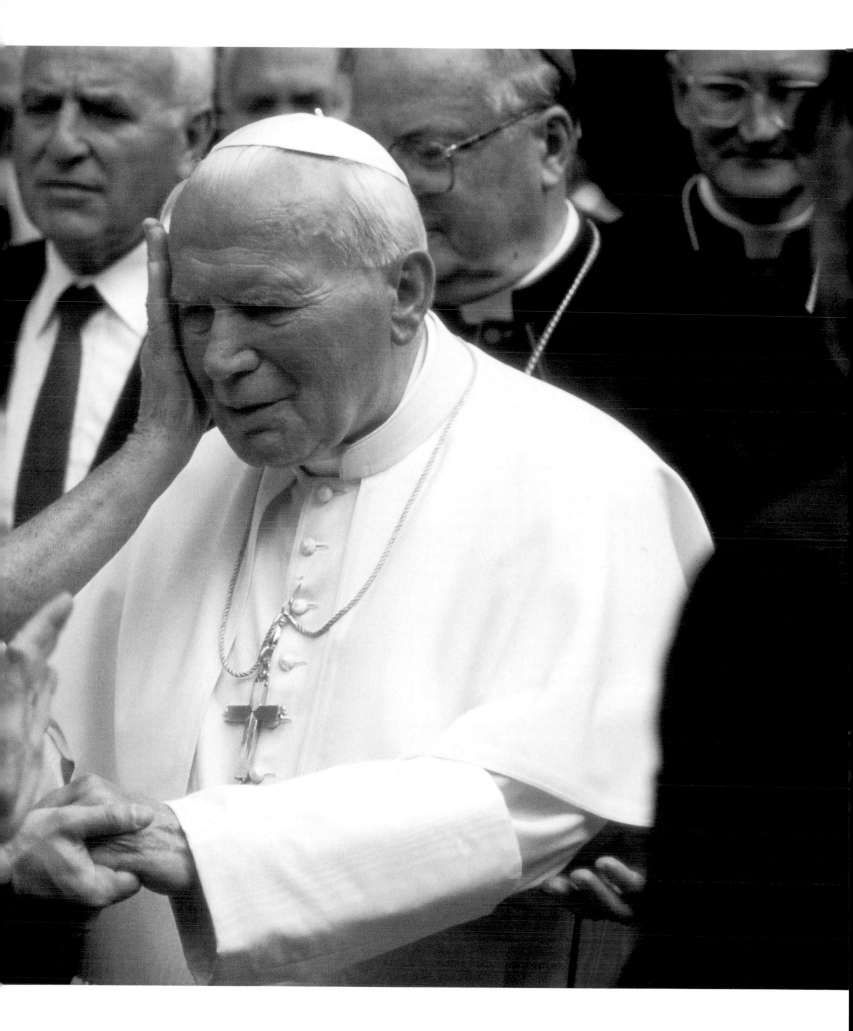

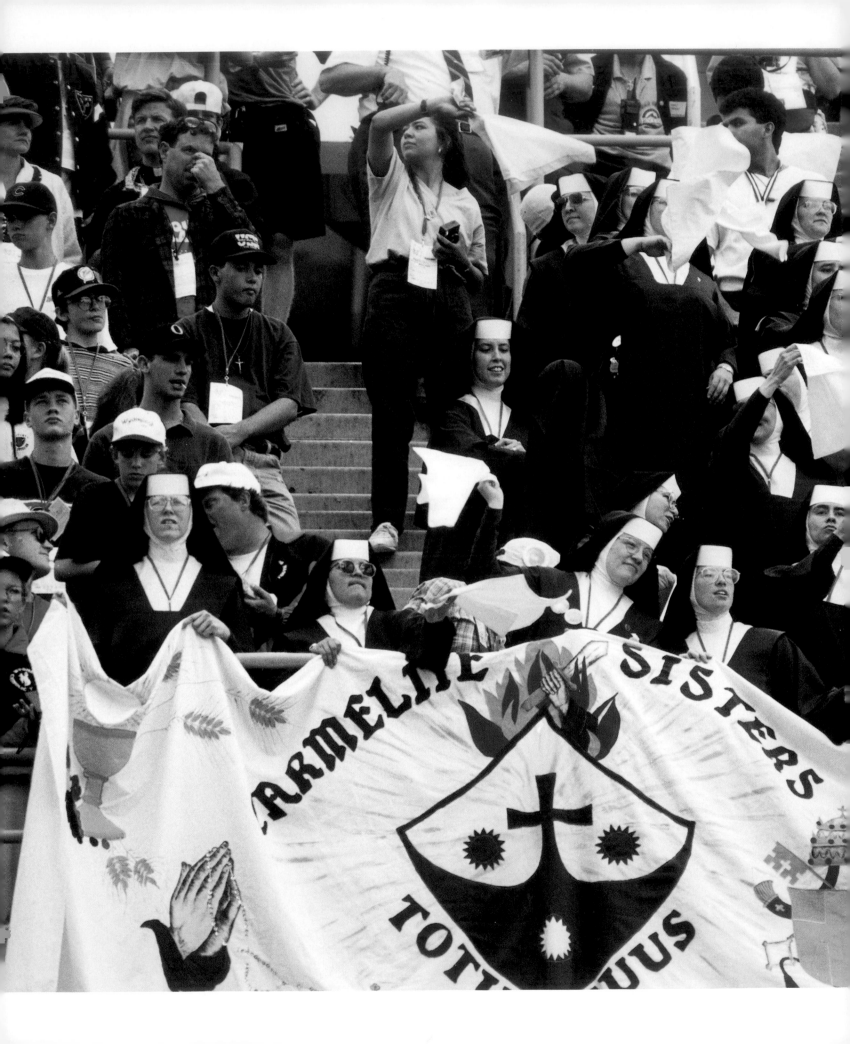

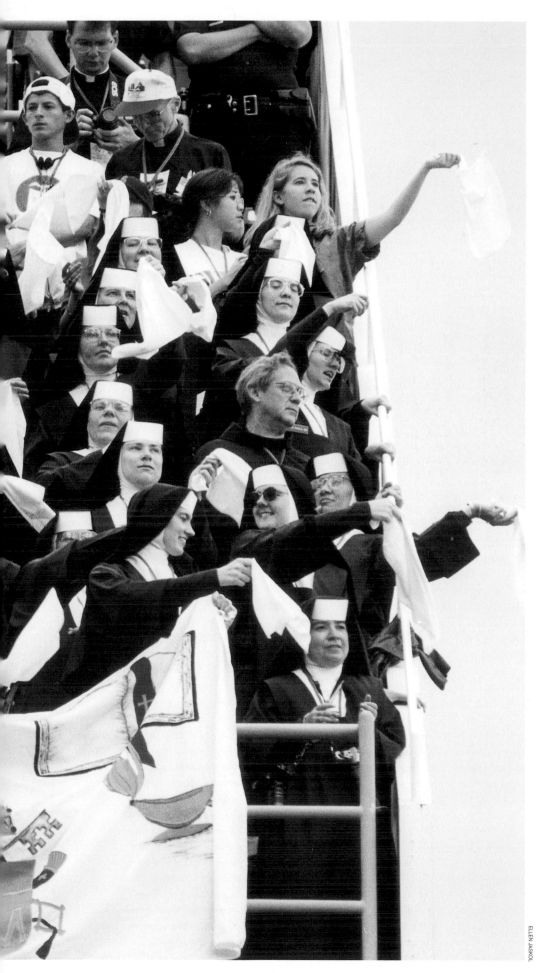

In 1993 these Carmelite nuns waved a banner with the pope's Marian motto (*Totus tuus*—"All yours") at a ceremony in Denver. The pope's visits to the U.S. in the 1990s were love fests. John Paul railed against abortion and birth control, of course, but everyone kept smiling. "All the great causes that are yours today will have meaning only to the extent that you guarantee the right to life and protect the human person," John Paul protested in one speech as President Bill Clinton stood alongside. Afterward, Clinton rated John Paul's "a great speech."

113

whom they were hearing, John Paul or his right-hand man, Joseph Cardinal Ratzinger. Their friendship dated to Vatican II, when they were young lions within the reform movement. Now, with the pope often appearing enfeebled, was his aide acting as pope? In 1995, Ratzinger decreed that John Paul's position on women priests was not just an opinion but was a dogma, and therefore "infallible." To some, Ratzinger was being presumptuous: Why not let the pope speak for himself? But shortly after Ratzinger issued his interpretation, John Paul sanctioned it. The partnership within the papacy was clearly a strong one.

The widespread disagreement with the pope on certain issues created, over time, an interesting dynamic. John Paul, who in the 1990s preached on the Internet, sometimes wrote with a felt-tipped pen and issued CDs of papal prayer, came to be seen as the world's great antimodernist—a reactionary to some, a visionary to others. "Only time will uncover the illusions and misunderstandings of modernization," the Vatican newspaper *L'Osservatore Romano* wrote. "All the popes of the contemporary age have had to walk in the mystery of pain and failure." John Paul certainly concurred with the sentiment.

"At the end of the day, when you look at this extraordinary life and you see all that he

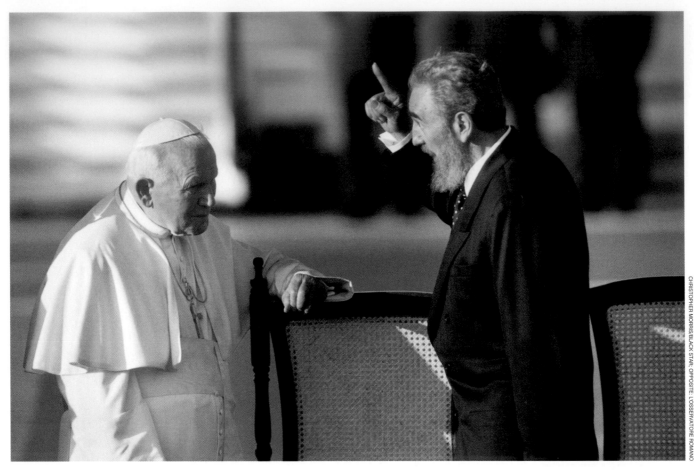

114 has accomplished, you're left with one very disturbing question," journalist Roberto Suro, who covered John Paul for *The New York Times,* told PBS during the filming of a September 1999 *Frontline* called *The Millennial Pope.* "On the one hand, the pope can seem this lonely, pessimistic figure . . . a man obsessed with the evils of the 20th century, a man convinced that humankind has lost its way . . . a man so dark and so despairing that he loses his audiences. That would make him a tragic figure. On the other hand, you have to ask: Is he a prophet? Did he come here with a message? Did he see something that many of us are missing? In that case, the tragedy is ours."

Indeed, all the pope's challenges and condemnations during the 1990s were invitations. The message was consistent: This is what we are missing. This is the way.

Battles of doctrine and dogma aside for a moment, the pope's great late-in-life crusade was not about just a few controversial issues. It was about faith and redemption, about what it takes to be good—to be God's children—about what it takes to coexist and about what was needed in terms of reflection, confession, atonement and forgiveness as the Church closed out its second millennium.

There were two centerpieces to John Paul's last campaign: There was a book, and a plan.

The book was published November 16, 1992, when the Church issued its massive new universal catechism, the first in more than four centuries. Completely overseen and partially written by John Paul, it reaffirmed traditional tenets of Catholicism while identifying a range of new sins, including tax evasion, drug abuse, mistreatment of immigrants, abuse of the environment, artificial insemination and genetic engineering. The historian Paul Johnson called the new *Catechism of the Catholic Church* "a masterpiece of doctrinal exposition," and it clearly expressed what the Church stood for and how it differed from other faiths. The book sold two million copies in 1994 when its English translation was published, and promised to be the foundation of the religion for decades if not centuries to come.

As for the plan, it involved preparations for the "Jubilee of the Millennium" in 2000. The drumbeat toward this great anniversary of Christ's birth began quietly—and curiously. On October 31, 1992, the pope said that the Roman Catholic Church had been wrong in condemning Galileo 359 years ago for asserting that the earth revolved around the sun. Yes, of course, the Church had realized much earlier that the great scientist had been correct in his analysis of natural events.

Three giants of the century: the saintly Mother Teresa, the despotic Fidel Castro and the highly spiritual, highly political John Paul II. Teresa, whose work among the poor won her the Nobel Peace Prize, suffered a heart attack during an audience with the pope in 1983. She nevertheless had the strength to attend Mass in St. Peter's in 1997 (opposite) but died that same year. In 1998 the pope ventured to Cuba, the last bastion of Moscow-style communism. Castro lectured John Paul, but the 77-year-old pontiff gave as good as he got: Cuba's 71-year-old pontificator subsequently loosened restrictions on the practice of religion. Following pages: Each year on Good Friday, the pope presided as the Stations of the Cross were said in Rome's Colosseum.

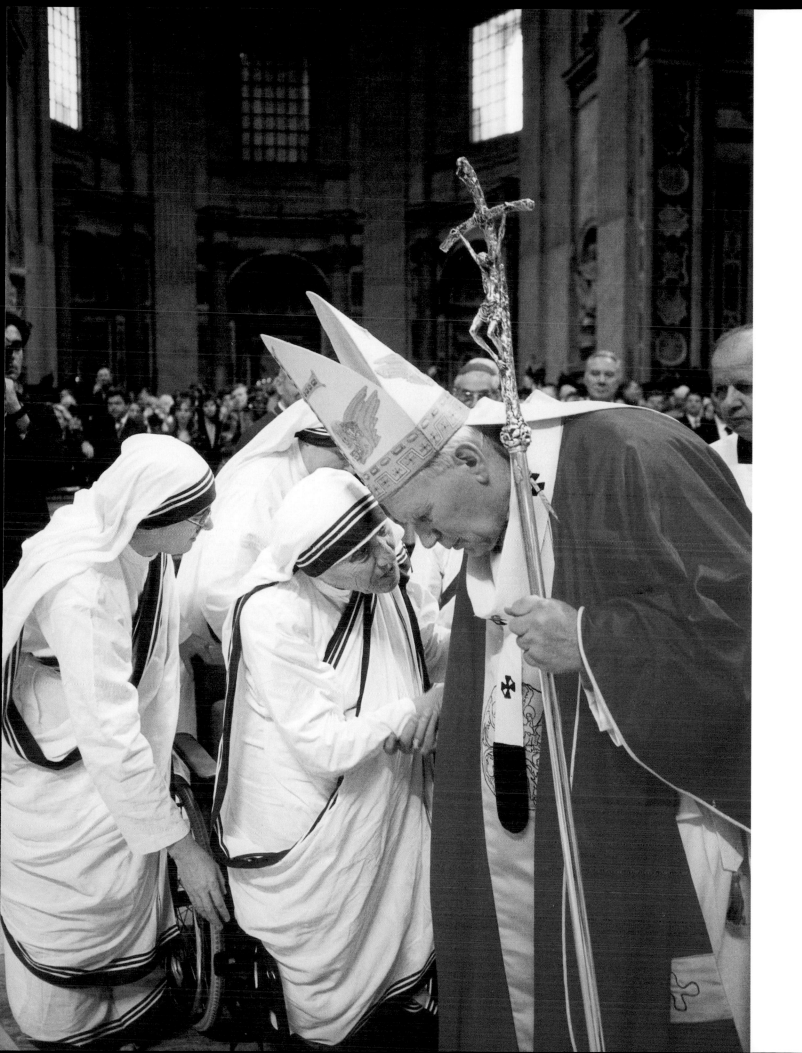

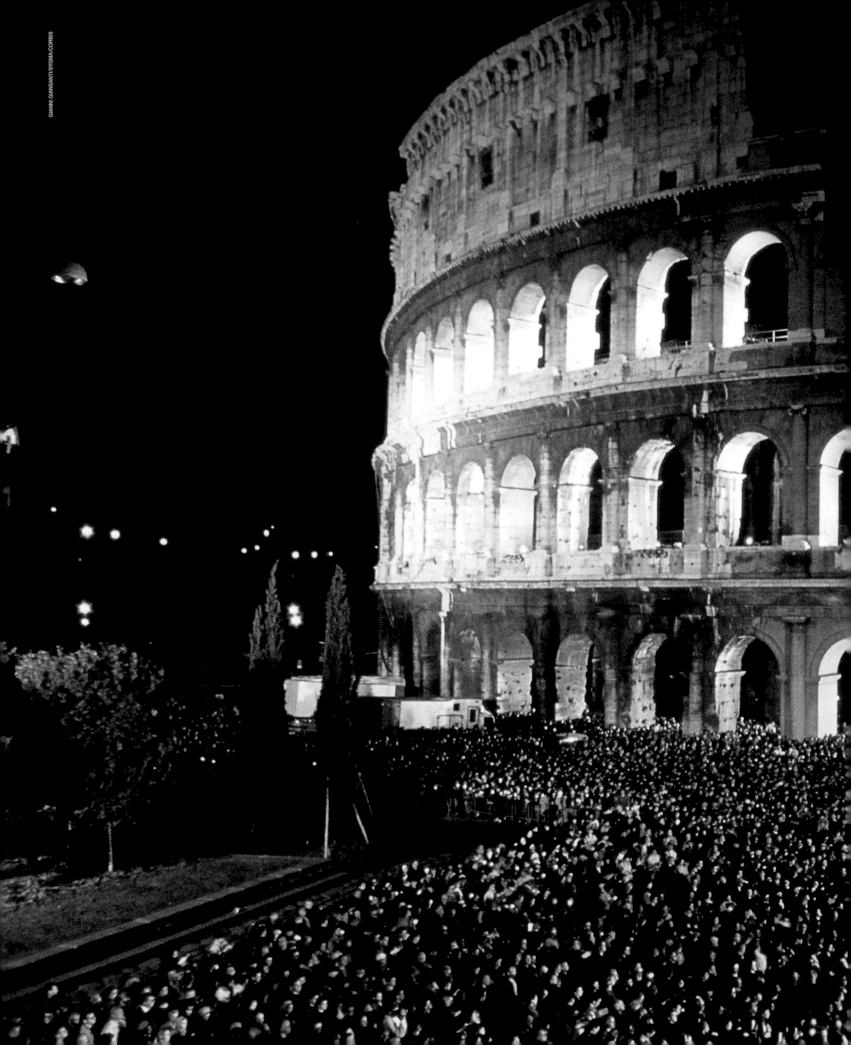

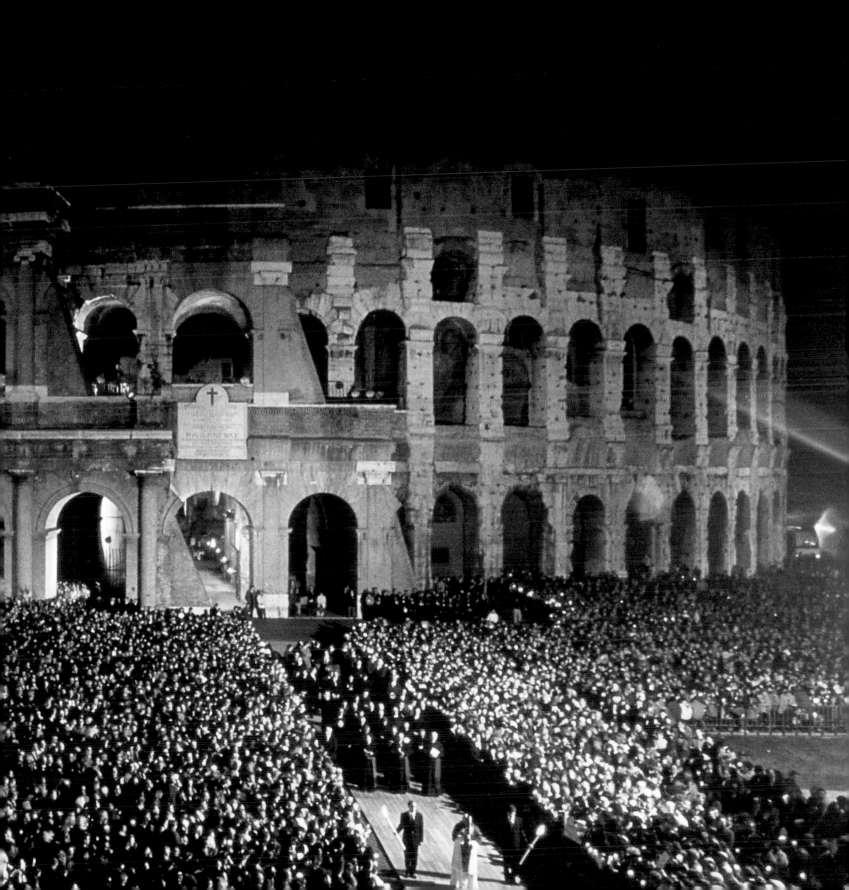

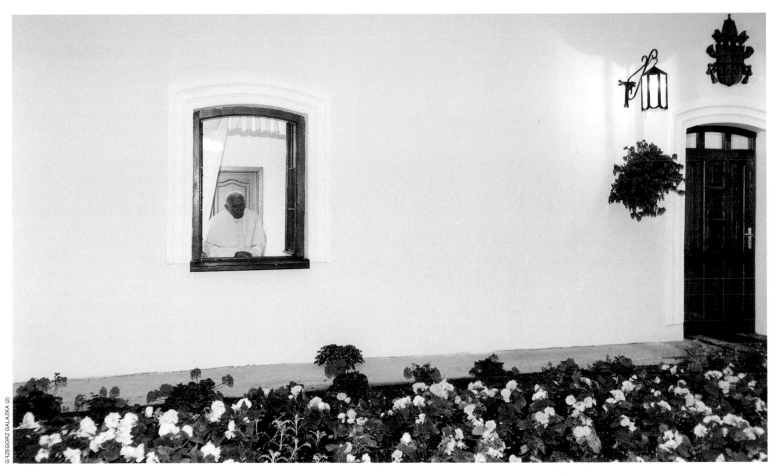

GRZEGORZ GALAZKA (2)

In the final year of the millennium, John Paul went home once more. Wearing a raincoat he had borrowed from a policeman, he took a boat ride across the lake at Wigry, Poland, where he stayed in a country cottage. The trip was one of warm reminiscence and some personal pain, as he watched many Poles march away from him down a secular path. Still, he could do nothing but love his native land. It was on this trip that he visited again the house at 7 Kościelna Street, where he observed: "People say that it's good everywhere, but it's best to be at home."

Nevertheless, John Paul was the first pope to acknowledge that the Vatican had been wrong.

This kind of thing—admission of error and begging forgiveness—was to be the soul of John Paul's call to Jubilee and then, his historic pilgrimage to the Holy Land in March 2000. In 1994 he sent a 27-page letter to his cardinals stating that religious wars waged by, or on behalf of, the Church had caused inexcusable violence and death. The Church, said John Paul in a subsequent apostolic letter, "cannot cross the threshold of the new millennium without encouraging her children to purify themselves, through repentance, of past errors."

In the late '90s, John Paul dug deep into his faith as well as his personal past and said the Church had not done all it could in the face of the Nazi evil. He fell short of criticizing the complacency—the complicity?—of Pope Pius XII. But that he addressed the issue at all, and in an apologetic tone, was a remarkable thing.

Remarkable, except to those who had known Karol Wojtyla. To these people, it was expected behavior, as was the pope's great, romantic, almost poetic hope that the Jubilee year might prove to be a time of global introspection, reconsideration and awakening.

If not for everyone, then for many Catholics—and surely for John Paul

himself—the Jubilee was precisely that.

What exactly is a Jubilee year, and why was the one begun on December 24, 1999, which lasted until January 6, 2001, termed the first-ever *Great* Jubilee?

The latter answer can surely be guessed: Although historians will tell you there's a 10-year window B.C. and A.D. in which the event itself happened, and that we will never know precisely when Jesus was born in Bethlehem (or perhaps, say some, Nazareth), this particular Christmas would mark, at least symbolically, the 2,000th anniversary of Christ's birth—and Christians would step forth into their third millennium. This would not be just any Jubilee, but the Great Jubilee—a Jubilee more attention-grabbing than all prior Jubilees.

Of which there had already been, in the Christian tradition, 27 (Pope Benedict XVI has subsequently called a 29th Jubilee, in 2008). Jubilees, as designated by the popes, are not simply 50- or 100- or 1,000-year anniversaries; they are not just big birthday parties for Jesus. Their purpose, as first delineated for Christians by Pope Boniface VIII when he convoked a holy year in 1300, is to encourage the faithful to pause, reflect, rejoice, remit and be pardoned. This thinking is based upon the biblical (which is to say,

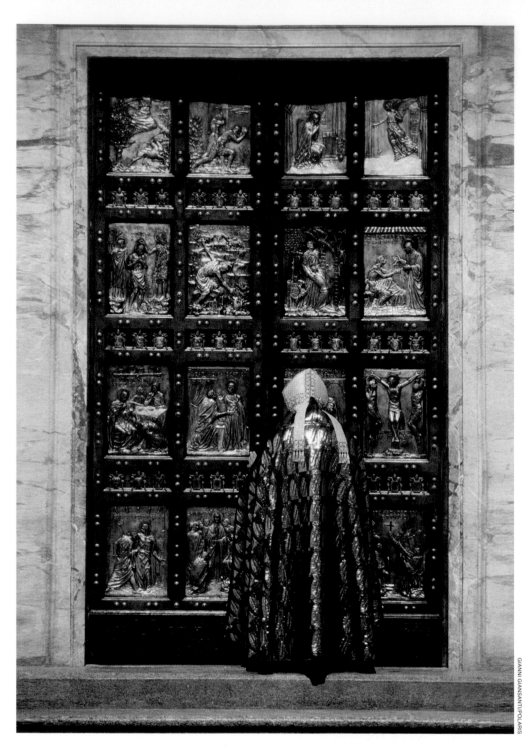

120

Shortly before midnight Mass on Christmas Eve, 1999, John Paul II, wearing his cope of many colors, approached the Holy Door of St. Peter's Basilica as prayers were said, hymns were sung and blasts were blown from horns fashioned out of the tusks of African elephants. He pushed on the doors and they were drawn open by assistants on the other side. He went to his knees and said his first prayers of the Great Jubilee year he had so eagerly anticipated. The symbolic significance of the Holy Door ritual may allude to a penitent seeking safe harbor within the Church, or to the expulsion of Adam and Eve from Eden and the subsequent redemption offered to all of humanity by Jesus' sacrifice.

Mosaic, or Jewish) tradition of Jubilee, which indeed asked for such a pause every 50th year to bring families together, free slaves and forgive debts. (A footnote from the Great Jubilee: The Irish rock star and humanitarian Bono, of the band U2, seized upon the economic aspects of the ancient rules of Jubilee, and asked the governments and banks to reconsider and forgive third-world debt. John Paul II had no problem with Bono's initiative.)

Through the centuries, Jubilees were decreed at regular intervals or in times of "need." In the 20th century Pope Pius XI

called two (in 1925 and 1933) and his successor, Pius XII, called one in 1950; Paul VI celebrated a Jubilee in 1975, and then John Paul II decreed a prior one in 1983 before the Great Jubilee—which certainly fell at an interval and at a time of great need for not only his flock but the global community.

The pope pointedly said that this was about the whole wide world; the Great Jubilee would be an ultimate showcase for his lifelong advocacy of ecumenism, even unto including his own historic and emotional pilgrimage to the Holy Land. He had already made that apology in the lead-up to Jubilee, and in his

apostolic letter, "As the Third Millennium Approaches," he invited Protestant denominations and the orthodoxies to join Catholics in the coming celebration (several of their leaders, including the Archbishop of Canterbury, would do so literally in Rome to launch the Jubilee). And then, on Christmas Eve 1999, he opened the Holy Door.

There are four patriarchal basilicas in Rome, the best known of which is St. Peter's Basilica at the Vatican, and each of them has a Holy Door, which remains firmly sealed between Jubilees but is thrown open during the Holy Year to allow pilgrims to

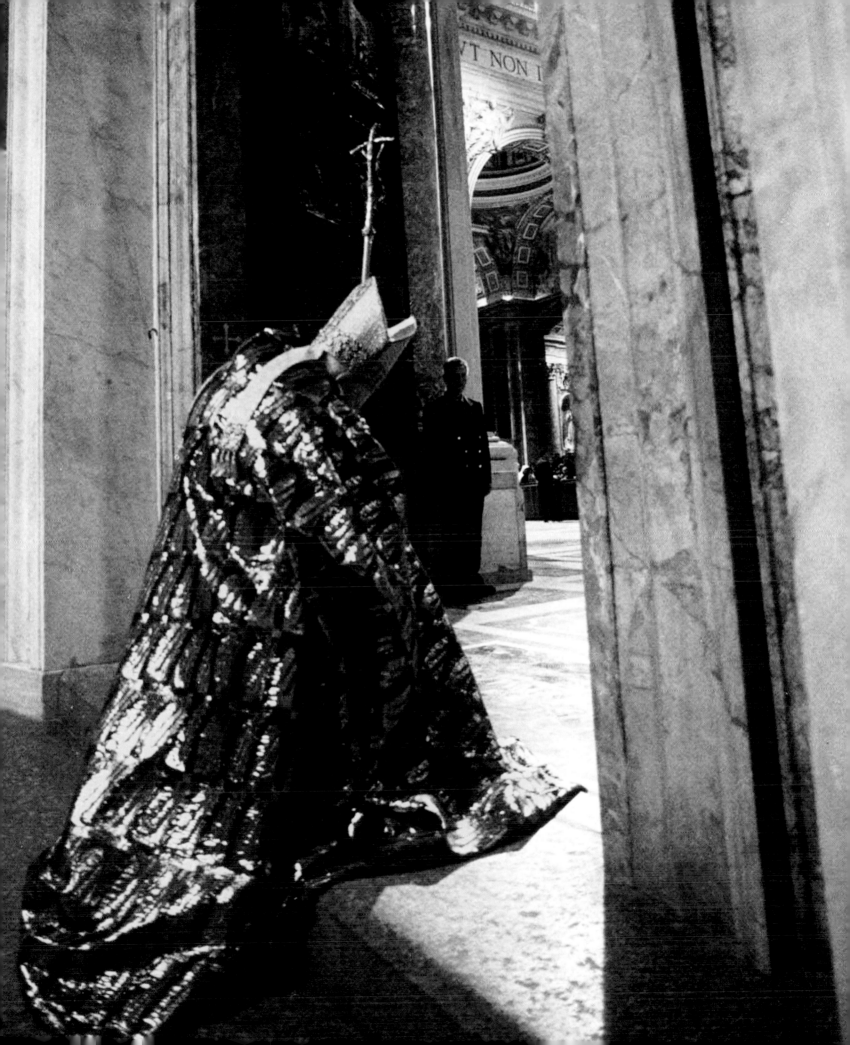

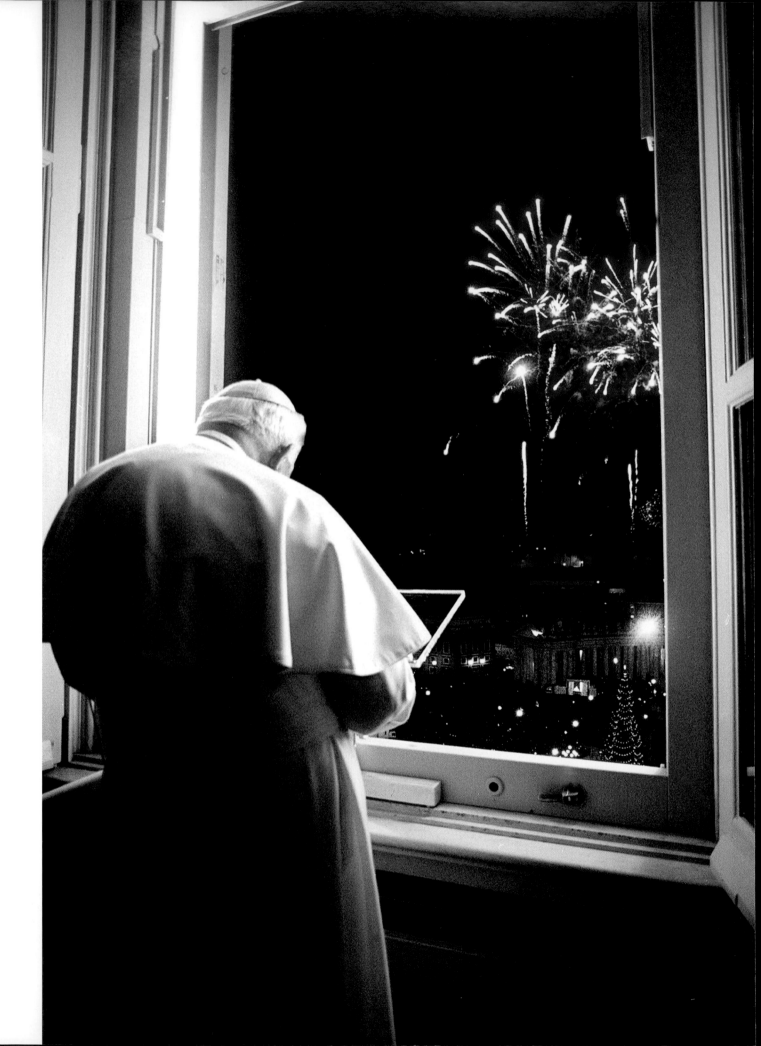

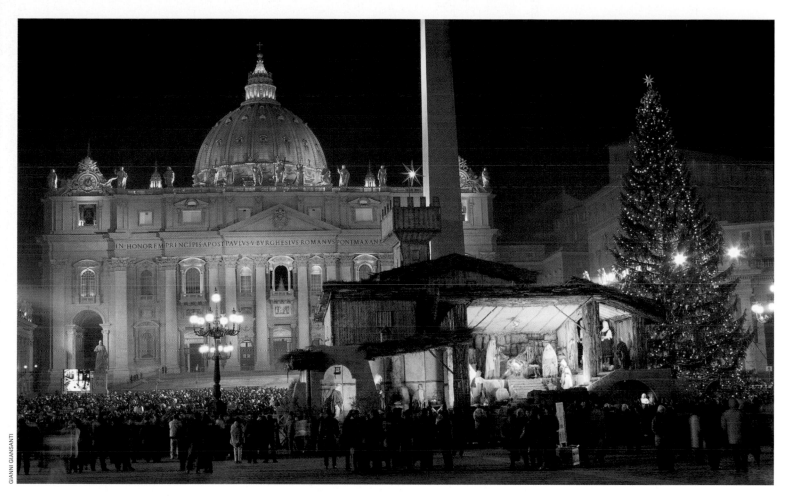

123

Holidays, holy days: St. Peter's Square was perpetually packed in the first week of the Great Jubilee, as John Paul II celebrated midnight Mass on Christmas and even broke with personal tradition to appear at his study window and greet a crowd of as many as 100,000 who had gathered for the stroke of 12 on New Year's Eve. In most previous years, the pope went to bed early on December 31 and said Mass on January 1, but this was different—this was the new millennium. As church bells tolled throughout Rome and fireworks exploded overhead, the pope offered a blessing: "As we cross the threshold of the new year, I would like to knock at the door of every home, to bring each of you my cordial good wishes."

pass through, thereby receiving the plenary indulgence: a general forgiving of sins, a spiritual reward to the penitent for his or her faith and his or her special effort in coming to Rome. In medieval times, the Holy Doors had to be wrecked with heavy hammers to begin a Jubilee; in 1999, the custodial staff at St. Peter's had removed a concrete adhesive before the ceremony, and the opening was an easier affair for John Paul II—who, nonetheless, insisted upon opening four Holy Doors personally rather than delegating the task at the other Roman churches to chosen cardinals. Once the doors were opened, the faithful began streaming through, and continued to flow for more than a year: Millions upon millions of Christians came forth, including in summertime more than two million children who flocked to the city for World Youth Day 2000. The Holy Doors were scheduled to be sealed on January 5, 2001, and three of them were—but at 6 p.m. there was still a long line at St. Peter's Basilica. In a decision characteristic of John Paul II's tenure and indeed his life, the door remained open— until nearly 2:30 in the morning—so that the last seeker might pass through. Then the pope closed the door and celebrated Mass in front of the basilica before a hardy gathering of 10,000.

Later during the Jubilee year, beginning on March 20, he began his own pilgrimage. He was too significant a world figure now to claim that this was strictly "a personal trip," but he did make that claim, though he surely realized it was a politically symbolic trip as well.

It is poignant to report that, while his reception was cordial in places where he was allowed to venture (and though he wanted to visit all of Abraham's land, he was barred from doing so—by the government of Iraq), it was rarely rapturous and never earth-moving or game-changing. The final verdict might be: Christianity is still a potent religion and a force that must be reckoned with anywhere in the world on a daily basis. But Christianity is no longer a dominant movement in the place where Christ was born and preached. Also: What Christianity there is in the Holy Land is predominantly orthodox, and the influence of Rome is negligible. The world of the Middle East had changed greatly through the centuries and grown ever more complicated. As John Paul II was always a supremely intelligent man who could parse any complication, this might have saddened him during his visit—to see that the land where Jesus lived and died was so little influenced in the present day by the life and teachings of Jesus.

On March, 20, 2000, John Paul
gazed out over the Holy Land
from the summit of Mount Nebo
in western Jordan. On a clear day
such as that one, Jerusalem and
Jericho could be seen from there,
and according to the Torah it was
from this vantage that God allowed
Moses to see the land that he,
personally, would not be allowed
to enter. While historians debated
which peak in the region was the
biblical Nebo, for the faithful
the spot that John Paul visited
and declared sacred worked fine
symbolically and spiritually. The
pope planted an olive tree as a
symbol of peace next to a nearby
Byzantine chapel—not 80 days
after Nebo had been included
as a target in one of Osama
bin Laden's unsuccessful 2000
millennium plots.

124 John Paul never expressed any such
sadness, of course. During his five days in the
Holy Land, he did what he could to matter,
and to make whatever was right in front of him
matter personally. "In this place of memories,
the mind and heart and soul feel an extreme
need for silence," the pope said in a speech
after bowing his head in a prolonged silence
in Jerusalem's purposely barren, dark and
cold Hall of Remembrance of Yad Vashem,
a memorial to the millions of Jewish people
murdered in the Holocaust. "Silence in which
to remember. Silence in which to make some
sense of the memories which come flooding
back. Silence because there are no words
strong enough to deplore the terrible tragedy
of the Shoah."

Surely the memories that came flooding
back for him were of Auschwitz—he leaned
on his cane as he made his way between the
words *Buchenwald* and *Auschwitz* carved
into the stone floor—and of his clandestine
seminary long ago in Kraków. He continued:
"I assure the Jewish people that the Catholic
Church, motivated by the Gospel law of truth
and love and by no political considerations,
is deeply saddened by the hatred, acts of
persecution and displays of anti-Semitism
directed against the Jews by Christians at any
time and in any place." He shook the hands of

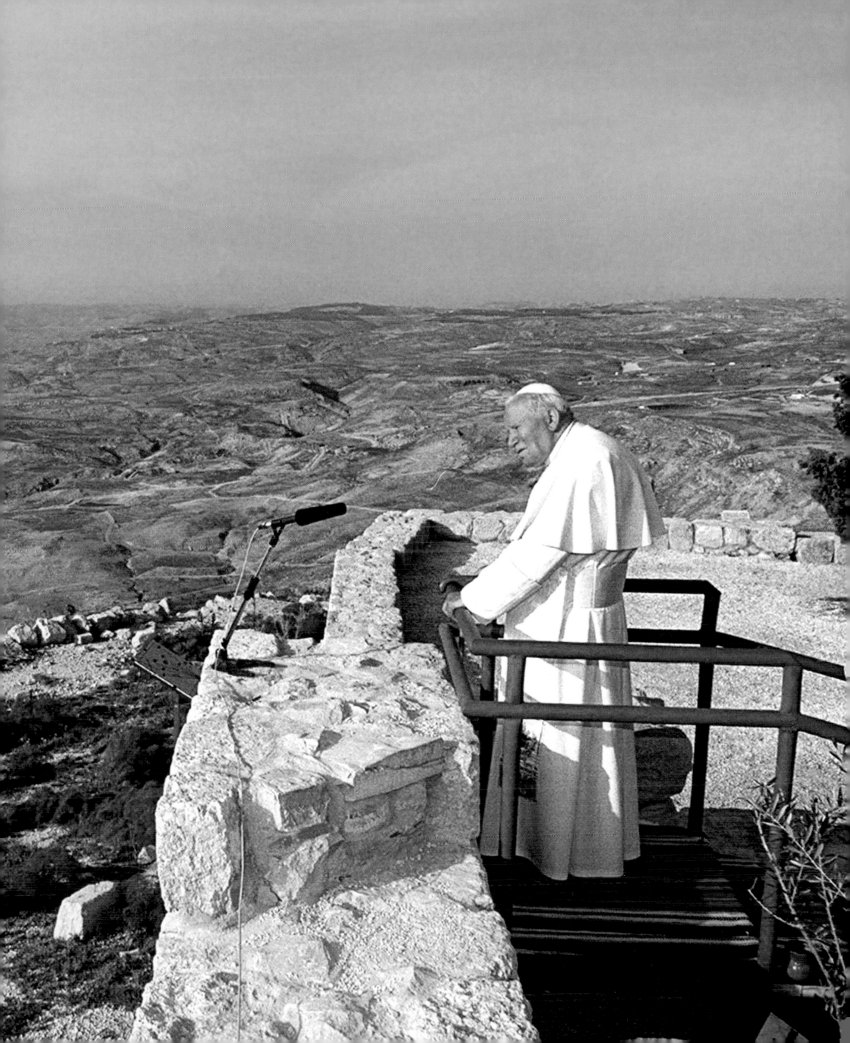

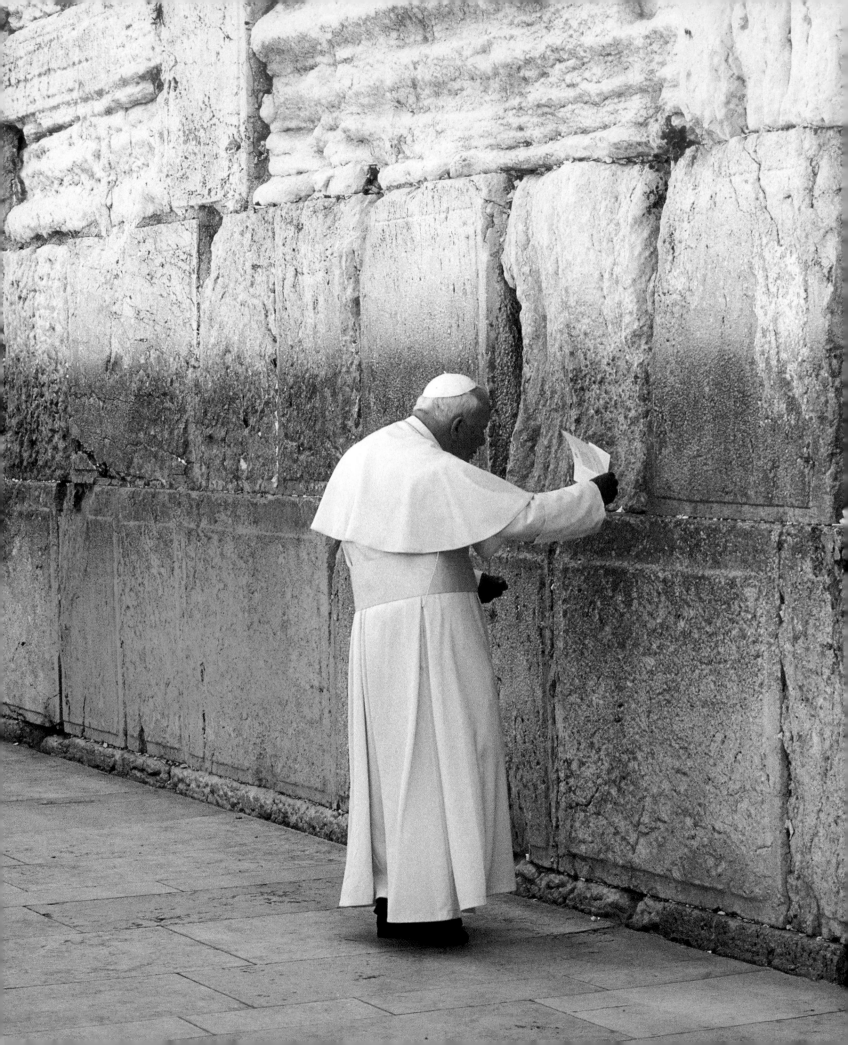

six Holocaust survivors in a moment televised across Israel. Said Prime Minister Ehud Barak: "Your coming here today, to the Tent of Remembrance at Yad Vashem, is a climax of this historic journey of healing. Here, right now, time itself has come to a standstill. This very moment holds within it 2,000 years of history. And their weight is almost too much to bear."

Almost too much to bear for one Michael Goldmann-Gilead, a 75-year-old Jew who, as a Polish teenager in the 1940s, had spent three years in Auschwitz before escaping in 1945 during a transfer to another concentration camp. "I am very glad he is coming here, but I want him to recognize the silence of that other pope," he told Alessandra Stanley of *The New York Times.* "I wanted that pope to say that killing Jews is not allowed. That would have had an impact on Hitler and his army."

Today, that other pope, Pius XII, whose name Goldmann-Gilead didn't—perhaps couldn't—voice, stands not far behind John Paul II in consideration for sainthood.

But if the institutional Catholic conscience is to be questioned, as it has been justifiably since the Crusades and even earlier, that of John Paul could not be doubted. In 1964 when

Pope Paul VI visited the Holy Land—the last pontiff prior to John Paul to do so—he never referred to Israel by name and pointedly did not address the Israeli president by his proper title. In 2000, John Paul, during a warm meeting with President Ezer Weizman, actually blessed the nation of Israel.

He also traveled, of course, to crucial New Testament sites: "Now I shall have the privilege of visiting some of the places more closely connected to the life, death and resurrection of Jesus . . . Today it is with profound emotion that I set foot in the land where God chose to pitch his tent."

He ventured, he saw, he prayed—and then he went home, and the tumult in the Middle East continued. In the decade that followed the pope's visit there would be war in Iraq and continued Israeli-Palestinian violence, as well as, recently, uprisings by secular freedom fighters and Islamic activists against authoritarian and undemocratic rule in the region. As opposed to what had happened with communism on Europe, in this case, John Paul had, it seemed, influenced little.

If the troubles in the Middle East and other calamities such as the events of September 11 had nothing, really, to do with Rome, another

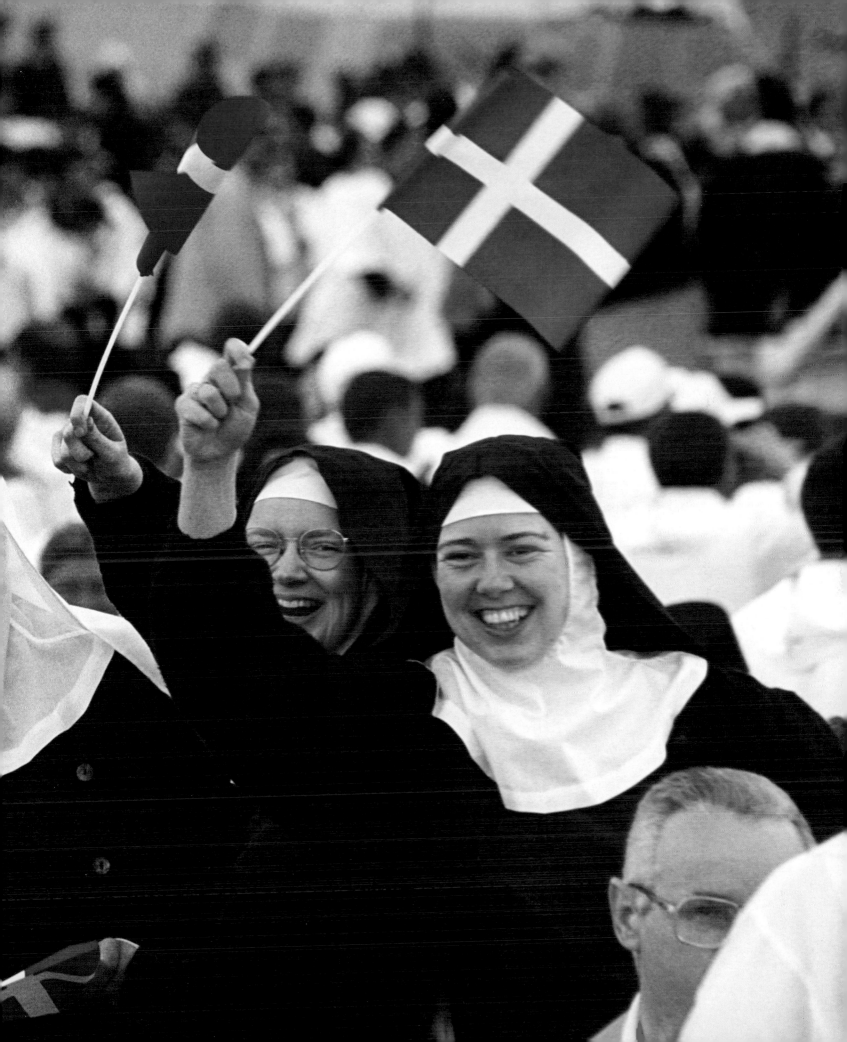

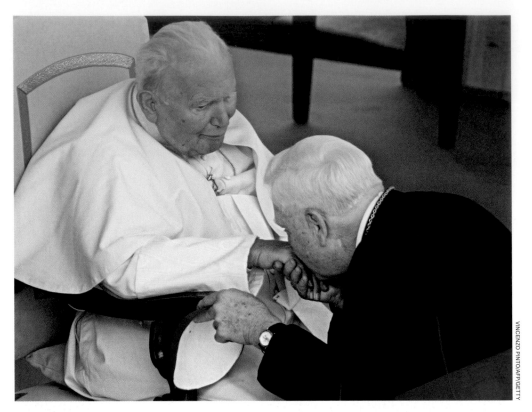

Among the American cardinals summoned to Rome to meet with the pope in the spring of 2002 (opposite) was Boston's Bernard Law (left). At the time, the dominant subject was the sexual-abuse scandal making front-page headlines in the United States, and there was talk of a "clash of cultures"—the Vatican's traditions of authority and secrecy running up against the laws of a nation that demanded transparency, accountability, justice. But in the years subsequent it has become clear that the abuse crisis was widespread—indeed, global—and that other nations were willing to move legally against culpable clerics. As for Law, he was, in the view of many, kicked upstairs at the Vatican, and critics were especially incensed that he was allowed to preside at one of the commemorative Masses that followed John Paul's death.

great crisis of the early years of the new millennium was laid squarely at the Vatican's doorstep. A flood of investigations and thousands of accusers made it clear that, for decades, Roman Catholic priests had sexually abused their parishioners—a great majority of the victims having been adolescents and children. Dioceses in England, Canada, Austria, Germany, Belgium, the Netherlands, Great Britain, Poland, Italy, Australia and, particularly, Ireland and the United States were rocked by the scandal. Priests were defrocked; some were criminally prosecuted and jailed. Churches were forced to pay restitution to victims (in the U.S. alone, more than $2 billion to date) and official reports by various government agencies confirmed the reported horrors. An investigation in Ireland begun during John Paul's tenure—but not issued until after his death—revealed that in that country, where 90 percent of schools are under the Church's patronage, priests and nuns had "terrorized thousands of boys and girls, while government inspectors failed to stop the abuse." As the grim news poured out, many churchgoers lost confidence in the institution that represented their faith. Churches emptied throughout Europe. It is now known that, between 1974 and 2008, attendance at Mass in Ireland, that most Catholic of countries, had been halved.

While he lived, John Paul presided over the crisis without being personally swept up in it. As Boston's Bernard Cardinal Law and

other highly placed church administrators became the poster boys for a systematic and years-long cover-up, the pope, if criticized for being out of touch, was not seen as complicit. It was generally conceded that much of the abuse predated his rise to the papacy, and he sounded strong and earnest in his denunciations of what had occurred. In 2001 John Paul declared that "a sin against the Sixth Commandment of the Decalogue by a cleric with a minor under 18 years of age is to be considered a grave sin, or *delictum gravius,*" and in April 2002, with the crisis in the U.S. raging out of control, 81-year-old John Paul summoned his American cardinals to Rome and ordered them to be more forthright in dealing with the situation. He said unequivocally that there was "no place in the priesthood" for any who would harm the young.

But then he didn't seem to follow his admonitions with any kind of crackdown. Bernard Law provides a case in point. John Paul accepted his resignation as archbishop of Boston in December of 2002, but then put him in charge of the august Basilica di Santa Maria Maggiore in Rome, allowing him to retain his status as a cardinal and bestowing the new title archpriest.

While the sexual-abuse scandal was the overriding controversy of John Paul's last years, it has been made even more clear since his death in 2005 that it will stand as the great stain of his long career. The question

has continued to be asked: How high did the cover-up truly go? John Paul's right-hand man and director of the Congregation for the Doctrine of the Faith, Cardinal Ratzinger, who of course succeeded him to St. Peter's throne as Pope Benedict XVI, has in recent years been drawn into the story: In his native Germany as a younger cleric, what did he know about the abuse and when did he know it? Moreover, it was revealed that the Rev. Marcial Maciel of the Legionaries of Christ, a conservative order in the favor of John Paul, had been accused of raping young seminarians in his charge, and that in the 1990s a canonical trial was quashed, apparently by John Paul's deputies. Had the pope, who was photographed several times with Maciel (images that have been removed from the official portfolio since John Paul's final march to beatification was announced in early 2011), known of this?

Also in early 2011, a 1997 letter from the Roman Curia, which together with the pope makes up the governing body of the Church, surfaced—a letter that critics see as a smoking gun indicating that orders to obfuscate came from on high. The wording of the Strictly Confidential letter, which was delivered to Irish bishops seeking counsel on how to report cases of clerical sexual abuse to civil authorities, is vague in the extreme—"procedures and dispositions which appear contrary to canonical discipline and which, if applied, could invalidate the acts of the same

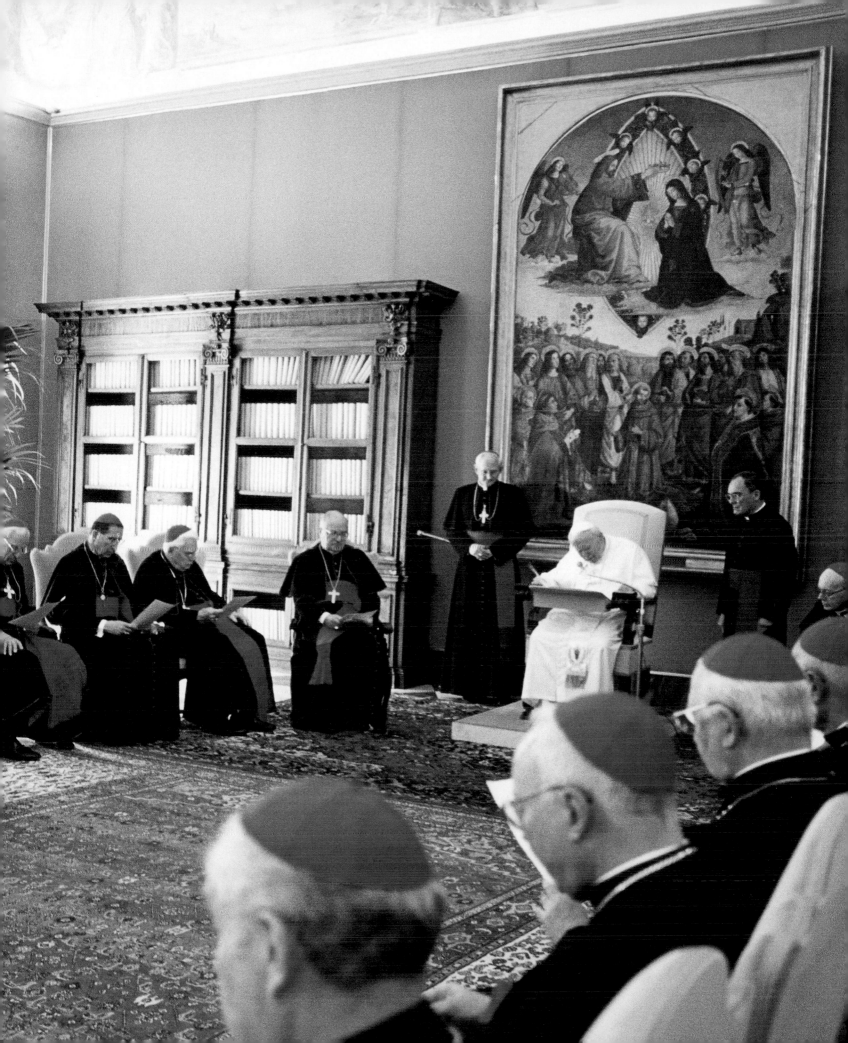

133

Testimony after John Paul's death from some who had been close to him indicated that the pontiff had seriously weighed retirement. But, of course, he would and did serve out all his days. On these pages we see the pope's body, attended by the Vatican's Swiss Guard, having been prepared for visitation in the Clementine Hall on the third level of the Apostolic Palace. In this setting, the late pope was blessed with the holy waters of baptism three times, and was thrice incensed. Then began the long procession to St. Peter's.

Bishops who are attempting to put a stop to these problems . . ."—but, in one damning interpretation, the wording does seem to urge silence. Did John Paul sign off on—or dictate—that 1997 letter?

If he did, he did so long after conceding that he might soon be unable to fulfill the responsibilities of the papacy in a fitting manner. Monsignor Slawomir Oder is a Polish prelate who has served (so far, successfully) as "postulator" for the pope's sainthood, and in a book published not long before Benedict's 2011 announcement of JPII's beatification, *Why He Is a Saint,* Oder wrote that on February 15, 1989, the pope signed a document laying out plans for him to step down if age or illness dictated. In 1994, John Paul reiterated in writing that he would retire if any physical or intellectual infirmity "impedes me from sufficiently carrying out the functions of my apostolic ministry." He was a man with Parkinson's, a once vital man deteriorating, and he could see the end.

He died at the Vatican on April 2, 2005. The rituals of celebrating his extraordinary life and mourning his passing began.

Eduardo Cardinal Martinez Somalo ritualistically removed the Ring of the

Fisherman from John Paul's finger and destroyed it with a silver hammer. Somalo then installed wax seals on the doors of the late pope's bedroom and study. On occasions in the distant past, grasping cardinals had sneaked into the rooms of recently deceased popes and stolen valuable souvenirs, so this strange security measure had been handed down by tradition. Much of what would ensue in the next six days was strictly dictated by tradition.

The funeral of Pope John Paul II was without question the largest and one of the most stunning the world has ever seen. And the world did see it, as it was the first-ever televised papal funeral. With the billions viewing globally, it in fact might have been the most viewed event ever—more widely watched than the funeral of Diana, Princess of Wales, or that of the pop star Michael Jackson.

The list of "firsts," "mosts" and "biggests" that describes what happened in Rome is endless. To begin: This was in all probability the largest gathering of Christians in one place in world history, as four million grieving pilgrims made their way to the city. By April 6, four days after the pope's passing, almost two million people had seen

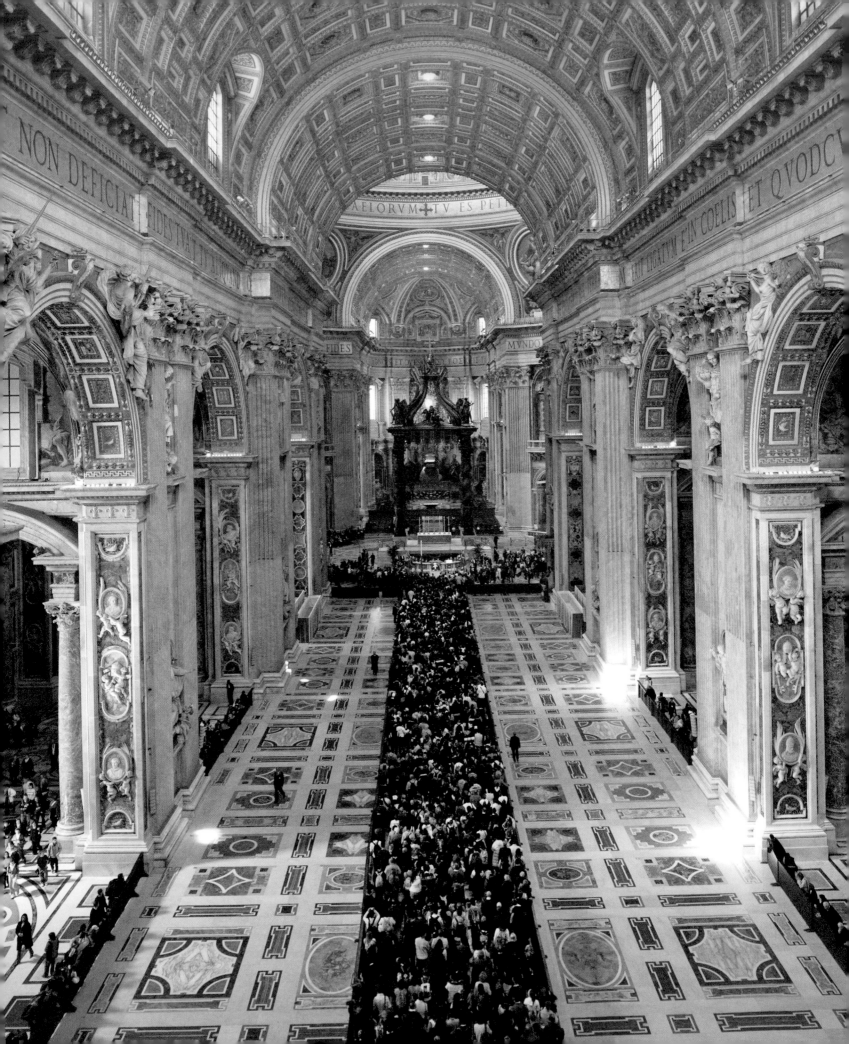

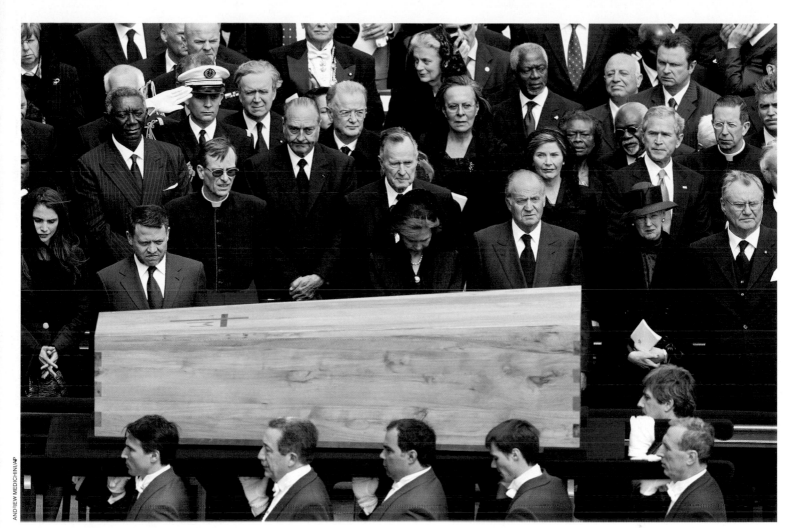

135

**The masses and the dignitaries:
Millions from around the world took
turns packing every square foot of
St. Peter's, inside and out (as seen
opposite and on the pages immediately
following), hoping for the briefest
up-close or far-distant glimpse of John
Paul, while leaders from nations near
and far, including both Presidents Bush
and First Lady Laura Bush of the United
State (above), also paid their respects.
Outside, on the steps of the basilica,
the Papal Gentlemen carefully lifted
the late pope's head for what the
presiding cardinal, Martinez Somalo,
said was John Paul's last, symbolic
look at his flock. A footnote on the
cypress casket: For the interment,
it was placed in a larger zinc coffin,
which was in turn put inside a still
bigger walnut casket, upon which was
a plaque reading, in translation
from the Latin:
*Body of John Paul II, Supreme Pontiff
He lived 84 years, 10 months, 15 days
He presided over the Universal Church
26 years, 5 months, 17 days***

John Paul's body lying in state in St. Peter's
Basilica. All people were invited, of course,
but some were formally so. The assembly of
heads of state—more than 70 presidents and
prime ministers, four kings, five queens—was
the largest ever outside the United Nations,
and the Mass of Requiem brought together in
one room the largest collection of statesmen
in history, surpassing the attendance
record set at the state funeral of Sir Winston
Churchill in London in 1965. George W.
Bush became the first sitting U.S. President
to attend a papal funeral. The ecumenical
John Paul would have been gladdened that 14
leaders of religions other than Catholicism—
Judaism, Buddhism, Islam—ventured to
Italy to pay their respects. Among Christians
in attendance, Rowan Williams became the
first Archbishop of Canterbury to be present
at a pope's funeral since the Church of
England broke with Rome in 1534; Patriarch
Abune Paulos became the first-ever head of
the Ethiopian Orthodox Church to attend;
and, in the honorary first seat for leaders of
churches not in full communion with Roman
Catholicism, there was Ecumenical Patriarch
Bartholomew I, the first of his position at a

papal funeral since the Great Schism of 1054.
China, which has no diplomatic relations
with the Vatican while Taiwan does, was not
represented, but beyond that it seemed that
any and everyone who could come, did.

According to Church law, a pope must be
interred in the period between the fourth
and sixth day after his death. In John Paul's
case, with so much to do and so many people
to satisfy, it was known at once that he
would not be buried until April 8. Meantime,
giant digital television screens were erected
throughout the city in public places to
accommodate the throngs that could not
cram in among the tens of thousands in
St. Peter's Square. Meantime, too, the pope
began something of a final journey through
the Vatican, as he was borne to different
places for various rites of visitation—some
private, some public—and ceremonies. The
Mass for the Repose of the Soul, to send the
deceased's soul to God, was said by Angelo
Cardinal Sodano on April 3, and Cardinal
Ratzinger, in his role as dean of the College
of Cardinals, led the Mass of Requiem on the
eighth. After the congregation sang "May the
angels accompany you into heaven" to close

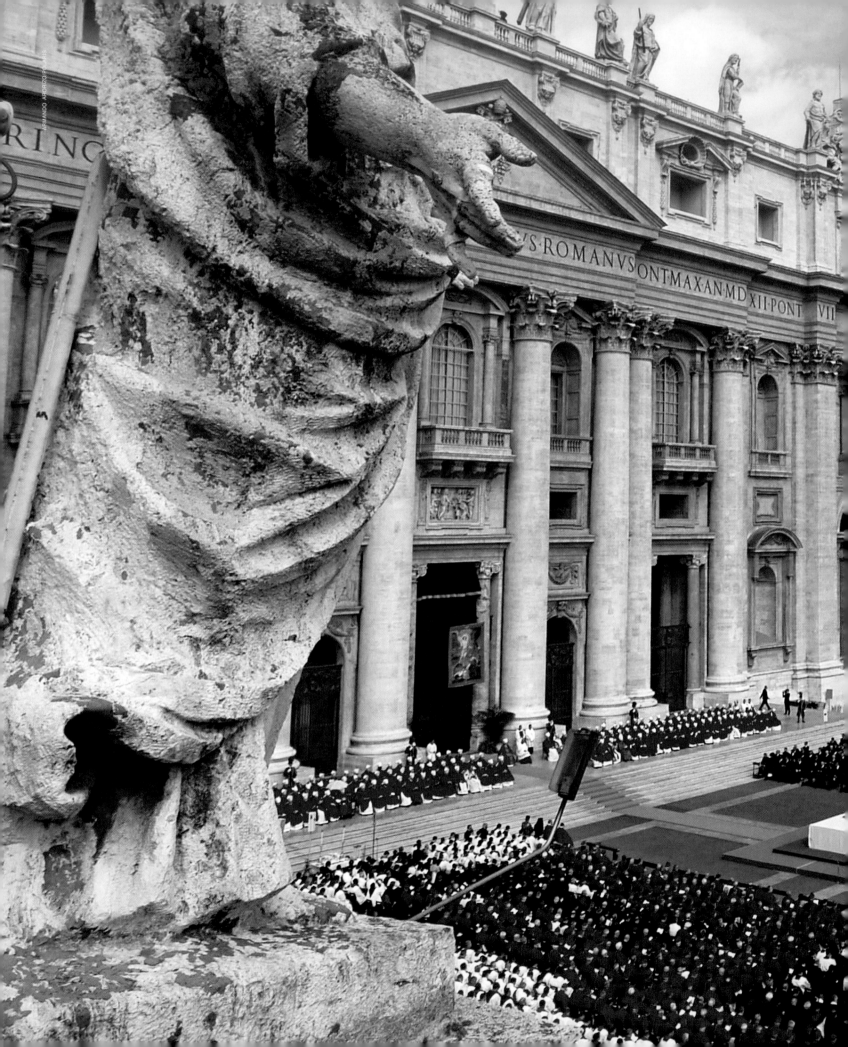

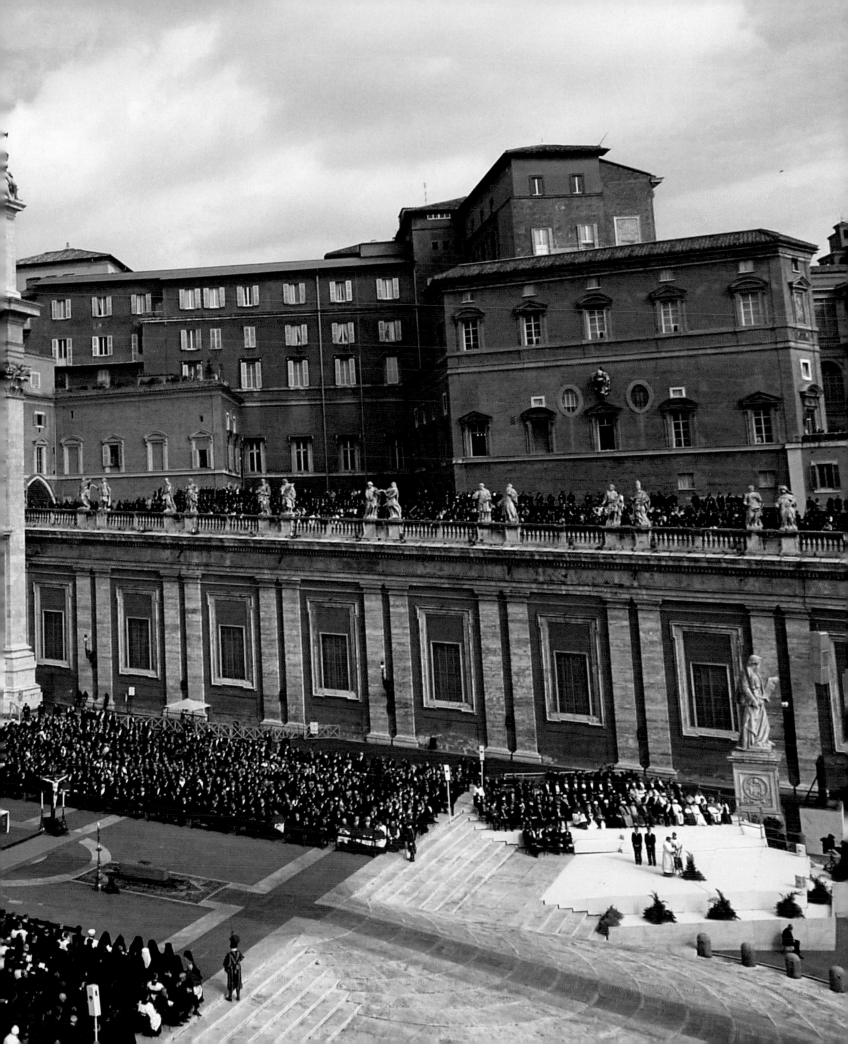

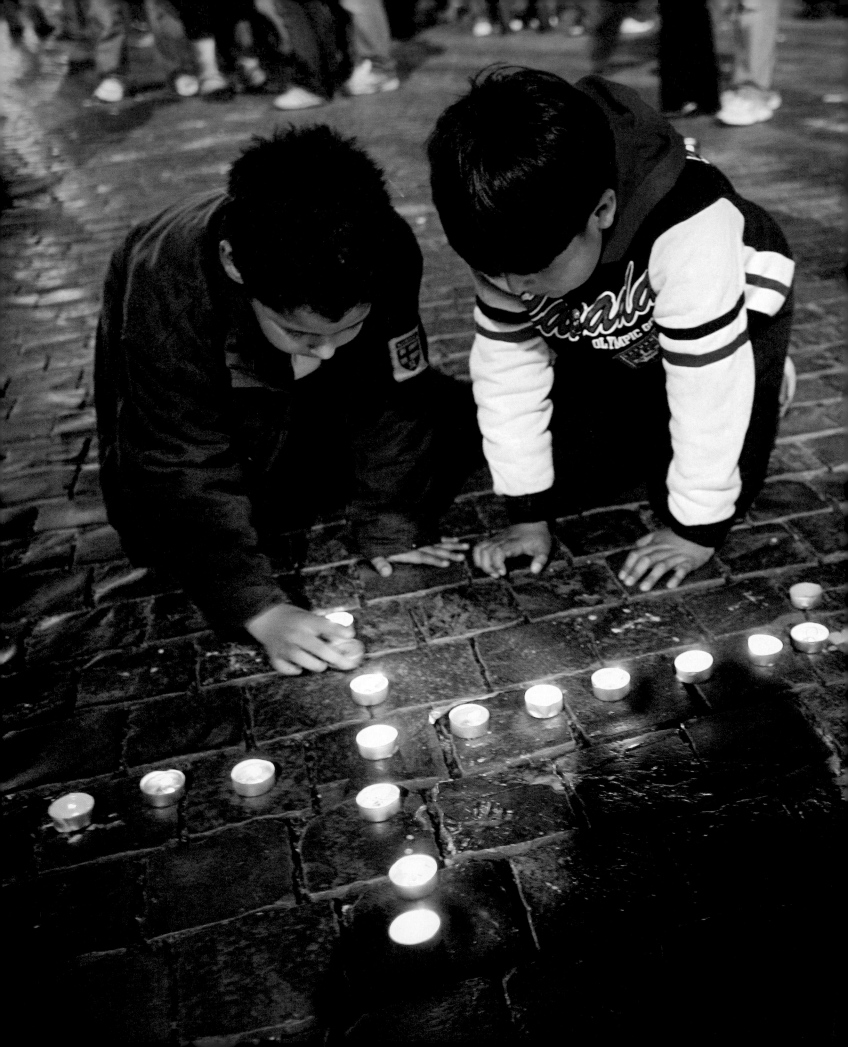

In St. Peter's Square, there were many personal expressions of devotion, none more poignant than when these children lit candles to bid adieu to John Paul II, their friend. The pope enjoyed a special bond with so many, but none mattered more to him than did the children. He wrote special messages to them often. Characteristic was this passage from 1994: "The pope counts very much on your prayers. We must pray together and pray hard that humanity, made up of billions of human beings, may become more and more the family of God and able to live in peace."

139

the Mass, the Papal Gentlemen carried John Paul's coffin to a subterranean grotto beneath St. Peter's for the Rite of Interment. Much that happened in Rome and around the world that week was, as we have seen, measurable. But there was no way to judge the weight of tears shed as John Paul was laid to his eternal rest.

Churchgoers do not usually interrupt a homily with applause, but Ratzinger was stopped nearly a dozen times that day as he remembered his late friend. He often grew emotional, especially when he recalled how John Paul could no longer speak as he neared the end. "None of us can ever forget how in that last Easter Sunday of his life, the Holy Father, marked by suffering, came once more to the window of the Apostolic Palace and one last time gave his blessing *Urbi et Orbi*," said Ratzinger. "We can be sure that our beloved pope is standing today at the window of the Father's house and that he sees us and blesses us. Yes, bless us, Holy Father. We entrust your dear soul to the Mother of God, your Mother, who guided you each day and who will guide you now to the eternal glory of her Son, our Lord Jesus Christ."

Many in the audience wondered how to interpret these closing words. Was the cardinal saying the late pope was already in heaven, perhaps already a saint? Chants

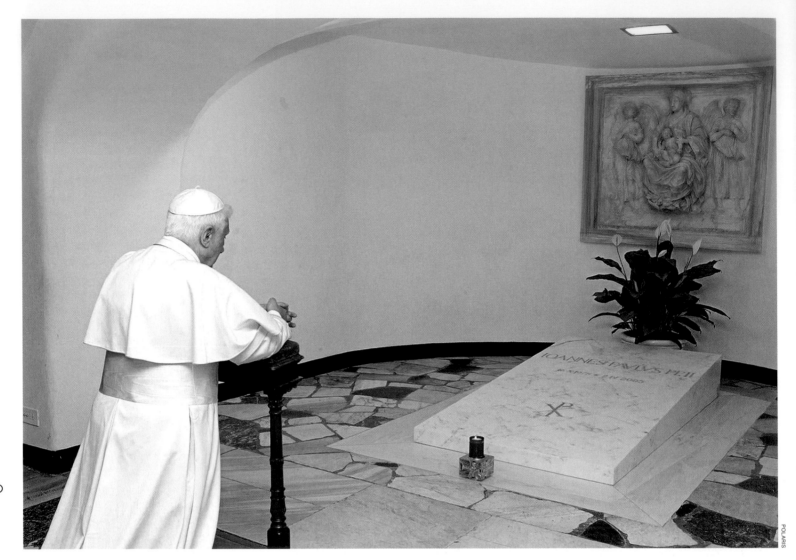

filled the air for the beloved John Paul to be canonized immediately: "*Santo subito!*"

If indeed that was John Paul's fate in his afterlife—instant sainthood—it would take somewhat longer for that status to be confirmed by his Church here on earth. To join Roman Catholicism's confederation of saints, any deceased individual must, these days, meet certain criteria. There was little question that Ratzinger, who was installed as Pope Benedict XVI on April 24, 2005—three weeks and a day after John Paul's death—would put the late pontiff on the road to sainthood. How quickly that road might be traveled was a matter of speculation.

What we have seen so far, as John Paul is beatified on May 1, 2011, has been called, though certainly not by the Church, "the fast track." While the Vatican will protest that all due diligence, including confirmation of the first of a saint's requisite two miracles to qualify for canonization, has been done, JPII's waiting time for beatification is nonetheless and officially the shortest on record: just more than six years from the

time of his death, beating out Mother Teresa's 2003 beatification, which John Paul himself oversaw, by a matter of days. Benedict, who is the first pope ever to beatify his immediate predecessor, has been pushing the matter since his first weeks upon the throne, when he waved the five-year waiting period that is traditionally observed before any candidate's worthiness as a saint can be considered.

Critics and skeptics have said that Rome is moving way too fast. "This is madness," wrote the columnist Michael Sean Winters in the *National Catholic Reporter,* a U.S. publication. "After years of being frustrated at the slow pace with which the Vatican embraces change, in this one instance where haste could spell disaster, they appear to be rushing."

Nonsense, said Ewa Filipiak, the mayor of Wadowice, Karol Wojtyla's native town in Poland. Filipiak told the Associated Press: "We have waited a long time and this is a good day for us." The Rev. Pawel Danek, who runs the museum in the former Wojtyla family home in Wadowice, explained

When the former Joseph Cardinal Ratzinger prayed at the tomb of the recently deceased JPII on May 2, 2005, he had just finished his first week as pope. His candidacy and quick election had proceeded seamlessly. Ratzinger's emotional homily at the funeral had moved many people, voters in the College of Cardinals among them, and when he opened the conclave to choose a new pope on April 19 by warning against the dangers of moral relativism, he all but sealed the deal. Another thing in his favor at the time seemed to be his age. At 78, he would be the oldest new pontiff since Clement XII in 1730, and many inside and outside the Vatican were hoping for a "transitional pope" after John Paul II's very long tenure. But in his sixth year on St. Peter's throne in 2011, Pope Benedict XVI remains in fine fettle, with no end in sight.

The Vatican's Congregation of the Causes for Saints surely knew it was soon going to be getting busy on the day John Paul II died. "*Santo subito!*" was in the air. The complication in any candidate's case as it advances toward sainthood is always the miracles. There must be two—one in the beatification stage, a second in canonization—and their authenticity as inexplicable without divine intervention must be proved. Some of the proofs in the case of Sister Marie Simon-Pierre were in these sealed boxes, put on prominent display on April 2, 2007, after a Mass marking the beginning of the first phase of beatification. Back then, observers could only guess at the contents. The intrigue would continue for nearly four years until January 14, 2011, when Pope Benedict announced that beatification would be celebrated several weeks thereafter on May 1.

further: "The Holy Father [Benedict] has confirmed what we all felt somehow. For us, John Paul II's holiness is obvious."

The main reason that Winters and others felt the alacrity with which beatification had occurred was problematic, and even "madness," can be put simply: the sexual-abuse crisis. As reports of stonewalling and mismanagement continue unabated, how can we proclaim a saint? John Allen, senior correspondent for the *National Catholic Reporter,* predicted an official answer to the question: "[I]n past cases when popes have been moved along the sainthood track, they generally insist that beatifying or canonizing a pope is not tantamount to endorsing every policy choice of his pontificate. Instead, they say, it's a declaration that this pope lived a holy life worthy of emulation, despite whatever failings may have occurred during his lifetime—including his reign as pope." Thus do Pius IX and Pius XII, the former of whom has been beatified and the latter of whom was declared venerated by Benedict in 2009, remain in consideration, despite

the fact that many historians view the 19th century Pius IX as an anti-Semite and Pius XII as a leader who was absent at best and cowardly at worst in the face of the Nazi evil. (A quick note about process: Achieving the "venerable" status, which John Paul as well as Pius XII did in 2009, is the first stage of beatification, requiring next the confirmation of a miracle attributed to the postmortem intercession of the potential saint.)

Despite the resilience of candidates such as Pius IX and Pius XII, and the strong cases put forth by Teresa, the beloved Pope John XXIII (the man behind Vatican II in the 1960s) and the 20th century American journalist and social activist Dorothy Day—all of whom are being openly considered by Rome—most Catholics feel that the next to be granted sainthood will be John Paul II. He is now, with beatification, only one step away from canonization, and there is little doubt that industrious effort is being put into the identification and certification of his second miracle. His first, which as said was needed for him to be beatified, was that he

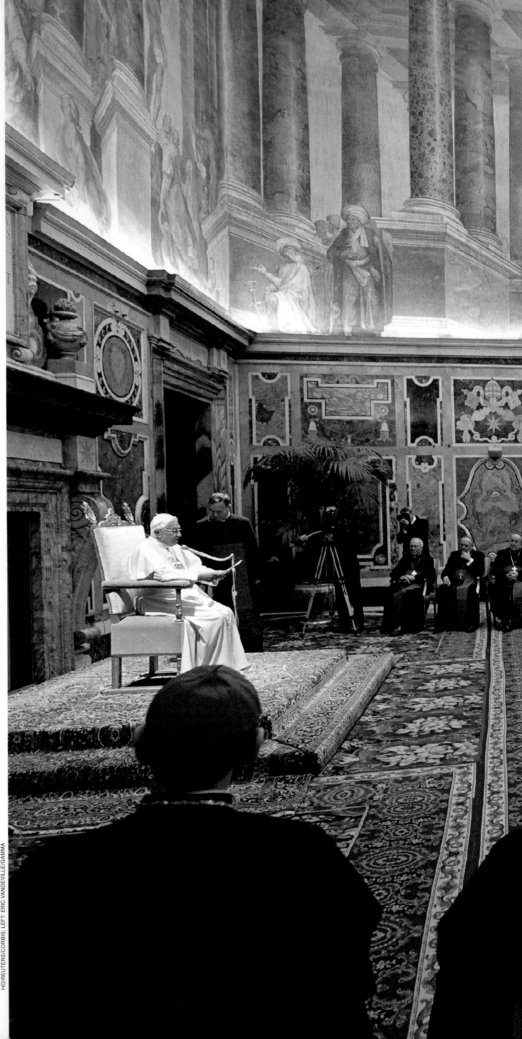

HO/REUTERS/CORBIS. LEFT: ERIC VANDEVILLE/GAMMA

Sister Marie Simon-Pierre (above, at the announcement of John Paul II's beatification, right) was diagnosed with aggressive Parkinson's in 2001. According to her testimony, her superior urged her to plead for the late pope's intercession, and one morning "I went to my sister and showed her my hand. It wasn't shaking. I said John Paul has healed me." The Vatican kept the progress and results of its investigation secret. Then it proclaimed its conclusions from the hilltops and began making preparations for May 1.

142 was responsible for curing the Parkinson's disease of a French nun, Marie Simon-Pierre. She and other sisters of her order, the Congregation of Little Sisters of Catholic Maternity Wards, had prayed to John Paul to make her well, and two months after the pope died, she regained her health.

 Should John Paul II be decreed a saint by Benedict or some future pope, the millions of faithful will again proceed, rapturously, to Rome—as they did for his installation in 1978, as they did when he summoned them to Jubilee at century's end, as they did for his funeral, as they have done, today, for his beatification. Why the reverence for this pope above so many other religious or world leaders? Theories abound—his personal touch, his intelligence, his keen and always evident sense of empathy—but it comes down at last to an intangible, almost mystical holiness. This is why the term "saint" seems perfect to many.

 Living a long life in an age of so many clear evils and rampant hatreds, Karol Wojtyla stood, to any who looked upon him—from his parishioners in Poland to the pilgrims in Rome—in constant counterpoint. Their conclusion: If there can be one among us like this man, God surely must be responsible.

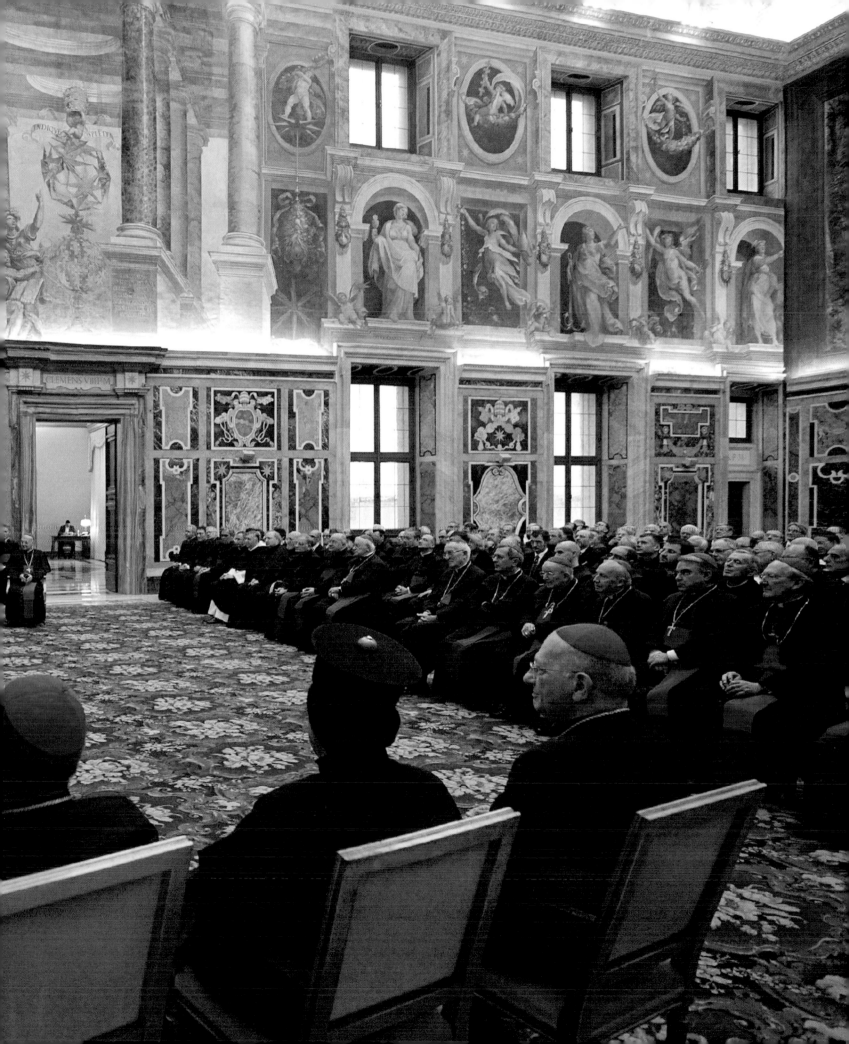